Graphical Facilitation

If 'a picture is worth a thousand words,' this book provides an approach to help create professional pictures that productively and powerfully capture conversations and thinking for individual and collective learning.

Individuals are bombarded by information, and organizations, managers, and teachers often lack a corresponding set of tools to make sense of this complexity—resulting in far too many "death by bullet-point" presentations. This is that toolkit, also offering invitations to readers to extend their thinking past these tools to enable the creation (and co-creation with teams, learners, and clients) of graphical depictions, models, and metaphors to help people make sense of their world. This accessible book is constructed as a visual reference so readers can quickly pick out the specific tool or strategy they need, whether working with individuals and teams to promote self-awareness, develop emotional intelligence, improve communication, or articulate vision and strategy.

This clear and adaptable guide will be a welcome resource for teachers, trainers, managers, and coaches to empower people to learn, think, and create in a powerful, memorable, and graphical way.

Dr. Curie Scott is an independent Education and Arts & Health consultant, coach, and artist. Qualified in medicine, science, and education, her knowledge and research span Arts and Health. She is an award-winning teacher, having taught hundreds of health professional students. Her thinking-through-drawing workshops help individuals and organizations within the Health and Education sectors navigate complexities and create meaningful narratives through drawing. Curie was the strategic lead for rolling out "Prosper", an innovative career development tool for researchers at the University of Southampton.

Dr. Steve Hutchinson has spent over two decades at the forefront of training and development practice. As an independent consultant, using graphical approaches, he has worked as a coach, trainer and developer for Universities and research institutes all over the world, as well as leading acclaimed events and programmes in the public and private sectors. He has previously co-authored or edited six books about professional development, coaching, supervision, and leadership.

Graphical Facilitation

Enabling Conversation and Learning Through Images

Dr. Curie Scott and Dr. Steve Hutchinson

Routledge
Taylor & Francis Group

NEW YORK AND LONDON

Designed cover image: Getty

First published 2025
by Routledge
605 Third Avenue, New York, NY 10158

and by Routledge
4 Park Square, Milton Park, Abingdon, Oxon, OX14 4RN

Routledge is an imprint of the Taylor & Francis Group, an informa business

ISBN: 978-1-032-53154-0 (hbk)
ISBN: 978-1-032-53145-8 (pbk)
ISBN: 978-1-003-41057-7 (ebk)

DOI: 10.4324/9781003410577

Typeset in Sabon LT Pro
by KnowledgeWorks Global Ltd.

CS

For Emma Ford and Linda Butler (from Coaching for Careers), our unknowing catalysts, whom we met at an associates meeting. To Steve, for saying "Oh, I draw for my work too. Let's chat" and subsequently breathing life into and sustaining this book project. Finally, to people who genuinely were (or appeared) to be interested in hearing about this book. And now (surely) are going to buy it!

SH

For anyone to whom I've ever handed a marker pen or sticky note, when all they probably wanted to do was passively sit. Sorry. Not sorry.

And for Emma, who continues to put professional trust in me—in spite of everything.

For Emma, Fred and Linda Butler (from Coaching for Change, our un-knowing catalysts, whom we met at associates meeting.

To Steve, for saving? Oh, I draw for my work too. Let's chat.

and consequently breaching life into and sustaining this book project. Finally, to people who genuinely were (or appeared) to be interested in hearing about this book. And now (surely) are going to buy it.

SH

For anyone to whom I've ever handed a marker pen or sticky note, when all they probably wanted to do was passively sit. Sorry. Not sorry.

And for E____, who continues to put professional trust in me—in spite of everything.

Contents

About the Authors *xiii*

Foreword *xiv*

Picturing the Scene: Introduction 1

Active Participation 3
Conversion and Articulation 4
Realization 5
Conversation—Creating Shared Meaning and Language 5
Capture 6

PART I
The Basics of Facilitation 11
In part I of the book we address the arts and sciences of facilitation and explore
how we might set up environments where growth and learning can safely occur.

1 Chapter One 13

 1.1 The Art of Facilitation—a Reminder for the Experienced 13
 1.2 The Purpose of Facilitation 13
 1.3 Moving Beyond "Drawing Pictures"—
 Facilitation and the Graphical Approach 14
 1.4 The Elements of Proficient Facilitation 16
 1.5 What About Technology? Facilitation in the Virtual World 20

PART II
The Graphical Facilitator's Tools and Technologies 23
Here we consider the practicalities and logistics of graphical facilitation, and
the notion of developing as a facilitator. We also illuminate what led us to
graphical approaches from different starting points and what we've learned
about flexibility, creativity, and actually getting people to engage with a
different type of professional approach.

2 Chapter Two 29

 2.1 The Graphical Facilitator's Kit List 29
 2.2 Adapting Your Approaches and Improvising 32
 2.3 Online and Hybrid Toolkit 33
 2.4 "Drawing Out" the Learning 35
 2.5 Creative Tasks Require Flexible Facilitation 38
 2.6 Preparing the Space for a Graphical Session 42
 2.7 Getting People to Pick up a Pen and actually Draw 44
 2.8 During the Graphical Session 46 ·
 2.9 At the End (and Cleaning up) 48

PART III
Graphical Approaches 51

In Part III we present a series of illustrated ideas and approaches organized around the form that the graphical approach might take. Each chapter shows a variety of activities, ranging from the simple to the ambitious and beyond.

3 Lines, Connections, and Clusters 53

 3.1 Simple Lines and Marks 53
 3.2 Timelines 54
 3.3 Metaphorical Lines 56
 3.4 Lines as an Illustrator of Change 58
 3.5 The Expressive Line 60
 3.6 The Line as a Visual Documentary 63
 3.7 Lines to Illustrate Connections and Clusters 64
 3.8 Connections, Clusters, and the Ubiquitous Sticky Note 66
 3.9 Beyond Basic Clusters 67
 3.10 Strategic Clustering 69

4 Triangles, Squares, and Other Shapes 72

 4.1 Triangles and Trifold Relationships 72
 4.2 Pyramidical Hierarchies 73
 4.3 Triangular Funnels and Filters 74
 4.4 Wedges 76
 4.5 Squares (or more likely, Rectangles) 77
 4.6 Boxed Comparisons 79
 4.7 The Square as a Frame—Storyboarding 83
 4.8 More Than Quadrilaterals—Hexagons and Beyond 86

5 Maps and Mapping 91

 5.1 Cartographic Conversations 91
 5.2 Maps to Navigate Complexity 94

5.3 Understanding Structure 96
5.4 Mapping a Journey 97
5.5 Mapping the Future 99
5.6 Mapping an Organization 100
5.7 Mapping Relationships—Networks, Politics, and Stakeholders 102
5.8 Mapping Discussions and Group Interactions 104

6 Models and Frameworks 108

6.1 The Right Tool for the Right Job? 108
6.2 Symbols and Systems and Encoding 109
6.3 Augmenting a Model 110
6.4 Using a Framework 112
6.5 What are You Trying to Achieve? 114
6.6 From Model to Reality—the Big Fat "So What?" 117
6.7 Beyond Models—Creative Interpretations 118

7 Circles 122

7.1 Targeting—Illustrating Proximity to What is "Core" 123
7.2 The Circle as Clock Face—Event Countdown 124
7.3 Unification and Equality 125
7.4 Compass and Direction Finding 126
7.5 Holistic Comparisons 128

8 Freeform Graphics 130

8.1 Less Framework, More Freedom 130
8.2 Collaging (2D) 131
8.3 Creating Vision—Picturing Success and Seeing the Future 135
8.4 Freeform Drawing for Writers: Visualizing "Flow" 137
8.5 Observational Drawings 138

9 Space and Movement 140

9.1 Using a Template 140
9.2 Mindful Drawing to Aid Wellbeing at Work 141
9.3 The Face or Body as a Spatial Template 144
9.4 Physical Movement and Visual Position 147
9.5 Ordering Ideas and Information Using Space 148
9.6 Drawing with the Body: Embodiment Practices 152
9.7 Beach School 152

10 The Third Dimension 154

10.1 Collaging in Three Dimensions 155
10.2 Origami Insights 157

10.3 *Masks—What People Show and What They Don't 160*
10.4 *Sculpting and Printing with "Found" Materials 162*
10.5 *Building Blocks and Lego® Sculptures 163*

11 **Mixing and Matching** 166

11.1 *String Theory 166*
11.2 *Mixing Graphics, Shapes, and Directions 167*
11.3 *Mixing and Matching the Written Word with Graphical Form 168*
11.4 *Annotated Sculpture 170*
11.5 *Annotated Images 172*
11.6 *Collaborative Cartooning 175*
11.7 *Off to the Art Gallery! 178*

12 **Digital Possibilities** 180

12.1 *Lifting a Basic Webinar 180*
12.2 *Virtual Considerations 182*
12.3 *Digital Issues 184*
12.4 *Image Sharing and Digital Collaboration 185*
12.5 *Digital Play and Practice 187*
12.6 *Word Clouds—Text to Graphic Translations 188*
12.7 *The Graphical Possibilities of AI 190*

PART IV
"Drawing" It All Together 193

In Part IV we bring everything together and invite the reader to consider how
they might continue to adapt their practice to suit an as yet unknown landscape.

13 **Reframe Your Thinking and Picture the Future** 195

13.1 *The Five Perspectives of Facilitation 195*
13.2 *Changed World, Changed Approaches? 199*
13.3 *Lessons Learned Along the Way 200*

Index 206

About the Authors

Dr. Curie Scott

Curie's work with drawing builds on her experiences as a medical doctor, lecturer, coach, and researcher into drawing for cognition as well as her artistic practice. She helps individuals and organizations within the Health and Education sectors navigate complexities and create meaningful narratives through drawing. She is the sole author of *Drawing*, part of the Arts for Health series (Emerald Publishing) and co-editor of *Drawing in Health and Wellbeing: Marks, Signs and Traces* (Bloomsbury Publishing). She has published chapters on drawing for the *Routledge Companion for Health* and *The Encyclopaedia of Health Humanities*. She has written guest blogs and magazine articles, of which her favorite (so far!) was for the Society of All Artists on "Anyone Can Draw." She enjoyed appearing on television on "Make Craft Britain" and speaking engagements. She launched "Drawing Edges," bringing drawing practitioners, academics, and researchers together who exhibited in a pop-up exhibition alongside the prestigious Jerwood Drawing Prize. Curie is most energized when she sees people have "aha" moments during coaching, educational programmes and in professional development. She enjoys laughing and creating meticulous patterns as well as messy ink drawings.

Dr. Steve Hutchinson

Steve was originally an academic biologist, has a PhD in Behavioural Ecology and spent a great number of hours analyzing dung flies having sex on cow manure. Oh yes. Subsequently he worked in research and staff development at the Universities of York and Leeds in the UK. In 2006 he left academia and set up his own company, Hutchinson Training and Development Ltd (www.hutchinsontraining.com), and works globally with many organizations in the Educational, Public, Not-for-profit, and Private Sectors. His work centres on leadership, career development, personal effectiveness, and communication skills. He has co-authored or co-edited six previous books about leadership, development, and coaching. As a qualified coach, developer, and facilitator he brings a graphical approach to all elements of his role and can frequently be found scribbling on whiteboards, flipcharts, and walls, and encouraging others to do likewise. He lives in Yorkshire with his family, spaniel, and too many jazz LPs and pairs of running shoes (apparently).

*

Foreword

The modern world is a highly complex, and more importantly for us, a highly visual, photographic, and infographic-driven place. People are bombarded by vast swathes of information but organizations, managers, and teachers often lack a corresponding set of tools to help individuals make sense of this complexity. If you've ever sat in a "death by bullet-point" presentation, you'll understand this.

If "a picture is worth a thousand words" then this book sets out, illustrates, and extends some graphical tools and approaches to help the reader to productively and powerfully capture thinking and conversations for individual and collective learning. Moreover, in a modern era of hybrid-working and team-working, this book provides the reader with a method for aiding collaboration and collective thinking through joint idea creation.

This book provides a mix of instruction and ideas alongside further enquiries and invitations to the reader to extend their thinking. By doing so, we hope to help managers, teachers, coaches, trainers, and facilitators to create (and co-create with their teams, learners, and clients) graphical depictions, models, and metaphors to help people make sense of their world. As practitioners, as well as authors, our professional portfolio includes teaching, coaching, facilitation, and management, recognizing that kinaesthetic involvement (i.e. "doing" as well as reading and listening) from teams and learners is paramount in helping people to learn and internalize complex interactions.

Finally, we invite you to consider when learning was "fun" for you. If your mind's eye took you to primary school, then think further about what was on the table in front of you, and almost certainly drawing, crafting, painting, and active participation will have been integral to your experience.

By using graphical approaches this book aims to help teachers, trainers, managers, and coaches to empower people to learn, think, and create in a powerful, potentially fun, and memorable way.

Picturing the Scene: Introduction

Some years ago, a colleague and I ran a big developmental event for PhD supervisors at a very prestigious intellectual institution. Some of the cohort had a great deal of experience in the area, but some had very little and were new to the role. As such we wanted the cohort to share experiences, ask questions, and discuss varieties of good practices. We also wanted the group to reflect on how the supervisory role might change over time as their doctoral researchers move towards professional independence and academic graduation. To achieve this, we decided that we would split the group and ask subgroups to draw an annotated map of the doctoral journey from arrival to viva and beyond. We hoped that their possible metaphorical depictions of the (fictional) forest of literature or the swamp of analysis or the marshes of writing would be enlightening and stimulate productive conversations about the supervisory role. Neither of us had any idea whether this approach would work.

To add to the risk, we asked that half of the supervisory subgroups created a representation from their own *current perspective* (i.e. that of an academic with a PhD student), and the other half of the subgroups drew the doctoral journey from their *remembered perspective* of being a research student.

The groups immersed themselves in the map creation far more enthusiastically than we could ever have hoped (volcanos of imposter-ness and dragons representing nefarious competitors who steal ideas both featured—it was all very Tolkienian).

When the drawing process had finished we asked the groups to display their artwork for comparison and discussion, and something amazing presented itself.

The "student perspective" groups all drew a roadmap where the student and supervisor walked the journey together. The two roles were depicted as colleagues in the same physical space. They traveled with each other and shared the trials and tribulations. The "supervisor perspective" groups all drew similar fantasy quest road maps; but, in marked contrast, the supervisor was at no point present on the road—instead they were depicted floating above the scene on a cloud and pointing the right direction, like an intellectual deity or a disembodied mentor (to continue the fantasy analogies, I seem to recall at least one of their supervisor depictions being surrounded with the blue-green glow of a dead Jedi).

What was instantly and graphically striking was the huge difference in role need and expectation and desire from the two camps. One group thought that the role was an intellectual one. The other wanted a far more companionable and pastoral focus. The pictures showed this instantly, and gave it weight and meaning. Even if bullet points on a flipchart had used words like "intellectual" or "pastoral," the difference would never have been as clear. This discrepancy shook the group and made for one of the richest days of development I'd ever had.

DOI: 10.4324/9781003410577-1

Over the past decades, both of us have spent a great deal of our professional lives drawing pictures and asking groups and individuals to draw pictures. As professional developers our kit-bag is full of marker pens, sticky tack, rolls of paper, and a variety of other kit that normally would be found in a primary school craft cupboard. The people with whom we work are often very, very clever and often very, very serious. It is always a risk to choose a style of group work that asks a clever, serious group to move away from texts and towards pictures. It was a risk with the academics in the story above. But it was a risk that paid off handsomely and we've both taken subsequent professional risks many, many times. They usually pay off.

For example, Figure X.1 shows three different responses from three groups (in the same cohort) to the given brief of "Produce a captivating image illustrating leadership in your organisation."

Three groups created three totally different depictions. One, a conventional concept map, another a linear road map with directional arrows towards and away from the promised

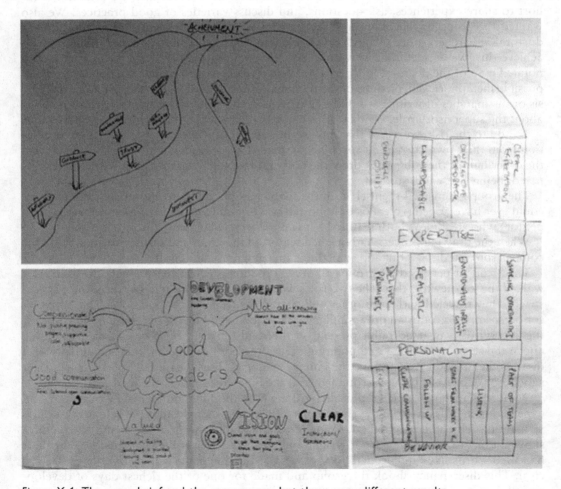

Figure X.1 The same brief and the same room; but three very different results

land of "achievement," and the final one a hierarchical tower with different architectural levels from behavioural "foundations" to the "expertise" supporting the higher decorative elements. The variety of styles evoked a varied and stimulating conversation, and no little amount of intra-group admiration for their different interpretations.

So while "a picture is worth one thousand words," we've realised that the *right* picture can quickly get to the *right* words. And moreover, a picture that someone creates personally, or that a group co-creates, is worth potentially far more than a graphic or model that is prescribed.

There are several other books and printed works about drawing or graphical capture for professional developmental (but non-artistic) reasons. For instance, *The SketchNote Handbook* (Mike Rohde) is a good primer on graphical note-taking, and anything by Tony Buzan (for instance *The MindMap Book*) sets out much of the rationale for why a graphical approach (especially in a radial, colorful, and spatially prioritized form as opposed to linear, monochromatic, and one-sized) has advantages. Moreover, many books for facilitators and trainers have "learning capture" sections. There are also books for coaches that use art as a facilitative tool (for example *The Art of Coaching* by Jenny Bird and Sarah Gornall and the work of Sarah Crawford (see *The Art of Graphic Coaching*), and books about graphic capture in business (e.g. *The Art of Business Communication* by Graham Shaw). There are also books about graphical problem solving (e.g. *Back of a Napkin* by Dan Roam) and graphics as a facilitative business strategy tool (for example, the excellent *Business Model Generation* by Alexander Osterwalder and Yves Pigneur, and also *Visual Collaborations* by Ole Qvist-Sorensen and Loa Baastrup) and a leadership device (e.g. *Visual Leaders* by David Sibbett). Finally, there is also material available for 'graphic facilitators' (for example *The Graphic Facilitator's Guide* by Brandy Agerbeck). These works are all excellent and we'd recommend you read them. However, the reason we find drawing and graphical approaches to be so powerful is that we set it up to be something actively done by groups and workshop participants (as opposed to the complementary style of facilitator-led drawing outlined in Agerbeck's book and Shaw's approach above).

Put simply, in our world everyone gets to hold the pen.

This book is ***about empowering people to create and co-create the visual***, and in workplaces and centers of education, where inclusion, (neuro)diversity, involvement, and buy-in are very much the modern watchwords, this approach is hugely advantageous—and, as we know, it can be hugely powerful. As such, our shared rationale behind the process of graphical facilitation is to set up a process that will aid professional groups and individuals to do a number of powerful things.

Active Participation

As a trainer, facilitator, coach, or educator you probably have a way of achieving "balance" in your sessions. We grew up with the now-questionable notion of a "learning styles model," which for both of us was a means of paying attention to diversity as opposed to an end in itself. Regardless of your model (or, for that matter, whether you feel that such models are over-simplistic and questionable in their application), you'll recognize that a balanced approach to training or teaching is probably going to yield better returns than an approach that is one-dimensional. (These notions of flexible training approaches and experiential

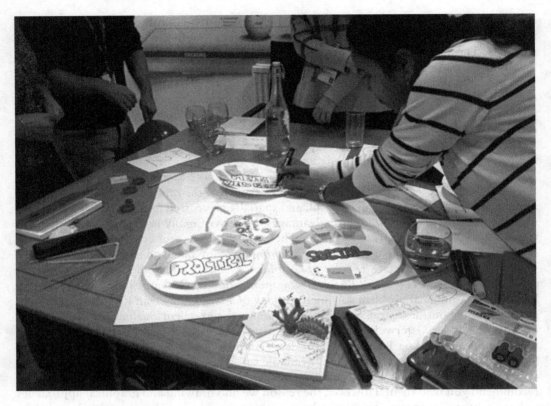

Figure X.2 Active engagement and co-creation

learning are explored in more detail in the book *Playing with Purpose* (Hutchinson and Lawrence 2011)). Graphic facilitation, and the notion of handing over the pen, involves the group in a process of active contribution and discovery; it demands creativity and ensures that groups and individuals process material personally.

At the very least the size, scale, and scope of an activity that involves a large sheet of paper brings a kinaesthetic engagement to the group, not to mention the visualization, discussion, listening, and collaboration that creating a shared visual image or metaphor may require.

Conversion and Articulation

Yesterday I worked in a room where a group of very clever research academics drew pictures of their jobs with regard to supervising doctoral researchers. To give a flavor of just two of the conversations, the metaphors they created and drew included:

- Students who are lost in a forest of data and being pursued by peer-review bears, while the supervisor is in a hot-air balloon (for a wider view) with a chainsaw (to clear a forest path—or maybe the bears...)
- The compost-heap of ideas leading to the market garden of publication, in which intellectual vegetables are grown that contain the seeds of further inspiration.

You don't need to understand anything about the academic world to get an immediate sense of the sheer enormity of a "forest of data" or the fear that "peer review bears" might generate. What's more, you can understand straight away how the agricultural metaphor of laboring to create marketable produce, which also contains further inspiration, is a helpful frame to explain the intellectual experience to the uninitiated.

These metaphors arose because the group members were asked to draw pictures and had to find easy and quickly sketchable representations of what something (and remember that the "something" in question is fairly complex) was "*like*." Giving words to an object or metaphor has been studied from a psychological perspective (i.e. Fetterman et al 2013) especially regarding the effects of such conversions or metaphors on an individual's state. With groups, something interesting seems to happen in the collective creation of a metaphor. For a start, it allows the group to quickly short cut their discussions to a point of productivity as and when the metaphor occurs. For instance, using the example above, "peer review bears" instantly conjures *for the whole group* a shared understanding of the potentially docile, but perhaps incredibly threatening experience of a perhaps less-than-objective outsider critiquing their efforts. The use of the object and image of "bear" has agreed connotations for the group, both positive and negative, that objects or animals (peer review ducks, anyone?) may not have. This agreed conversion and metaphorical representation is a hugely useful facilitative lever to help the group get to interesting places very quickly and then to get there immediately each subsequent time the metaphor is used. Of course, metaphor and conversion can happen away from graphic depictions, but the group conversation of "how shall we depict that?" means it happens frequently and easily when the group members have drawing on their mind.

Realization

Of course, as well as metaphor and imagery the group, when carrying out a graphical task (especially a free-form one that doesn't center around an existent model or framework) must also consider elements such as the size of any given object (i.e. is the bear big or small?), its weight compared to other objects (i.e. are we worrying unnecessarily about an unlikely bear attack?), and its position relative to other elements (i.e. do bears attack at the edge of the woods or deep in the center?), and to the rest of the page. This notion of paying attention to the weight, position, colour, and size of a visualization is well known in Cognitive Therapy (for example see, Hackman (2011)) and tools associated with Behavioral Coaching as a way of helping an individual to make certain desired states more resonant (i.e. picture success and turn up the brightness and color resolution of the mental image), and undesired states less fear filled (i.e. picture your fear and make the associated image small, dull, and monochrome). With graphic facilitation and coaching these elements are still important, as they allow *enquiry* as to the position, weight, color, and size of an object. Frequently these enquiries lead to very little, but on occasion they can be the key to unlock hugely productive territories.

Conversation—Creating Shared Meaning and Language

An oft-heard complaint in the modern world is that we have lots of "information" nowadays but perhaps less professional "wisdom" than before. In some ways our world is better informed and connected than any previous era, and anyone with a smartphone has the

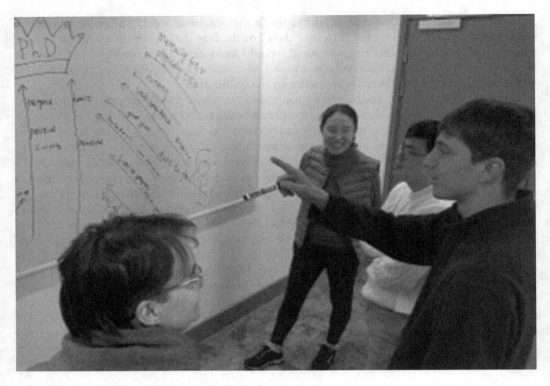

Figure X.3 Shared activity, shared image, shared meaning

potential to access all the information from history and reach out and connect to anyone on the planet. Yet at the same time we are seemingly less connected at a human level and more confused. Text-based "information," from a developmental perspective, is not always helpful here—and sometimes a socialized or conversational approach is more useful and insightful. In reality, this is illustrated by the difference between reading a company manual and having a decent conversation with a long-standing employee.

Helping groups to have meaningful conversations and create shared metaphors facilitates a transfer of knowledge through dialogue. It also allows the implicit understanding that an individual may have to be made explicit and combined with the knowledge of others within the group. This shared understanding of the group can then be used by the individual in their daily work. (This process of learning by dialogue is captured neatly, and graphically, by Nonaka and Takeuchi (1995) in their Knowledge Spiral model.)

Capture

I have, deep in the bowels of my laptop, a file marked "personal development." It contains articles that I've downloaded (and some that I've even actually read...) and a large number of PowerPoint handouts from seminars I've attended and lectures I've been to. I may review these notes following a seminar, but then truthfully they sit unloved and unread until my laptop starts to creak and I purge them to create space. However, on my smartphone I have images of facilitative whiteboard or flipchart drawings that I or others have created. When I

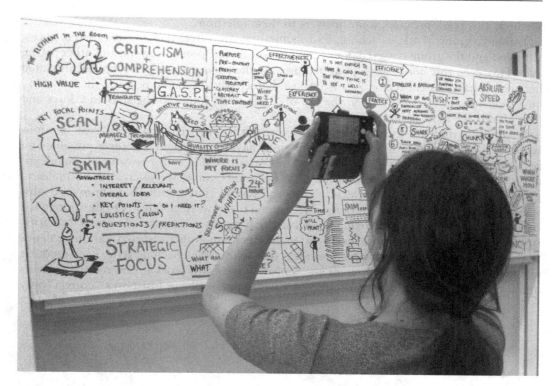

Figure X.4 A participant captures a workshop output

see them, or my phone reminds me of what I was doing on this day in history, I am instantly taken back to that time, that course, that conversation, and those ideas and learnings.

The modern world is a very graphical age—we are the smartphone and Instagram generation. And whilst the images we take on our cell phone devices are disposable, there is an immediacy and a shareability to them, which can make for useful facilitative aids and reminders of lessons learned. So a facilitative picture, if captured and stored on an object that someone carries around with them all the time, can be a near-permanent reminder of a powerful learning event or insightful discussion. And thus, just by its portability and graphical immediacy, a picture can be a reminder to take compelling action in a way a document or PowerPoint slide deck maybe cannot.

So, in essence this book is about how you as a facilitator, coach, manager, or trainer can use drawing, painting, collage, or artistic mechanisms to enhance the learnings, discussions, and actions of others. Or, in the form of a short question:

Is it possible to facilitate and extract professional learning from drawing pictures?

We believe that the answer to this question is, of course, "yes"; but it leads to three others:

- *How can you do this more effectively?*
- *How can you create new ways of doing this that can access the kind of learning you're interested in?*
- *How can you adapt a graphical approach to new ways of working and professional being?*

We hope this book provides some answers to these questions.

Training, group work, coaching, and facilitation are often very *personal* experiences, with you and the group cosseted out of sight of recordings, peer reviewers, and other prying eyes. However, this book was a joint venture and the concepts and philosophies presented herein are shared or collective. As such we've shamelessly alternated between the use of "I" and "we." So, to help the reader, the use of "I" is often found in the solo anecdotes and "we" binds the more abstract material.

In addition, many of the graphics that we present herein are taken from "real" sessions with "real" groups and individuals. Permissions have been sought wherever possible and sometimes the graphics have been cropped or partially redacted for reasons of confidentiality. Where such cropping or redacting has been impossible, we've created facsimiles to give an impression of the real artefact. No "professional" illustrations have been used—for which neither of us make any apology. We wanted to show "real" efforts to illustrate what is possible when people who frequently declare that they "cannot draw" or have "no artistic talent" are let loose with flipcharts and marker pens and other assorted stationery items.

We present the models, concepts, and ideas that follow in a coaching style. Each modular chapter of the book contains content and tools that we know work for us and our learners and programme delegates. We certainly don't wish to prescribe or insist on a "correct" way

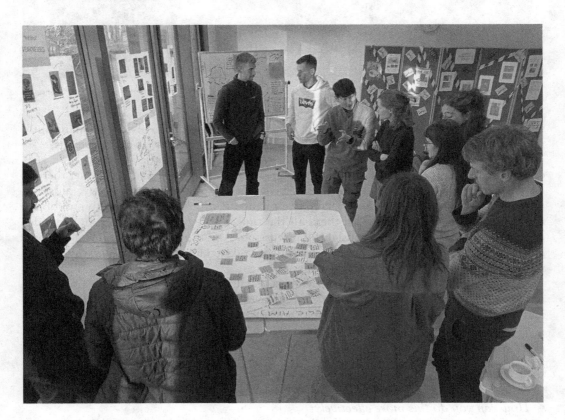

Figure X.5 A group fully immersed and engaged in a graphical conversation. (Notice that the windows (left) have also been commandeered as extra whiteboard space.)

of doing things. Feel free to select what you need, adapt those ideas that need modification to your context, and reject what does not chime with you and your work. Each idea is followed with coaching-style questions to help you to interrogate or reflect on your own practices and approaches. As part of this reflection and considered practice, we would, however, urge you to take risks. The "safe" option is very rarely the memorable or powerful one—however much you believe it is what your organizational higher-ups might want to see.

Finally, as you will notice, each chapter contains ideas around *Purpose*, or professional need, for which a graphical facilitatory approach might serve. It then outlines a range of *Processes* that could be followed in order to achieve a result in line with said professional purpose. It then offers a number of *Possibilities* that the reader could use to extend the idea or adapt it to serve different professional environments (for example—different group sizes or an online webinar format). Of course, the most important adaptation that you could make would be to tailor the ideas and models so that they are authentically "you-ish." In our long experience as facilitators we've realized that the best ideas are not just the ones that work on the areas of need, but also those that we are personally comfortable with—or at least, that are not too far outside of our comfort zone. It would please both of us immensely to know that you continue to stretch and develop the ideas we've shaped and developed so far.

<div align="center">*</div>

Introduction—References

Agerbeck, B (2012) *The Graphic Facilitator's Guide: How to use your listening, thinking and drawing skills to make meaning.* (Loosetoth.com Library)

Bird, J and Gornall, S (2016) *The Art of Coaching: A handbook of tips and tools* (Routledge)

Buzan, T and Buzan, M (1996) *The Mind Map Book: How to use radiant thinking to maximize your brain's untapped potential* (Penguin)

Crawford, S (2018) The Art of Graphic Coaching: A picture is worth 1000 words, https://coachingfederation.org/blog/the-art-of-graphic-coaching

Fetterman, AK, Bair, JL, Werth, M, Landkammer, F, and Robinson, MD (2016) The scope and consequences of metaphoric thinking: using individual differences in metaphor usage to understand how metaphor functions. *Journal of Personality and Social Psychology,* 110(3), 458–476

Hackman, A (2011) *The Oxford Guide to Imagery in Cognitive Therapy* (Oxford Guides to Cognitive Behavioural Therapy) (Oxford University Press)

Hutchinson, S and Lawrence, H (2011) *Playing with Purpose: How experiential learning can be more than a game* (Gower)

Nonaka, I and Takeuchi, H (1995) *The Knowledge Creating Company: How Japanese companies create the dynamics of innovation* (Oxford University Press)

Osterwalder, A and Pigneur, Y (2010) *Business Model Generation: A handbook for visionaries, game changers, and challengers* (John Wiley & Sons, Inc.)

Qvist-Sorensen, O and Baastrup, L (2019) *Visual Collaboration* (Wiley)

Roam, D (2008) *The Back of the Napkin* (Penguin Group)

Rohde, M (2013) *The Sketchnote Handbook: The illustrated guide to visual note taking* (Pearson)

Shaw, G (2015) *The Art of Business Communication: How to use pictures, charts and graphics to make your message stick* (Pearson Business)

Sibbet, D (2013) *Visual Leaders: New tools for visioning, management & organisation change* (John Wiley & Sons, Inc.)

Part I

The Basics of Facilitation

DOI: 10.4324/9781003410577-2

Chapter One

1.1 The Art of Facilitation—a Reminder for the Experienced

When we sat down to plan this book we had a lengthy conversation about the target readership. We wanted to create something that an experienced practitioner could pick up and think "I could try that technique." As such, we decided that we didn't want to spend a huge amount of time or word count outlining what facilitation was (and what it was not) or to go deeply into the mental toolkit that we carry around with us. To that end, there are many helpful books and source materials on that topic—such as *Facilitating Groups* (Rogers 1999), *How to Run a Great Workshop* (Highmore Sims 2006), and *The Skilled Facilitator* (Schwarz 2002) (and its superb companion *The Skilled Facilitator Fieldbook* (Schwarz et al 2005)), and we make no attempt here to replicate their thinking and work.

Instead we decided to shortcut much of this hard-gained professional wisdom and produce a book that could be picked up by a professional colleague with a degree of knowhow, an element of confidence in their own ability to try something unusual with a group, and the keys to a stationery cupboard.

However, we thought it prudent to spend some space revisiting the purpose of facilitation, as from time to time this can get forgotten, even by seasoned professionals—especially if they have a new toy or technique with which to play.

*

1.2 The Purpose of Facilitation

The notion of facilitation, in its most essential form, stems from the same origin as the word "facile" —that is "to make easy." The purpose of facilitation is to help organizations and people, in groups or alone, to make a process easier. This process might be:

- Acquiring skills or knowledge
- Making decisions
- Identifying and/or solving problems
- Improving a specific workflow or operational method
- Helping a team or group to work together more effectively
- Working through difficulties or getting unstuck
- Formulating plans
- Moving towards actions

DOI: 10.4324/9781003410577-3

The function of making things easier can be led by a coach, manager, teacher, or trainer, from within or without the organization in question—and can seem simple or even, at times, childlike and playful. It is, however, a very complex art that requires a myriad range of skills and capabilities—not least of which is the ability to quickly establish trust with a new or unfamiliar group so that they engage in a process that's been designed to help them. Knowing what will "work" and what may not is an integral part of faciliatory wisdom—as is the ability to stay in productive areas and away from dead ends. As a very wise colleague once said—"Good facilitation is like really good shampoo. It works on the parts where it's needed and not on the rest."

In this regard, a graphical facilitation approach is no different—it should be used to work on places where it can have the most benefit. All of the models and ideas and techniques outlined throughout this book are about helping people to make things easier—whether that is to come to realizations, make decisions, or clarify plans and actions. As an approach, it requires many of the same faciliatory skills as those used by a group-centric or learner-centric professional (i.e. planning of purpose and process; asking open questions; noticing patterns; and ensuring meaningful and equal contributions)—but does require an additional level of skill when it comes to overcoming (potential) resistance from a group or an individual who perhaps "cannot draw" or is wed to the notion that "serious" professional discourse happens solely through the written word—usually in the form of flip-charted bullet points or a set of PowerPoint slides.

Finally, it is essential that we as facilitators (and managers, coaches, teachers, and educators) are able to flex our natural style and approach to fit what a group may need. To this end, ask yourself these three very simple questions:

- Who is in charge of the session, direction, and content?
- Who needs to be in charge of the direction and content?
- Am I able to flex my behavior and approaches to accommodate any discrepancies between the first two questions?

It may be that a very hierarchical approach is required—one in which the facilitator exercises full control over the content and process and activities. It may be that directions and outcomes are co-created and co-decided with the group and the facilitator's view is one among several, or it might be for certain groups and contexts that the facilitator's role is simply to create the right environment for a group to fully determine, design, and own their own objectives, processes, and successful outcomes. There are many shades of gray between full facilitatory control and complete freedom for the group—true success as a facilitator is knowing what style is appropriate and having the skill to implement it.

*

1.3 Moving Beyond "Drawing Pictures"—Facilitation and the Graphical Approach

A quick flick through the pages of this book will reveal a host of images. None of them were created by a professional illustrator. Some of them are, frankly, deeply inaccurate depictions of the things they aim to capture. We'd argue that this discrepancy does not matter; if a group decides, for example, that the way they operate is like a hive of bees, then their depiction doesn't have to be entomologically correct. What matters is the meaningful and memorable visual

shared metaphor that they co-create. However, unless the facilitator (or coach or trainer) sets this co-creative process up in the "right" way, then it could be easy for the activity to be dismissed as simply "drawing pictures" (and frequently not particularly "good" pictures either).

Moreover, even a group that is seemingly fully engaged in a playful (see Hutchinson and Lawrence 2011) or creative task can be completely derailed by a reminder that they are in a "serious" or "professional" work environment. A group of mid-level managers I worked with in a fishbowl meeting room a few years ago physically turned over the flipchart they were drawing on, and started writing "sensible" words as they saw their boss enter the adjoining atrium. So, in order for a group to engage with a facilitated process—especially one that is novel, unusual, or perhaps seemingly playful in nature—it is vital that the facilitator spends preparatory time and real effort in determining the following areas.

Purpose—in whatever ways available to you, ensure that you are clear as to the purpose of any given action or intervention and how it fits into a larger schema. Are you clear as to what "success" means for any given activity or process?

Process—ensure you are clear as to how you want the group to engage in a task. This is not to say that the end product is prescribed or that there is a "right" or "wrong" result—but it's essential that elements such as timings and group interactions are carefully considered. Are you clear what you want people to be doing, with whom, and for how long?

Possibilities—make certain that you have thought carefully about the possibilities that could occur and the contingency measures that might be required after each stage if a group take things in an interesting or potentially productive direction. Similarly, knowing when to park a conversation—even an interesting one—to revisit at a later time is also part of the facilitator's art.

Participation—what needs to happen so that everyone in the group feels comfortable and able to disclose and share and talk openly and honestly? Do the group know and trust each other sufficiently? To this end, a participative and encouraging style where different solutions and ideas are encouraged, and not initially or unconstructively criticized, is hugely helpful.

Practicalities—How do things need to be set up so that everyone can see, hear, contribute, participate, and move? Consider the connotations that a meeting room layout has in the mind of someone entering it for the first time.

Paraphernalia—what kit do you need in order to do what you want to do? Do you have reserve kit in case contingency actions are needed? How visible do you want the kit to be at various points in an event? (A colleague once reported to me that they'd upset a senior manager who had been onboard with an idea to get a group to paint pictures, because the paint had been laid out and tables covered in protective paper right from the start of a meeting. The group had been completely distracted and the boss had been unable to have a planned "serious" discussion at the start of the meeting.)

Pace, Energy, and Impact—Are you able to ensure that any element you plan has requisite pace and energy, involvement, and impact? This is a tricky balance to achieve—too little and any task falls flat (or worse, the focus turns to the facilitator to fill the vacuum) —too much and the exercise itself becomes the focus, as opposed to the questions, learning, decisions, and potential actions that it might generate. Every different facilitator has a different personal style and preference in terms of the spend of time and energy on any given activity. Personally I trade a little potential impact for a fast pace and high energy —others strive for potentially deeper impact, but (to me at least) run the risk of a group becoming bored or disengaged.

Problems of Resistance—have you thought about what (conscious or unconscious) resistance might occur in any given group, about why this might be occurring and about what you'll do if it does? Sometimes resistance (especially to a graphical or creative approach) can be centered on the task itself ("oh, I can't draw!"), which tends to be less problematic than that which is centred on the underlying purpose ("I don't know why we're even here!!"). Much potential resistance can be pre-empted and ameliorated in preparation for an event simply by addressing it head on. Some can be dealt with via the vibe and energy that you create in the room and some can be addressed with ground rules (such as the need for confidentiality and safety of idea-sharing) at the commencement of a session.

Personal Style—When we discuss our professional activity, from time to time we say that an activity requires a degree of "chutzpah"—a Yiddish word meaning nerve, front, audacity, or confidence on the part of the leader. As you read on, you'll notice that some of the things in this book require little in the way of departure from the activities that might occur in a day-to-day meeting (e.g. clustering ideas using sticky notes). However, you'll also notice that some ideas we present might seem left-field or even risky, and would require a degree of bravery or chutzpah to run with a group or even suggest to a client or decision-maker in the first place. So a skilled facilitator will also spend some time preparing themselves and their own confidence—since facilitation requires leadership, at least at the start of a process where a group, or subsets of it, may be reticent.

1.4 The Elements of Proficient Facilitation

As mentioned previously there are many weighty and excellent resources outlining the skills of a facilitator. However, when we think about the work that we do on a day-to-day basis, there are a handful of skill elements that we use again and again. They are simultaneously simple but difficult to do well, and so are easy to forget. Good facilitators pay attention to their core toolkit, and continue to develop them through formal training and informal observation and peer to peer conversation and discourse. The core skills—as we see them—are as follows:

Time-Keeping and Focusing

It's easy to mythologize and add complexity to the facilitatory role—but it's paramount to remember that perhaps the most useful part of the skillset is to ensure that a group keeps focus on the purpose and task at hand, and to keep activities and elements to time. A skilled facilitator can make their role look very simple, but the best ones plan meticulously, ensure reasonable time buffers around task components (to give expansion or contraction room for long or shorter conversations), and generally ensure the right things happen at the right time.

Watching and Noticing

Sensory acuity is a key component of the facilitator's skill set. For instance, noticing that certain elements of a depiction are larger or smaller, clearer or more blurred, symbolic or more well-defined might be important. Alternatively, it may mean nothing at all. The vital element here is to ask. For instance, "I notice that (e.g.) there's a big gap between the

manager that you've drawn and the rest of the team. Is that deliberate?" The resultant conversation is potentially where the facilitated value lays. Of course, you'll potentially have no idea whether the group intended to depict (in this case) a distant manager, so it's important to pay constant attention and be curious as to things that might be interesting.

Listening

Active listening (and notetaking) is paramount, as often little asides in conversations carry great meaning. The snippet of conversation might be as small as the suggestion of "let's draw her [a colleague] in blue," which is met by approval from the group. Again, the color choice might be relevant or not—but the general agreement from the group is worth noticing and enquiring about.

Curiosity and Enquiry

As with both of the examples above, the graphical depiction or the conversation that produced it is but one part of the process. The enquiring discourse or discussion that follows, usually stemming from a series of open, curious questions, is what elevates a picture into a meaningful spur to realization or action. With each graphical tool that we'll showcase later in the book, we include a few questions that can be asked to unlock a conversation that may stem from the picture. However, in all of these cases, a simple "can you explain some more about that?", asked from a place of genuine, non-judgmental curiosity, helps hugely.

Agility

Linked to the aforementioned notion of "chutzpah" it is vital that a facilitator has the confidence in their own capabilities and an ability to reflexively and flexibly alter their behavior to accommodate the reactions, behaviors, relationships, and emerging themes from the group. Often this agility is most needed when an initial plan doesn't seem to be working out—in which case it can be aided with a contingency plan and a spare activity in the facilitator's back pocket. However, more interesting is the situation that arises when an intervention reveals an exciting new area to explore—which begets the challenges of deciding whether to change tack, the time cost this may cause, and whether this new territory is necessary or simply shiny and exciting.

Clarifying

Linked to "noticing" and "curiosity," a key tool in the repertoire of a decent facilitator is the ability to request clarification of certain elements of a conversation, interaction, or, pivotal for our work, picture, and either request clarification or mentally tidy it up on behalf of the group. The request of 'can I just clarify something...?' (especially if a group have multiple interpretations of the same entity) can be tremendously productive.

Reframing

Central to our work as graphical facilitators is the notion of translating—or reframing—an idea, paradox, or process into different (in our case—pictorial) forms. Reframing or

reimagining can be powerful creative tools in their own right (for more on this, see the excellent book *Framers: Human advantage in an age of technology and turmoil*). Requiring groups to examine or interpret things differently can be very challenging initially, but also very interesting and potentially liberating. For example, asking:

- Could that problem be an opportunity?
- How could that weakness actually be a strength?
- You've got the senior management team at the top of your diagram. What if they were at the base of it?
- What if you showed this from another (e.g. different stakeholder) perspective?
- You're using [a certain] word or phrase here. Could there be a different way of referring to that?

As a quick creative warm-up I sometimes randomly assign each member of a group a different instruction that has been reframed around a simple brief—for example, the notion of "Redesign the Umbrella." Each individual might get a different reframe instruction—such as:

- Draw a design of how state of the art technology might keep you dry outside
- Sketch an original way to stop the rain from getting to you
- Design a new device to protect you from the weather
- Invent a radical object that will stop you getting wet outdoors

The notion of an "umbrella" is usually associated with a foldable canopy and a u-shaped handle, but different re-framings of this concept provoke sometimes vastly different interpretations—as is shown in Figure 1.1.

Once a group have quickly played with the notion of reframing (the umbrella exercise in Figure 1.1 takes no more than three minutes to run and perhaps five to unpack), it becomes quite a simple request to ask them to "see things differently" or "use different words" as a potential way of helping them to get unstuck.

Diagnosing and Solving

One of my favorite graphical tasks that I use with groups in formation stages is to ask them to "draw a group problem solving process that can be applied to any problem." It's simple, accessible, and requires minimal creativity or artistic talent—all of which are advantageous elements with new groups who may be unsure of each other and unwilling to take risks. Having a shared and clarified process to work to (and, in an experiential learning situation, to review other tasks against) is incredibly helpful for group and facilitator alike and it may be worth spending some time articulating your generic problem-solving process—which may be something like this ten-point list:

1 Identify Success (What is our objective?)
2 Define the problem or situation (What's the problem(s)?)
3 Clarify the root cause(s) (Why is it a problem?)
4 Identify priorities (Which causes are more/less problematic?)
5 Creatively explore a range of solutions (What could be done?)

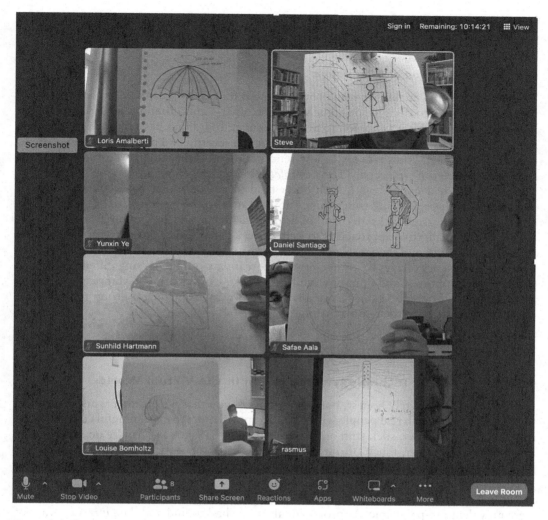

Figure 1.1 Creative online exercise showing drawn interpretations of the word "umbrella."

6 Decision (Weigh solutions based on what may practically achieve success) (What will be done?)
7 Agree plan of action (How will it be done?)
8 Implement Solution (Who will do what, by when?)
9 Evaluating the results (Has the objective been met?)
10 Iteratively review each stage to ensure that the Objective, Diagnosis, Creativity, Decision, Plan, or Action are still current and valid and that no assumptions have gone unchecked.

As a facilitator, it pays real dividends to have a generic process similar to the above to help a group to navigate any challenge that they face. As we'll explore in later sections of the book, a graphical approach can be used at any of these ten stations—from graphical visioning to

identify success, through tools like Weighted Elements to help identify priorities and make decisions.

Conflict Confrontation and Resolution

When I started as a facilitator with groups I found that often we would get into territory that caused people to disagree or argue with each other—and I found it hugely challenging because a) I believed it was my job to prevent conflict; b) I didn't have the skill to "fix" the argument; and c) I didn't realize that (providing it is respectful and polite) this conflict could be really healthy. (If you share my callow reticence then I'd thoroughly recommend the insights of John Heron—especially *The Complete Facilitator's Handbook* (1999).)

Groups that fear conflict with each other tend to be somewhat dysfunctional and not particularly high-performing (since things don't matter to them enough to argue about, or any leadership decision lacks any kind of healthy challenge and correction).

Part of the facilitative approach is to help groups safely bring unspoken conflict to the surface, confront it, and then resolve it in a healthy way. As we'll see later, asking subgroups to create images or collages to a same brief is a great way of highlighting differences of approaches, assumptions, and opinions, whilst tools like Conversational Mapping (See Maps and Mapping—Chapter 5) can be a really powerful way of helping a group to see where they're getting stuck in their conversation.

<div align="center">*</div>

1.5 What About Technology? Facilitation in the Virtual World

If we are both completely honest, both of us will tell you that we'd rather work as facilitators in a live room with real people where we can spread out, have meaningful conversations over a coffee, get messy, stick stuff on the wall, and not have to say "You're on mute" every five minutes. However, much of our professional life is spent in virtual rooms on shared group platforms with participants who are in different buildings, countries, and time zones. Economically, the costs of operating in this way are far cheaper and so some organizations are unwilling and unlikely to return to the types of away days and expensive retreats that were prevalent pre-pandemic. As professionals we've had to find and then improve ways of working in a facilitative style with virtual groups.

The primary difference with virtual working, whether in a purely facilitative space or in a training and learning space is that the recipient (as opposed to the facilitator or trainer) has to take far more responsibility for their engagement, participation, and learning. If they want to disengage, turn their camera off, and plead computer troubles, then they can. As such it is vital for trainers and facilitators to strike a balanced blend between:

Clear expectation setting—For example, outlining the need, wherever possible, for webcams and working microphones and requesting that colleagues join from a space where they can talk as freely as possible, and encouraging people to switch off their email and myriad other technological distractions. Moreover, we have to let people know that they are responsible for the quality of their own experience—and the more they put in, the more they'll get back.

Focused leadership—Being explicitly clear about the aims and objectives and purpose of any given session is an essential first step, but to also lead by the example that one sets in terms of providing energy, enquiry, and interest to the group.

Explicit Clarity—In a virtual space, especially where connections drop in and out, it is imperative that everyone knows exactly what is expected of them at all times. This means that as facilitators and educators we must slow down, repeat frequently, and where appropriate, give instructions or briefs in multiple forms. For example, I write out some of the things I ask a virtual group or subgroup to do, and then post it in the chat bar or message to a breakout group at the same time as saying it. If someone's audio feed cuts out momentarily they then still get the core instruction.

Empathy and Humanity—For example, recognizing that online working is tiring and hard work for everyone and ensuring that people are given plenty of breaks or time away from their screen to think, draw, or simply reflect.

Trusting—While we can deploy a toolkit designed to force people to contribute (focused questions asked to named individuals, etc.), to an extent we simply have to be more trusting in a virtual space. We have to create activities and opportunities that allow people to engage and participate if they want to and we have to allow time and space for them to do so. For all of its economic benefits of minimal travel costs and no room hire, and for all of the time benefits of online information delivery, good quality online facilitation and training takes longer to reach points of deep learning.

Simplicity—Experience has taught us both that just because you *can* do something with technology or a tool doesn't mean that you *should*. In our experience, the simpler the interface and the simpler the task the better. The more easily a person can engage, the more likely they are to do so. There is nothing in our graphical toolkit that can't be adapted to a virtual environment—but consistently we both look for ways to simplify a tool to make it quick and easy for a virtual group; rather than trying to recreate a "real" and "live" experience with technology that is neither as quick nor as intuitive as a face to face interaction.

<div align="center">*</div>

References

Cukier, K, Mayer-Schoenberger, V, and de Vericourt, F (2021) *Framers: Human advantage in an age of technology and turmoil* (WH Allen)

Heron, J (1999) *The Complete Facilitator's Handbook* (Kogan Page)

Highmore Sims, N (2006) *How to Run a Great Workshop* (Pearson)

Hutchinson and Lawrence (2011) *Playing with Purpose: How experiential learning can be more than a game* (Gower)

Rogers, J (1999) *Facilitating Groups* (Management Futures Ltd.)

Schwarz, R (2002) *The Skilled Facilitator* (Jossey-Bass)

Schwarz, R et al (2005) *The Skilled Facilitator Fieldbook* (Jossey-Bass)

Part II

The Graphical Facilitator's Tools and Technologies

As trainers who use a graphical approach, both of us frequently get asked how we learned to do it. Since neither of us had any formal training (and at least one of us failed a very basic art qualification due to a near-complete inability to create anything other than rudimentary pencil sketches), we felt it would be useful here to briefly outline how we arrived at a point where our core professional business involves creating, and helping others to create graphics and images.

Curie

I used to love drawing. I kept old greetings cards and copied them. For my regular drawings, I did not use anything grander than the ubiquitous school HB pencil. When I did a "special" drawing for my mum I used colored pencils or watercolor. I used to like the same things I still like: nature-based themes. I have three significant memories about drawing:

1 I got a higher examination mark (aged 12) for my drawing of a leaf than the cleverest person in the class, though it is worth noting I am still smarting from a "D" grade for a collage in the same year
2 I folded A4 sheets of paper into four, tucked them into my school books and drew birds, cats, and horses during lessons
3 After many (many) years of weekly (hated) violin lessons, enforced by my mother, I rebelled and did adult education art classes instead.

As school continued I got sidelined into science subjects, but still enjoyed the drawing that accompanied observing mitosis under a microscope (such joy to see it!) in biology classes, as well as involved genetics tree diagrams of fruit flies. Yes, I was a geek then and remain so!! Then I went to medical school. Drawing continued but mainly diagrammatically (complicated biochemistry diagrams, molecular structures, and flowcharts) and depicting histology samples of cells under the microscope. I recall especially liking the way I was taught pharmacology, the study of drugs, through drawing by Professor Neal (author of *Pharmacology at a Glance* (Neal 2016)) and this led to me taking Pharmacology for my first degree. I don't recall doing much "artistic" drawing during this time but then I started "using" drawing regularly as a medical doctor. As part of writing up patient assessments, handwritten medical shorthand included drawings, e.g. the shape of the lungs with crosses where we heard "crackles" and I would draw to explain things to patients. These explanatory diagrams continued during my work as a university lecturer, teaching nursing students. At the same

DOI: 10.4324/9781003410577-4

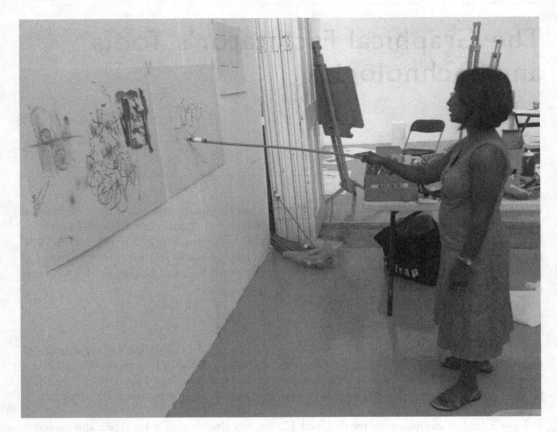

Figure 2p.1 Curie—inventive approaches personified

time, I started painting again and then selling artwork. I did a number of exhibitions and slowly started building resources, which have now become an at-home art studio. My two lives of science and art became aligned during my PhD, which centered on using drawing as a teaching tool for health professional education. I spent the first year really learning to draw in order to facilitate the learning of others.

This was a wonderful luxury and instilled an almost daily practice of drawing. I developed a technique in the PhD called Generative Drawing to explore the difficult topic of our own aging: where drawing or mark making is the basis of further thinking. My doctorate, and meeting artists deeply invested in drawing, have given me a much healthier respect for how knowledge is created in different ways. This has enriched my life and I hope you are similarly enriched by bringing graphic facilitation to life in your own settings!

Steve

In many ways, my journey to the way of working I now use is a very simple one. I spent a long time sitting in lots (and lots) of dull, insipid presentations where the presenter read texty slide after texty slide. Worse, I probably was responsible for giving presentations like this—at least to some extent. At some level, I knew—just as everyone from children

to neuropsychology professors know—that this method of information transfer is, at best, limited and limiting.

I'd look at my own notebooks and realize that my personal way of capture was graphical—involving connected ideas, lines and shapes, diagrams, and no small number of doodles to reinforce certain points. I also realized (and I appreciate this makes me seem like someone who is mildly unhinged) that all of my notes were written in capital letters. I also saw that when I was planning a new project or piece of work I would, without thinking, spread out and start creating charts and plans where elements were in discrete boxes with connective arrows and lines. In short, I liked to *see* rather than *read*. I'm not alone in this realization and many people create spider diagrams, concept maps, and bubble charts every single day. However, as a trainer and coach I figured I might try to make the way I *distributed* information more aligned with the way that I *received* and *processed* it.

More recently, when people asked my kids what their dad did for a living, they must have gone away thinking that I'm some sort of vandal, since "Daddy draws on walls for people" was a fairly typical answer. Over the years I've evolved my style from PowerPoint slides to a blank whiteboard that builds and grows as a learning session develops (See Figure 2p.2). (The pivot to online webinar delivery was massively difficult for me, since in 2020 it had been about five years since I'd used a slide deck and I had to create all my teaching resources from scratch.)

I realize that showing off at the front of a training room is not the core subject of this book, but I get asked how I do things graphically and neatly. It's really very simple and

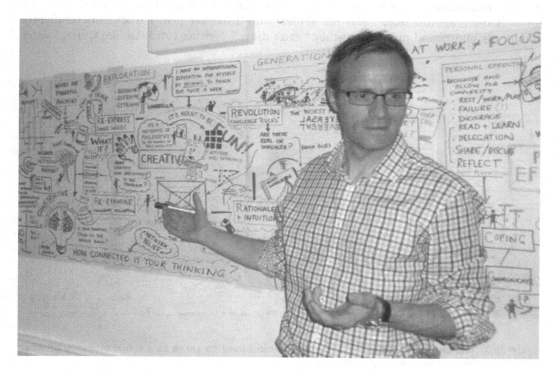

Figure 2p.2 Steve—sleeves rolled up, pen in hand.

certainly not worth a book in itself—and this seems like an appropriate space to answer the question.

A few years ago I also realized that, as a teacher, I needed to plan any learning session very carefully and I would often break a course or workshop down into a number of boxes to help my planning process. It wasn't hard to move this boxed planning onto a whiteboard. For instance, a course that had three main elements immediately became a triangle with a title at the center. Four core thematic elements became transposed to a square on the board. Even I now use this as the foundation of any graphical teaching that I do. If I am running a day-long session that I know (and as a trainer I know more or less what I want to cover) will have eight elements to it, I mentally, or with a thin dotted line, create a three-by-three-by-three grid on the board. This gives a central title box and eight equisized spaces in which to work—a bit like a jigsaw with eight large pieces around the central label. These pieces can be mentally or physically branded or numbered from the beginning and populated with content as the day progresses. A conversation ostensibly about "box 1" might reveal insight about something more appropriately housed in "box 5"—so I simply place it in box 5 with a joining arrow. Later in the day when we cover related material about "box 5" everything is situated magically in the right place. A combination of neat handwriting, spatial planning, and mental organization leads to a unified finished learning artefact. You can see rectangular boxed areas on a finished wall graphic in figure 2p.3 below.

The final part of the journey from linear bullet point to graphical mural was for me to convert my notebook doodles into something that could illustrate concepts for course participants. Again, this is not as difficult as it might seem. When I started on the journey towards the graphical side, I was not skilled with a marker pen. Participants frequently admire my efforts and profess that they "can't draw." Neither can I. Unlike Curie, I can't

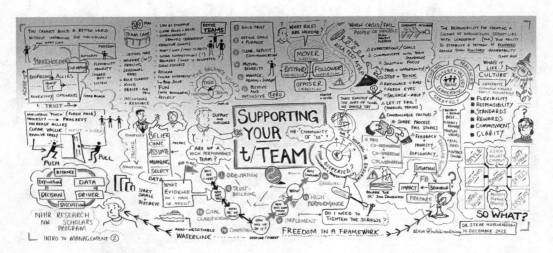

Figure 2p.3 The end of a session. A completed whiteboard to serve as a visual memory of what was covered during a training session.

draw a human portrait that looks anything like the subject, but I can draw stick people. And everyone can draw stick people. Try it.

- Draw a circle and fill it in. The head.
- Draw a rectangle underneath it. Fill it in. The body.
- Give the rectangle two legs. Point the feet in the right direction.
- Give the rectangle two bent arms.

That's it. Everything else is a variation on that theme. (You can see several examples of stick figures serving different illustrative functions in Figure 2.3.) For example:

- If you want to show "Thinking"—put one arm bent to touch the waist. The other arm touching the head, like Rodin's "The Thinker."
- If you want to show an "Idea," put one arm bent to touch the waist and the other pointing at the sky. Place an exclamation mark over the head and Eureka!
- "Teamwork?" Draw three figures and join their hands.
- "Success?" Place their arms in the air and stand them on a 1st, 2nd, 3rd Olympic-style podium. Simple.
- "Pushing" or "pulling" at an agenda can be shown by bending the stick figure's legs and leaning them towards or away from an idea.
- "Hard work?" Have the stick figure push a circle up a slope.
- "Impossibility?" Make the slope into a triangular Sisyphean hill.

In sessions, at times where I control the content delivery, I'll plan the graphics that I want to use. When I am soliciting input from a group I create a space and neatly capture "their" ideas in list form and then integrate this with taught content (existing models and frameworks) and "my" structure. I leave space at the margins of the board to give expansion territory if we discover entirely new territory. And as such, every day mural is different, because every course is different, because every group is different.

When I look at my early efforts, they are in no way as snazzy as they now seem. I've learned to cartoon a little and my skill with a marker pen has improved. I've also simplified my color scheme and use only black, white, and red—for no other reason than I like the aesthetic—and you can see my cartoon "influences" (Peanuts, Calvin and Hobbes, PhD Comics). But the fundamentals are still the same. Planning, Neatness, and Organization are my building blocks, around which I draw and around which creative things happen.

Curie approaches things from the opposite angle. But we meet in the middle by asking our delegates and participants to draw and create. For me, modeling the idea of drawing and not having the safety net of a slide deck gives permission and encouragement for groups to break out the pens. If the vandal at the front of the room can do it—so can they.

*

Following this briefly indulgent autobiographical interlude, we'll now return to the pragmatic notion of how you might prepare for, learn, develop, and adapt this particular style of people development—starting with a toolkit.

Chapter Two

2.1 The Graphical Facilitator's Kit List

In this section we set out the material and kit that a graphical facilitator might carry around with them, as well as the generic technologies that they might employ and how these can be adapted and improvised depending on the circumstantial constraints and group needs.

For any facilitative approach to training or learning or running productive meetings it pays to be able to flex to what is required by any group at the time. As freelance developers, we've learned by experience to carry around a kitbag that will allow us to take a graphical approach to activities if that is required. While conference centers or classrooms typically have whiteboards, magnetic paper-attachment wall strips and magnets, blank walls, flexible furniture, and flipcharts (albeit usually with pens on the verge of expiration...), hotel meeting spaces often have limited equipment beyond a data projector and infinite bowls of boiled sweets. The resources that you already have as a facilitator will suffice for most of the graphical activities in this book. There are, however, a few other ideas that may need specific items—but, as with much facilitative work, you may need to improvise with whatever is at hand in the room, and use the physical space or objects that the participants produce from their bags. As such, it is worth carrying a few items that will make your facilitative approach easier. On a day-to-day basis we'd recommend the following, which can all be packed into a cheap one meter long tripod or roller-banner bag.

- Marker pens—at least one pack of four to six different colors. Replace the yellow and brown with a duplicate blue and red. If you are working with larger groups then obviously more markers (or biros, crayons, or pastels) are required.
- Flipchart paper—one roll. It's worth providing your own, and it can always be (ahem) replaced from a venue if your stocks get low.
- Blank A4 printer paper. Twenty or thirty sheets take up little to no space in your bag, but can be used as individual canvases or compiled into a long line or made into a multi-piece jigsaw etc. Sometimes, wall space is oddly shaped or a "training" space is utterly unfit for purpose—and a compilation of A4 papers stuck together (as per Figure 2.1) gives necessary flexibility.
- Roll of "invisible" sticky tape or masking tape—ideally the kind that can be written on and that doesn't reflect light. Useful for joining paper to create larger formats (i.e. when creating long timelines or composites of subgroup efforts). Also useful in air-conditioned rooms when sticky notes become, simply, notes...

DOI: 10.4324/9781003410577-5

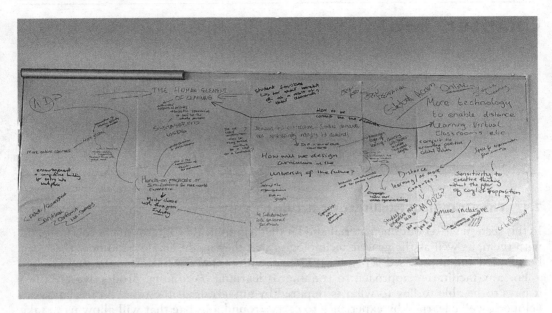

Figure 2.1 No whiteboard? No problem. A4 sheets combined.

- White (non-marking) sticky tack—a small packet. Ensure you buy the non-marking kind and learn quickly where you can (door frames, windows, painted walls) and cannot (expensive fabric wallpaper etc.) stick it. Branded versions of this product can be re-used, while store's own-brand tack dries out quickly.
- Sticky Notes—the branded ones are more expensive, but will actually stick to walls, whiteboards, and glass windows. There is nothing more dispiriting than watching a group's hard-created efforts and thoughts slowly fall from a wall like autumnal leaves. We suggest, from experience, that you opt for those with the strongest adherence possible!
- Whiteboard pens—one pack with between four and six black and red pens. (I also carry a few cotton Q-tips, which I use to "write" in white against a solid block of color—which is effective for creating numbered bullet points or labels that stand out.)
- "Magic™" whiteboard roll—plastic that clings via static force to a surface without adhesive. It comes in meter-long perforated segments on a roll of about twenty-five sheets. Excellent for creating impromptu whiteboards and for group idea creation and clustering. While expensive (approximately £1 per sheet) it is re-usable, but not really portable once used.
- Postcards/images—I typically carry around a small plastic pouch of about 100 picture postcards with no writing on them. I've collected images of animals, landmarks, and people that I use to help groups create quick collages and to facilitate conversations (we'll explore how to do this later in the book).
- A small ball of string—helpful for plotting journeys and meandering paths as well as for joining ideas and clusters of notes on walls where a pen can't write.
- Scissors. For cutting string, paper, magazines etc.
- At least one Glue Stick. This takes up minimal bag space but allows the creation of collage and composition from any other torn or cut printed material.

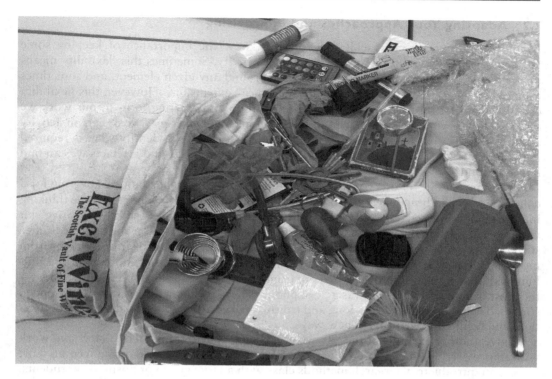

Figure 2.2 Some tools of the trade

Of course, as your practice develops you may find that other things become staple items in your kit bag. And while it may seem cumbersome to carry a mobile stationery shop around, I've always been glad to have the *option* to use mine. If nothing else, most groups that I work with are delighted when I tell them we won't be turning off the lights and showing thousands of slides.

You may also find the need, or see an opportunity, to use more specialist objects such as:

- LEGO®
- Pipe cleaners
- Playing cards (printed and blank options)
- Origami paper and card
- Random assortments of 3D objects (see Figure 2.2 above)
- Drinking straws

These, however, are things that we might take specifically for a given activity for a given purpose and they're not things we routinely carry around or have to explain away at airport security.

2.2 Adapting Your Approaches and Improvising

If you are an experienced facilitator, you will know the importance of keeping some "looseness" and flexibility in any given plan of activity. Sometimes this flexibility means to simply allow expansion or contraction time around any given element, and sometimes it means having "necessary" components and "nice" expansions. However, this flexibility can also manifest through seeing a need in the group and reacting to it. In our work we often venture beyond pen and paper and sticky note, and sometimes we design an activity around an object (such as origami folding); but sometimes we'll identify what is required in the moment and will have to improvise with whatever objects and artefacts we can find laying around.

For instance, I (Steve) was recently dropped into a session at short notice, covering for a colleague who had been taken ill. The workshop was aimed at developing creative thinking in a group of trainee engineers. I had very little time to prepare and very little "creative" kit with me. I decided in the moment to go foraging at a nearby coffee shop and collected coffee stirrers, paper cups, and disposable napkins, which I augmented with stationery items from my basic kitbag. I asked the engineers to build something from this improvised and pur-loined kit that would "improve the lives of engineers." Several brilliant creations resulted—the most memorable of which was a "cell phone prison" fashioned from cups and wooden stirrers. Their efforts triggered a long and fruitful conversation about creativity, need, func-tion, and combining elements in new ways.

To give another example of the advantage of being able to think on one's feet and work with improvised resources, a couple of years ago I (Curie) was asked to cover, at short notice, an introductory research methods class with a large group of hospitality students. Research methods can be quite a dry topic (especially in a large group format), so to personalize and to make it real and living, I asked the group to take out their phones and find the most recent photograph of food or a meal (since they were hospitality students) that they had captured. I then asked all of them to share their image to a class Padlet. We then collectively viewed these images and asked people to tell the story associated with their image. We then extended this conversation to start to formulate questions of the photographer ("Tell me more about the context of this meal?", "On a scale of 0 to 10, how satisfied were you with this meal?", "How could this hospitality experience of a meal be improved?" etc). This harnesses the power of images and visual research in today's personally photo-documented age and made it relevant and engaging for the audience. In both of these stories (you'll notice they were both last-minute colleague-cover situations) we had to improvise and work with the facilities, resources, and kit to hand—but similarly we were clear about our purpose, yet flexible in the manner we aimed to achieve it.

Most of the examples in this book were created physically with paper. However, the notion of "graphics" can be very flexible and we've given examples of three dimensional "drawing" through building blocks and combined objects, drawing with sticks into sand or using natural materials to create a graphical metaphor (such as the beach stones in Figure 2.3), creating a spatial drawing by physically moving objects or people, using fixed physical objects on location, and even utilizing space to create a multidimensional draw-ing. In short, we believe that just about anything can be used and adapted for graphical facilitation.

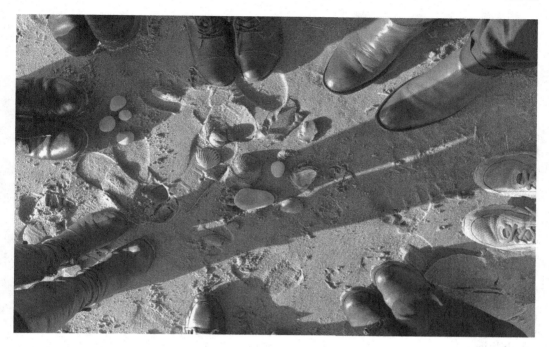

Figure 2.3 Beach stones depicting a group's professional "blocks" and "reminders"

*

2.3 Online and Hybrid Toolkit

Throughout the book, you'll notice that our starting point for each idea is usually paper-based and low-tech. We typically then extend to explore some possibilities of using technology to facilitate a graphical approach for online or hybrid groups. There are several really interesting pieces of kit available at the time of writing to help groups collaborate and collectively contribute to a visual discussion. For instance:

- Virtual whiteboards such as those built into platforms such as Zoom, or those such as Google Jamboard (https://workspace.google.com/products/jamboard/) that have greater facility for adding images and files. Tools such as Stormboard (https://stormboard.com/home) allow multiple whiteboards to be created and compiled by the group.
- More structured tools (such as Miro—https://miro.com) are available to help groups create collaborative projects and designs and convert these plans into tasks and actions. They often come with preloaded templates that can be useful to steer a conversation into certain areas.
- Concept or Mindmap software (such as Ayoa—https://www.ayoa.com) is widely available—sometimes for little or no cost—and often is used in classrooms and learning settings with collaborative groups. Such software frequently makes a feature of its neurodiversity-friendly nature and allows users to create structured connective maps of their thinking processes.

- Tools such as Mentimeter (https://www.mentimeter.com) became fairly commonplace in virtual classrooms throughout the COVID-19 pandemic home-school era as educators desperately tried to keep their remote classes engaged. They can be used as a facilitatory tool for activities, such as having groups use their phone app to create shared word clouds—though from my perspective, the more I can reduce the potential of people getting distracted by using their phones, the happier I am.

As with all things, the more comfortable you are with a technology, the more you can see its possibilities. You'll sense very quickly in this book that our approaches try to revert back to "low tech" even when working with online groups or individuals. This is partly through a shared technological aversion from both of us, but also because we tend to work with groups for short periods of time and frequently only once or twice. It's our experience that most people with whom we work don't have the technology listed above and aren't familiar enough with it to use it in a meaningful way straight away. And when group members are more concerned with the technology, they're not focusing on the real issue at hand. (And while software companies trumpet the neurodiverse-friendly functionalities of their products, they usually don't mention that people all have different systems, software, and hardware capability, and may be dialling in on their phone and unable to actually use the kit in the way you'd like.)

However, if you are working with a group, team, or organization that is willing and technologically liberated, then having played with several products over the last few years, we'd suggest investigating virtual whiteboard products that have the following features or capabilities:

- Usability by all the group. Is everyone able to add images, attach files, draw lines, add text boxes, and move things around on screen? If not, the conversation ends up being controlled by a moderator—which is not always wholly healthy, especially in creative endeavors.
- No outer-limits to the display frame. If the graphic can't extend up, down, left, and right in an unlimited capacity, eventually you'll run out of space. Moreover, this large virtual "canvas" needs to be easily navigable and allow the group to zoom in and out of any given area.
- Linked to this, consider what you want to "do" with the "end product." Can the final board be easily compressed if people want to capture or print it? If the final work is to be presented, is it simple to reveal parts of the graphic in narrative sequence etc.?
- Finally, is it accessible and available to the group? Can the application work through a standard web browser or does it require a (large) download? Can it be accessed and used in a meaningful way through a cell phone device? If not, it's likely that some (and sometimes, in our experience, most) of any given group won't be able to access it.

For all this, our suggestion (and personally, our preferred approach) is that you pay less attention to the technology and more to what is required to help the group or organization be focused on the desired purpose. For instance:

- a group can create individual maps, pictures, or diagrams, photograph or scan them, and send them to a shared WhatsApp group, thus enhancing a virtual conference later in the day;
- a graphical collage can be created with remote team, using a shared screen and an MS PowerPoint slide with images being uploaded through Zoom or MS Teams chat function;

- a pre-prepared frame or template (like a grid or set of axes) can be prepared in advance on a simple Zoom whiteboard and then individuals can add dots, lines, or shapes to it.

There is a wealth of possibility here—and all options are potentially more powerful and memorable than preordained words on a screen. It is, however, essential that the costs of usability, time, and slight clunkiness don't outweigh the benefits of using a tool simply because one can.

We'll explore some more in-depth ideas for using technology to graphically facilitate conversations later in the book.

<div align="center">*</div>

2.4 "Drawing Out" the Learning

It is of course one thing to ask a group to simply draw pictures, but another thing entirely to be able to draw out learning and meaning from their efforts and outputs. Indeed failure to do so renders any richness and value of the approach far less powerful, and indeed may even reduce the purpose of the exercise, in some peoples' eyes, to little more than a childish icebreaker. A previous book by Steve concerned the value of experiential learning and was called *"Playing With Purpose"* (Hutchinson and Lawrence 2011). There we argued that, in professional environments, experiential learning through play could yield enormous benefits providing that the creator and facilitator of such simulations and games first considered the purpose behind them. We advocate a similar tonal approach here. That is to say that we, as facilitators, must understand the underlying *purpose* behind a request for a group of professionals to act in a way other than the normal production of lists and bullet points.

Firstly, ask yourself what is your purpose behind this graphical task? What, from a facilitatory point of view, is success? You may wish to refine your thinking here with questions like:

- Is the illustrative output itself important (sometimes it is, and sometimes it isn't), or is the creative process the vital part of the facilitated intervention? Does the group understand this purpose distinction—since asking a group to draw something that is going to be seen by other people outside of their group is potentially paralyzing?
- Is the end pictorial result something that the group will use to inform future discussions, or is the conversation that occurs during the creative process the entire purpose of the activity?
- How do you as a facilitator want to use the information that the graphical process and product reveals? Once they have created something interesting—then what? To our thinking, the best group sessions often occur when a picture created by a group or groups acts as a visual signpost or index for other activities and discussions that follow.
- Do you have a specific piece of learning in mind, or is the task completely open-ended? For instance, I recently asked a group to graphically plot their effectiveness on a timeline, because they'd all recently experienced a specifically challenging setback that they weren't talking about. I *wanted* them to draw a large downturn in effectiveness immediately following this setback that they hadn't recovered from. Which is exactly what happened. I could have simply named it, but I wanted the group to name and label it—and

also for them to show in black and white (and other colors…) that they hadn't recovered to the effectiveness levels they had previously been operating at before the challenging setback. The facilitatory risk here was that the task was open-ended and the group may have continued to ignore the elephant in the room.
- Do you want everyone to contribute graphically, or would it be appropriate for the group to delegate all artistic responsibility onto one person? If success is a situation where everyone needs to contribute, a possibility is to give everyone an individual piece of A4 paper, ask them to pictorially fill that page with their response to a given question, and then ask the group as a whole to incorporate these options into a larger image (for instance, by collectively mounting them onto a larger piece of paper).

For example, in Figure 2.4 below (for confidentiality reasons, a slightly doctored and anonymized version of the original), a group was asked to quickly create individual pictures on separate pieces of A4 paper. The instruction was that, without using words, they should create an image that depicted their organizational role. With groups whose members are new to each other—i.e. as part of an induction process or large project kick-off—the group could be asked, as an icebreaker, to guess what their new colleagues' pictures represent! Once individually completed, the images were compiled onto one large sheet and combined with their colleagues' drawings to show relative position and prioritization within the organization, i.e. in Figure 2.4 you can clearly see that a depiction of a calculator and a bag of money—i.e. the financial department—is tellingly located centrally. The group

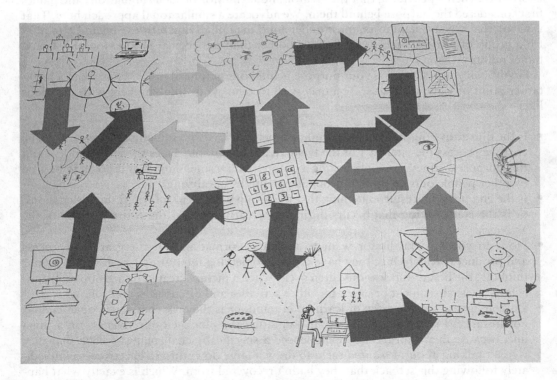

Figure 2.4 An organizational depiction of departmental roles, connections, and synergies.

members were then equipped with a large number of colorful arrows that they placed onto the graphic to highlight departmental connectivity, synergies, economies of scale, or lack thereof. In the case illustrated, this composition took the form of tight tessellation into a near jigsaw. However, a spider's web, concept map, or a looser, less restricted form would also work. Of course, the creation of the individual graphics themselves was interesting, but the conversations during and after the placement were where the real value was realized.

Secondly, in order for a graphical approach to be successful the facilitator needs to be precise as to the instruction offered to a group. This maxim is, of course, transferable to just about every form of training, coaching, teaching, and facilitation, but when it comes to a pictorial approach that is potentially higher-risk than asking for a collection of text bullet-points, every word may matter in terms of what the group picks up on. For instance, regardless of topic at hand, the following requests (which might be used interchangeably) can result in very different interpretations.

- Draw a picture of…
- Create an infographic of…
- Map out the following…
- Sketch the issues that…
- Form an illustration of…
- Depict using minimal words…

As a facilitator it is imperative that we offer instructions and suggestions with care, since—in a maxim attributed to, amongst others, Wittgenstein and Heschel—"words create worlds."

Thirdly, even with precision of instruction, have you as a facilitator considered how you are going to question the creating group and unlock any learning? For example, Figure 2.5 shows two results of two conversations from two groups given the same briefing in the same room. The instruction given was clear and given to both groups simultaneously, but resulted in two very different outputs. Both groups drew very different lessons from their efforts, and a certain amount of post-creation flexibility and maturity was required from

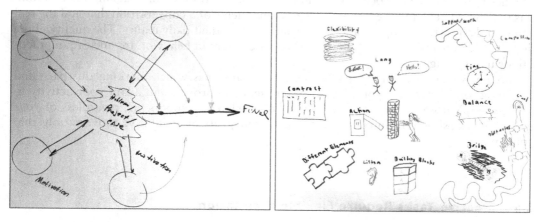

Figure 2.5 Two groups, when offered the same instruction, often produce very different outputs. In this case, the input was "What makes teams work?"

Table 2.1

What?	So What?	Now What?
Concerning the graphical product and conversational process	Concerning the learnings and transferable realizations from the activity	Concerning any future actions or changes that may follow
What drove your interpretation?	What can you learn from your drawings?	What will you DO as a result of your learnings?
What were the interesting depictions and metaphors that you concocted?	What have you realized? Are there any elements that seem to be more or less important?	What further conversations need to be had? What actions need to be taken?
Did you prioritize certain elements?		
How did you (or would you) connect separate components?	**Does any review conversation actually focus on these areas? If not, the activity may be enjoyable, but lacking purpose and longer-term value.**	
What's still missing, or what needs to be moved or redrafted?		

the groups, because there was no facilitatory one-size-fits-all set of questions that could be asked to both simultaneously.

Finally, as a facilitator, you should be considering how you wish to draw out any learning from the group's efforts—a process that may normally occur through some sort of post-exercise review. Regardless of the output that a group produces, an effective review will probably be centered on three questioning areas: "What?," "So What?," and "Now What?." The "What?" element of the facilitator's review and questioning concerns the physical artefact that has been created and the conversations that fuelled it. For example, in the example above in Figure 2.5, the difference between the structures (on the left) at play and the behaviors depicted (on the right) made for a very productive conversation. The "So What?" component of the review conversation concerns the learnings and realizations that a group may wish to take forward. The "Now What?" concerns future concrete actions or changes that may need to occur. Of course, as with any training or coaching intervention, it is the "So what?" and the "Now What?" components of a conversation that add the real value, and allow the group to take the learning back to their daily reality. The quality of the drawing matters little if any resultant actions or changes in behavior are unclear, impractical, or uninspiring.

Though we won't explicitly show this table again, it is worth marking this page and returning to it every time you plan and exercise, or improvise and adapt your activity to suit a group's needs. The "so what?" and "now what?" components, regardless of your personal style, should be integrated into the vast majority of facilitative conversations that you have.

*

2.5 Creative Tasks Require Flexible Facilitation

Without delving deeply into the intellectual and pedagogical mechanics of things, most developmental professionals will be well versed, at least theoretically, in the notion of being

a reflective practitioner. That is, simply, to spend conscious time after an event or process to reflect on:

- Action—What actually happened? (Practically, tonally, process-wise, or emotionally?)
- Outcomes—With hindsight, what worked well or otherwise? (Precisely and specifically)
- Rationalization—What were the specific reasons and possibilities behind what played out? What theoretical models or practical wisdom can be used to explain the observed events?
- Learning and Planning—Specifically, what does this event reveal to you so that you might plan for a more effective performance in the future?

For more on this topic, you may wish to read up on Experiential Learning (see Kolb 1984) or being a Reflective Professional Practitioner (see for example Bassot 2023).

Practically, after a graphical task, you might wish to ask yourself questions such as:

- How long did that task require? Did it need more or less than planned?
- How did the group respond to the task? What surprised you?
- What would you change and what might the impact of that be?
- Would different kit or materials offer different possibilities?
- Did the task or exercise require a different briefing?
- Were there *accidental* ambiguities in any instruction, rules, or briefing materials?
- What formal feedback did any activity solicit from the people involved?
- Do you see any new possibilities about the task that you could incorporate for future iterations? For instance, a graphical task that I used to run with groups was sometimes dominated by a single individual each time, who monopolized the pens. I tweaked the exercise and required that every group member drew at first on their own paper—and *then* these individual images were combined in a second phase to form a composite illustration.

It is rare that a new exercise works perfectly the first time (and well-established tasks sometimes don't hit the mark in the intended manner), but reflecting on practice and continually striving to improve both elevates your skill set and keeps your toolkit of techniques fresh.

Such professionalism and commitment to improved performance is highly laudable, but doesn't particularly help a group that you, as a facilitator, may only see once. If something isn't working, or takes a fascinating new direction, or reveals something in a group that is utterly unexpected, a skilled facilitator needs to be able to quickly pivot and go in a new—though still purposeful—direction. On occasion we hear this type of response to new developments derivatively referred to as "busking" or "winging it"—but to genuinely respond well immediately to a group's unexpected needs or a new unforeseen direction actually requires great skill. This improvisation, sometimes called reflexive practice, requires the ability to observe, appraise, tweak and pivot quickly (see Stîngu 2012).

Once an activity is in motion it is difficult (and probably disruptive) to change it in midflow. Of course, your activity design might incorporate a series of phases that offer natural check and change points. (For example, asking a group to draw the "reality" of their situation might be followed by a conversation about this reality. A second phase, to be revealed after the first phase is completed, might be that the group augment their drawing with a depiction of a future utopia if everything was working optimally. The gap between the first and second phase would be a logical place to change the brief, or the rules, or the kit, or the group composition.

To build in flexibility to a task, think about what you are trying to achieve, what the group needs at that moment and what might help them to work more effectively. For instance:

- If a group is worried about committing to a 'final' answer (i.e. unwilling to pick up a pen and mark the paper in a permanent way), could you make a feature of this and *enforce* an initial period of thinking and planning with no actual physical drawing?
- If a group is slow to commit to anything tangible (lots of possibilities and no actualities), could you insist on a quick sketch sub-deadline that could be filled in later?
- If one person is dominating the conversation, could you insist that every person draws equally? (For instance I sometimes ensure that a group is provided with the same number of differently colored pens as there are people, so every member holds a different colored pen. I request the group create something using equal amounts of color without swapping pens from person to person.)
- Could you "fishbowl" an activity, so some group members can watch and listen in on the conversations from the other half of the group?
- Where would simplifying your instructions help a group and where would it hinder them? Different groups respond to different types of instruction. For instance, a very open-ended instruction ("Draw how you feel about the culture here") may be paralyzing or generate lots of creative possibilities?
- Where would making an instruction more complex help or hinder? Some groups revel in tight structure. Some are utterly paralyzed by it. You won't know which type they are until you meet them.

Perhaps the key facilitative attribute that can't really be taught, but has to be learned by experience and gained alongside professional confidence, is an ability to take a risk in a moment and see what occurs. For example, recently I spent a session with a training group working on the notion of effective collaborations. I split the group into two subgroups and asked them both to produce a graphical depiction of what collaborations could be when they worked at their best. I'd anticipated a "compare and contrast" review conversation after the drawing process where each subgroup reported back. The groups were provided with a range of stationery including round paper discs and large-sized sticky notes. One subgroup used the circular discs and connected them to create what was essentially a flow chart of the different *stages* of a collaborative journey, whilst the other subgroup used the large sticky notes to represent the different *behaviors and requirements* of a successful collaboration. Because the second group had captured its conversations on large sticky notes, it suddenly occurred to me that it would be entirely possible to take a risk and ask the two groups to combine their efforts and create a composite image—and, in doing so, to enact a real-life collaboration between the two groups. The result (shown in Figure 2.6) was perhaps a little messy, but the conversation—which had been already rich—was particularly helpful as the two subgroups negotiated and flexed to each other's styles and limitations. To ask for the two groups to deconstruct their efforts and combine them was a risk—but one that I decided, as an experienced facilitator, was worth taking, since the process (the collaborative creation) and the product (an illustration of collaboration) were aligned.

The activity took longer than I had planned, but the process of collaboratively illustrating a collaboration was far more meaningful than the theoretical model that I'd planned to introduce at that point in the proceedings. In responding to an emergent vision of what I thought would work for the group's benefit I took a risk and, in so doing, developed a transferable process that can be used again in the future. The cost of this improvisation came

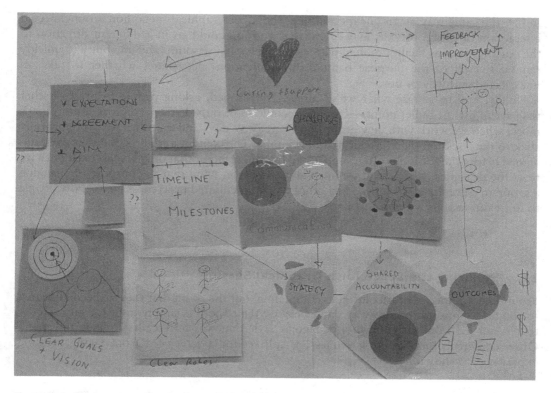

Figure 2.6 A composite image created to both model and illustrate the process of collaboration

in the form of time—rich, meaningful, and unfolding tasks and processes nearly always take longer than you might imagine, and so a key skill is also to know what to cut from an agenda or programme when one element over-runs.

Ultimately, reflexive practice—this ability to improvise, change, tweak a plan, and work with the needs and drives of a group—is hugely important for a facilitator to develop. With a fundamentally graphical approach, one never knows what direction a group or individual may take and so it is pivotal that a facilitator can adapt and change plans quickly.

To this end, as a facilitator, you may wish to pay attention to the macro-processes within any group that you are working with. This part of the role has little to do with the task, drawing, or creation that the group is engaged in working to, but is far more concerned with how the group members are functioning with each other. For instance, pay attention to elements such as:

- Which of the group is the first to pick up the pen?
- Who talks, and who draws?
- What different roles are playing out in the group?
- Who pays attention to basic elements such as the timeframe and deadline for completion?
- Does the group orientate the paper or arrange the table so that everyone can see and participate?
- Does the group encourage each other?
- Do they acknowledge each other's contributions?
- Do they seem to be enjoying the co-creative process?
- Where was leadership shown? Who deferred to whom? On what grounds?

In just the same way as an unexpected line, shape, or graphical metaphor, an unexpected interaction or group process may reveal that a group could go in a different direction to the one that you, as facilitator, had planned. Professional wisdom (and an ability to quickly remind oneself of the purpose behind an intervention) determines whether to take an unexpected pathway or not.

Finally, and to restate what we've already mentioned, asking people to draw—rather than write lists of bullet points—can take people right outside their comfort zone. What's more, when we work with new groups on team away-days and meetings we probably only stick to our "session plan" about half of the time. The content and direction that we'd imagined before the session is often supplanted by a huge factor that only reveals itself once we meet the delegates. Ultimately, we must always bear in mind that the purpose of engaging a group in a graphical (or indeed any other type of facilitated task) must be to allow people to draw out lessons and not just lines.

*

2.6 Preparing the Space for a Graphical Session

From time to time we hear colleagues complain about the room that they've been allocated to run a training session or away day—because their room is simply unfit for any activity that is not led from the front in a pedagogic style that was once called "chalk and talk." Often conference and training venues are still set for a screen-led front facing learning experience, as shown here.

Figure 2.7 A juxtaposition of venue expectation (reset straight lines of neat furniture) and the reality of a day's graphical discussion (stuck to the wall).

While there is often a difference in the institutional promises of state of the art learning facilities and the reality of the training room, we both hold that graphical learning and success can be achieved even at times of adversity. So, while flexible furniture, blank walls, whiteboards, and crucially, lots of space are helpful enablers, they are not absolutely essential. With some forethought about intent and some ingenious use of space and materials, even the most inflexible space can be a site for creativity and conversation—as shown below.

You may be lucky enough to work repeatedly in the same designated training space (if for instance you work within an organization's development unit), and if so you may have a say in the design of the room and the storage facilities therein. However, if you are not in this position, you'll need to arrange a delivery of resources to the host institution or transport it yourself. If you're carrying kit yourself you'll need to establish a packable set of kit that can be carried on public transport or through an airport.

On arrival at the venue you need to think carefully about what resources you place out in plain sight before the start of a session. Bear in mind that having items, such as paint or postcards, laid out before delegates arrive is an opportunity to build intrigue. This can be a useful dimension, as it gets people talking about what the materials are for and may dissipate some of the nervous energy in the room that arises when people don't know each other. Equally, it may be useful to do this with an established team that has a set way of working, as a way to disrupt the normal dynamics. However, you may wish to hold things in reserve so as not to distract from other agenda items or, worse, other speakers who are on before your part of the day.

Figure 2.8 Creating collages in a raked lecture theatre.

What is interesting here is that, unlike children, most adult groups do not intuitively start playing with whatever kit you place on the table. Pens, paints, collage images, and piles of LEGO® bricks will go often completely untouched—either through respect, ingrained cultural reticence, or, we recognize, apathy. Regardless of the reason, groups frequently need some help or permission to engage. This permission can, in and of itself, form an interesting icebreaker for groups. For example, if we want a group to create a sculptural drawing with LEGO®, we sometimes place piles of it in the middle of each table, and as the session starts, kick things off with a with a few playful prompts, such as "build the tallest tower you can in one minute" or "gather the most different sorts of bricks in thirty seconds."

In addition, this "permission giving" is a teachable moment for trainee lecturers or new trainers about power and authority in a learning space. However, it must also be noted that some individuals dive straight into the kit that you've carefully laid out—others follow this lead and fairly soon the session is in (delightful) chaos before it even starts.

Ultimately, without over-egging things here, you need to carefully consider your ultimate developmental intent from before the session starts. If you want a group to think collectively and collaboratively you may want to lay out objects that fit together or shapes that tessellate in a pleasing way. If you want them to draw, make it acceptable for them to do so from before any formal start. You don't need to reveal your activity in advance, but you do need to set out the space and kit to make it as easy as possible for them to move in the right type of direction when the time arises.

2.7 Getting People to Pick up a Pen and actually Draw...

It's all very well for us to make sweeping predictions of the value of graphic thinking and to show pictures of arty kit and finished collages, but it's another thing entirely to make the process of graphic creation work in the first place. As facilitators we must always bear in mind that any given group, or individuals therein, may be uncomfortable, and perhaps do not fully trust any sort of process that we may have in mind for them. Simple process fundamentals like establishing confidentiality, contracting ground-rules, using people's names, and co-ascertaining the purpose of the event and conversations will go a long way towards easing any discomfort. If the group is aware from the outset that you value and respect their time and treat their learning and professional standing seriously, they will be more disposed to do likewise—even with activities that seem new, unusual, or even childlike.

As organizational facilitators and educators it is essential that we are aware of the messages that are silently communicated from the very first moment of contact with a group. For instance, if you have materials laid out before a session, then participants will gain clues as to your intention from the layout as they walk into the room. This signaling can work both positively and negatively. Contrary to the usual expectations of tables and chairs and a data-projector, more "arty" resources (paint, postcards, colored paper) generate conversation. This conversation can be especially useful with a group of people who do not know each other, and you may overhear comments of intrigue and interest ("Oh! I wonder what we are going to do?"). However—and especially problematic if you are a new facilitator, or are prone to imposter-syndrome—do be aware that comments might also include uncertainty ("I'm terrible at drawing...") and derision ("I thought I'd left playschool!"). Right

from the start we would usually circulate to introduce ourselves and start conversations to build rapport and reassure qualms, but you'll have your own authentic behaviors and style preferences.

If you do not put kit and resources out in the room, there may be a point to announce "we'll be doing something different today" or "right, could you draw a …". Again this may unsettle people. It's worth noting that both of us understand the value of the learning edge, and the "stretch" associated with uncertainty and the unknown. We use our skills to help people explore and discover more about themselves to improve their teams and organizational strategy. This means enabling people to look beyond what they already know within the realm of their "comfort zone" into places of growth, and is sometimes known as a "growth mindset."

As we've already outlined, to kickstart this movement from comfort and into graphical stretch and growth, you may wish to use some sort of warm-up exercise. To avoid taking too much time, or requiring too much from the group immediately, such a warm-up should be fast, fun, and light-touch. To create energy and "level" any differences in artistic talent in a group, you might want to place a very quick time limit onto the warm-up. For example, asking a group to each draw a house on a sticky note in ten seconds ensures that everyone contributes more or less evenly, since in ten seconds it is very difficult to draw anything that looks like a "real" house. It's sometimes worth joining in with this process to show a group that you're not expecting them to do anything that you won't do yourself (see below).

This drawing warm-up can comprise a single drawing or a series of mini-pictures; a folded sheet of A4 paper creates four drawing panes or a grid. Ask the group to suggest four objects or items, and then request that each group member draws them in their four-pane grid in one minute.

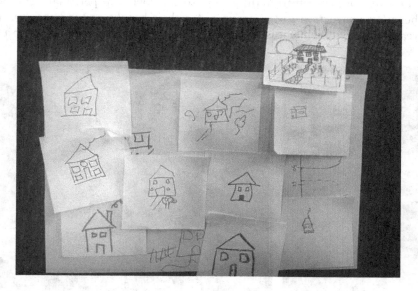

Figure 2.9 A simple, levelling, high-energy warm-up

Other fast drawing prompts might be:

- Draw a space rocket/dog/snowman/guitar
- Draw a map of your route from where you've parked to this room (for an in-depth adaptation of this approach, see Chapter 7 (Circles))
- Draw your favorite thing
- Draw something that represents your character
- Draw the best/worst thing about your job

2.8 During the Graphical Session

In the middle of a session, once you've set out the objectives and the purpose and engaged the group in a creative or graphical activity, you'll notice fairly quickly that people respond in very different ways. When a session is simply discursive it is relatively easy for some people to sit back and not to participate. This is not just because one person speaking means that others can't, but rather that it is relatively simple for participants to become passengers and not to say anything nor listen actively.

However, using an active making or drawing technique means that more people are participating during the session. For example, shown below are two contrasting groups, both engaging in HR-organized "workplace kindness" events (the type of event which, statistically, is likely to have its fair share of "passengers" and even "prisoners"). You can see that the groups are engaging in different ways—the one on the left need instruction and guidance, and the group on the right have immersed themselves. But both groups are, in their own way, engaged.

Depending on how people are reacting to an activity, you may need to expand or contract the timings (and so build flexibility into your planned schedule); you may need to increase the amount of steer or back off from the group (so consider your personal need for control and whether your instruction to the group is for their benefit or for yours...). You may need to tweak the activity while it is underway to react to an emergent theme or a valuable

Figure 2.10 Structured or chaotic—but both groups are engaged.

detour. You may wish to add a twist or a mystery to the activity that can be introduced if needed. For instance, when working with three or four tabled groups in a room I sometimes ask them to pass their drawing or labelled infographic onto the next table and then introduce a new theme—so as to create a new "layer" of illustrations and metaphors. Two examples of how this could work might be:

- Divide the whole group into two. Ask both groups to draw the challenges that they face in the workplace. Then ask them to switch paper with the other group, who complete the exercise by drawing solutions to these challenges.
- Divide the group into three and, using long sheets of paper, ask groups to draw the "past" of their organization or project. Once they have done this, pass the papers to a new table and ask the next group to build on this work and draw the "present." Once this is completed, rotate the paper on for the final time and ask the final group to complete the drawing with their depiction of the "future." (Each group draws a past, present, and future.)

Such a process challenges the groups to both decipher what the previous group(s) had drawn and then to integrate and build upon it. Deciphering, deciding on how to integrate, and actually drawing are quite different mental elements but all require active participation and engagement, as also does defending the extension of a drawing to the original creators from the previous group(s).

Depending on the intention behind the session, you may wish to ask questions of the group as they engage with the task, or you may wish you leave the group alone until they have completed their work or until the allocated time has passed. You certainly need to be physically present, but too much intrusion can be detrimental. However, on occasion, it can pay great dividends to interject at the right moment. For example, during a recent session about creative and critical thinking, I noticed that a group had conjured the concept of the "mind jail"—a really interesting metaphor for how the narrow strictures and structures and rules of their organization and superiors was stifling their creativity. This small cartoon (below) could have been an amusing footnote in the day, but I asked them to expound and explain the meaning of the mind jail, and they came up with elaborate and entwined

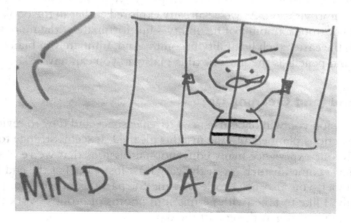

Figure 2.11 If it seems productive, go with your facilitatory instincts.

metaphors linked to being mentally incarcerated. I then redesigned much of what came later in the day as a way of helping them to break out of the "mind jail" that they had invented.

We would be somewhat remiss and naïve if we didn't acknowledge the notion that drawing, graphical, and creative approaches take time. Time is a precious commodity and therefore we, as facilitators, have to decide how to best spend it. I like to think of the value of an activity plotted against the amount of time a group spends on it. Value will rise and fall in a bell curve shape. Too little time on an activity and the peak value isn't reached. Too much time and the group gets bored or sees the time being wasted. The facilitator or trainer's job is knowing when the peak of the bell curve is reached. (For what it's worth, one of us confesses to typically leaving an activity too soon, while the other stays too long. Facilitation is by no means a perfectible art.)

Packing sessions full of "content" may end up being counterproductive, for example, if the goal of the session is for people from different teams to connect and improve integration. As facilitators, we both attest that spending precious time getting a group engaged in purposeful drawing pays dividends. For a less experienced facilitator, it is understandable if you feel uncomfortable about the value of "using up" time drawing or "playing" with materials. However, by being clear, purposeful and respectful of peoples' inputs you can amplify the value of an activity very quickly. You may, however, wish to experiment with a blended format; that is by using time before or after the formal session. For instance:

- Can people be given focused pre-thinking so they are ready for any given conversation or course?
- Can people be set small drawing tasks to be engaged with pre-session, so that the face-to-face activity is more about combination and compilation of their existing images—rather than "from scratch" creation? Such an approach works well in online sessions.
- Can people be given "content-filled" resources after the session?
- Could you create a handout that is more akin to a resource document, rather than a direct replica of a pre-ordained slide show (thus allowing immediate flexible departure from the planned script of a class, workshop, or session).

Whatever your decision about how to use time—fundamentally, during the session the role of any facilitator is to strike a balance between proactive planning and direction and reactive enquiry and improvisation. As we've already explored earlier in the book, good facilitation requires an enormous amount of flexibility—but fortunately, the more tools you have at your disposal, the easier such flexibility becomes. And, ultimately, a blank sheet of paper and a few pens and pencils is the most flexible platform you can have.

2.9 At the End (and Cleaning Up)

At the end of a session you will of course need to leave space and time to review the content covered and the actions planned and the insights gleaned. It seems strange to have to write this down, but in our experience many conventional sessions that we've observed or been participants in have come unstuck (or at the very least lost value) at the end because things over-ran. Remember, you also need to leave time for participants to take photos of their efforts. Personally, I like to take (with permission) photos of groups' work throughout the day to avoid a large backlog at the end of the day.

If you want to improve your facilitative craft, you may wish to spend a couple of minutes soliciting feedback about the process that you undertook with the group. For instance, asking questions such as:

- What were you expecting from this session? What did you gain?
- I hope to repeat this [drawing activity] again; this was the first time I've used it—do you have any thoughts on how to improve it? (Note that this isn't the same question as "what do you think of the activity?" Asking for improvements generates construction, not simply criticism.)
- What two new insights did you gain about yourself/your organization/your team from this activity?
- How has this drawing helped your strategy/writing/project going forward?

Finally, at the end of the session, you will need to build in time to clear your materials away. Obviously pens and paper will be quicker to shift than sculptures and glued magazine collages or LEGO® models! This is especially important in shared spaces where another group may be due in next, or when events are tightly scheduled (i.e. as part of a conference). In our experience, the easiest way to clear things away quickly is to involve the participants in the tidying process. Even more deviously effective is to competitively gamify the clean-up (i.e. give each subgroup one minute to plan their clean-up strategy and have them race the other groups to be the first to have a spotless workplace!). That said, we both always have the back-up of big, strong, foldable bags or boxes in which everything can be swept for sorting at a later point.

Different facilitative environments require different clean-up processes—for example with the "beach drawings" that feature later in the book, these activities required Council permission to use a public beach involving risk assessments and a strict clear-up protocol. In our case using various drawing activities on the beach, all the items had to be collected so that no debris remained. The area had to be swept and flattened after everyone had left, to reduce trip hazards from randomly dug holes and piles of sand. Clearly this is an extreme example, but on a day-to-day basis both of us spend a lot of time—once our participants have departed—tidying, cleaning, and resetting the furniture before turning out the lights.

*

References

Bassot, B (2023) *The Reflective Practice Guide: An interdisciplinary approach to critical reflection* (2nd Edition) (Routledge)

Hutchinson, S and Lawrence, H (2011) *Playing with Purpose: How experiential learning can be more than a game* (Gower Publishing)

Kolb, D (1984) *Experiential Learning: Experience as the source of learning and development* (Prentice Hall)

Neal, MJ (2016) *Pharmacology at a Glance* (8th edition) (Wiley Blackwell)

Stîngu, MM (2012) Reflexive practice in teacher education: facts and trends. *Procedia Social and Behavioral Sciences*, 33, pp. 617–621.

Part III

Graphical Approaches

In Part Three we present a series of illustrated ideas and approaches organized around the form that the graphical approach might take. Each chapter shows a variety of activities, ranging from the simple to the ambitious and beyond.

Chapter 3 Lines, Connections, and Clusters

In which we explore how simple marks and groupings on the page can elicit deep responses

Chapter 4 Triangles, Squares, and Other Shapes

In which we examine the frames and relationships that can be captured with geometrically angled forms

Chapter 5 Maps and Mapping

In which we consider how direction can be represented and found using cartography

Chapter 6 Models and Frameworks

In which we show how groups can annotate and augment existing models and diagrams

Chapter 7 Circles

In which we observe the facilitative value of the most special and useful of all shapes

Chapter 8 Freeform Graphics

In which we highlight the impact of having no graphical rules

Chapter 9 Space and Movement

In which we add dimensions of distance and motion to the facilitative toolkit

DOI: 10.4324/9781003410577-6

Chapter 10 The Third Dimension

In which we move upwards and outwards from the page

Chapter 11 Mixing and Matching

In which we reveal what can happen when multiple tools are combined

Chapter 12 Digital Possibilities

In which we try to bring pens, pencils, and paper into a modern technological workplace

Lines, Connections, and Clusters

Lines and connected groupings of information (we've called them "clusters") are an excellent basis for visual communication tools and hold a large amount of information. There probably isn't a facilitator alive who hasn't drawn connective lines on a flip chart or captured discussions and asked people to group and weigh up decisions with sticky notes. As such, this chapter contains familiar forms, but since these are the fundamental building blocks of the graphical tool-kit, we wanted to offer some new ideas and approaches. We start with the humble line.

3.1 Simple Lines and Marks

A basic straight-line plot includes any sort of scaling instrument (such as quick surveys using Likert scales) and timelines to summarize a historical period. They make up familiar infographics such as the line graphs of annual temperatures perused when searching for holiday destinations. In many homes, pencil marks denoting each child's height on a wall is a graphical familial storyline.

Line-based drawings or graphics are simple and easy for groups to create. They can be created with physical objects (including people) in a room or outdoors and can be straight or squiggly! Like all the other graphical representations in this book, the line is part of a broader context and conversation.

In terms of working with groups, anything that can be scaled works along a line. These lines work in standard increments such as those on evaluation forms, self-assessment tools, and staff/customer satisfaction surveys. For example:

- "Show on a scaled line of 0–5, how useful was this workshop."
- "If 0 is no pain, and 10 is the worst pain ever, indicate on this line what is your pain level now?"

As such, an easy line drawing is to ask a group, before the workshop, to draw a horizontal line and make a mark on it representing how confident they feel about the topic of the workshop. They do not have to share this, but they can then return to the same page after the workshop and, in a different color, note their new confidence level. This of course is subjective, but there is still an element of in-session evaluation. It could be broken down for different aspects for a big subject, like equality and diversity training, to separate elements. This is then helpful in-time feedback to review concepts.

DOI: 10.4324/9781003410577-7

Such an approach can be useful for any sort of dichotomy-based discussion (i.e. mark on a horizontal line the point where you sit between (e.g.) a preference for Extraversion and Introversion). Such an approach can also be used in a webinar chatbar, where typed hyphens create the line and an "X" marks the point where a participant resides.

3.2 Timelines

A basic timeline is a single line which refers to the (usually linear) passage of time. Timelines are versatile tools to visualize and provide clarity for complex events over a long duration. It is hard to articulate, on the spot, a coherent narrative in response to a broad prompt such as "What projects has your team done over the last five years?" Spending time constructing an annotated line collates a vast amount of information into a succinct visual summary.

After drawing a basic (horizontal or vertical) timeline, invite participants to add other marks such as dots or little drawings. Timelines work well for summaries. For example, you can ask a group to timeline the past ("draw a timeline and note when you started each job"), or create a timeline of the future ("Let's work together and visualize the key points for the merger of these two teams"), or goal setting ("Use the timeline to illustrate your professional goals for the next ten years").

Timelines can also be used to look for patterns. With project reviews we often ask to see the client's original project timeline (or Gantt chart) and then ask them to overdraw the reality of what has transpired. Patterns frequently emerge (especially over-runs) and it is powerful to have this information so clearly available to all of the team.

If a line is drawn horizontally across the middle of a page, the page is divided into top and bottom. This essentially offers the baseline for a line graph, with the top part representative of upward or positive experiences, and the bottom a negative experience. The horizontal (the x axis) can be time and the vertical (the y axis) expresses HOW positive or negative an experience was the further it is from the baseline, which I (Curie) usually refer to as "an okay level" (Figure 3.1). This experiential timeline now encompasses a different dimension to reflect short-term experiences (which we sometimes call a "happy chart") or a long-term situation.

An extension to this basic tool is that, once someone has plotted their life experience (either generally or with a specific focus), the same methods can be used to project forward. In my (Curie's) PhD research, participants used "Landscapes of life" to explore their perception of getting older (their own future ageing). People mapped the ups and downs of life (akin to mountains and valleys in the landscape) and then thought about potential ups and downs for their future ageing (Figure 3.2, adapted from Scott 2018).

The page is split into two: the left depicts their previous life experience and then, on the right of the page, they project forward from the current time to the age of 99 and depict how they think or feel their future may be.

In figures 3.1 and 3.2, these timelines were created and shared in pairs, and this co-construction assisted in building rapport where one individual leads and directs the conversation. The visual nature is also beneficial if working across fluency or language barriers.

Timelines can be accessed by multiple participants at the same time, for example to chart the collective memory of a team that has suffered stresses and anxieties. Moreover, multiple timelines can be displayed in parallel to map different autobiographical or professional contexts against certain shared events (see Adriansen 2012). A great, practical example of the power of timelines can be found in the work of Katie McCurdy, a user experience designer, who has myasthenia gravis (MG), an autoimmune neurological condition resulting

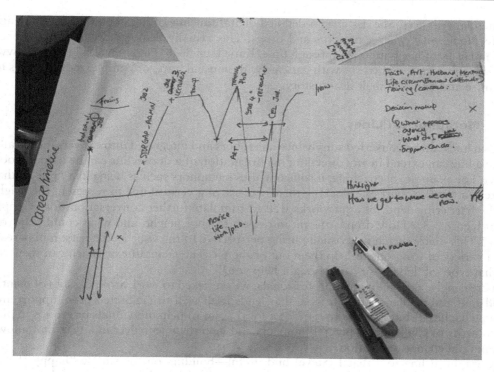

Figure 3.1 A career timeline of the subjective experiences during previous job roles, with experiences above and below the baseline

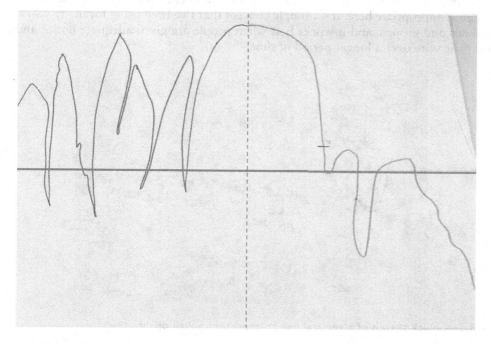

Figure 3.2 A timeline of positive and negative life experiences (either above or below the horizontal line respectively) representing past experiences (left half of the page) and projecting forwards (right half on the page) (Adapted from Scott 2018).

in muscle weakness. She designed a detailed digital timeline of her condition from the age of 13 along with other symptoms and drugs. This visually demonstrated the occurrence and intensity of her symptoms through time. Katie launched "Pictal Health" (https://www.pictalhealth.com/), and works with patients with unusual, rare, or complex health issues to organize and visualize their health story.

3.3 Metaphorical Lines

Drawn lines can be converted simply into metaphors and integrated into conversation—and since a line can extend in any direction, the orientation of a drawn line can be used to good effect. For example, in coaching, if someone uses metaphors such as being in a "pit" or that there is a "wall or barrier" blocking them, the use of a vertical line to represent the height of the barrier or depth of a pit works well to stimulate further conversation; for example as in Figure 3.3: "How deep is the pit in respect to your height, and what could help you out?" This quick sketch can visually bring perspective to the issue as the person may realize a variety of solutions to help them out of the pit. The facilitator or coach can then ask "What types of 'ladder' or 'ropes' might help you?"

Increasingly, as development professionals, we are asked to work around issues of mental wellbeing and resilience. It's an issue that lends itself well to facilitated peer support and group coaching—but it sometimes needs a focal point to help individuals or groups to pinpoint areas of challenge or pivotal moments and help them to reflect in a way that allows meaningful change and action.

A graphical line tool that I (Steve) find useful—building on the simple "happy chart" type depictions of experience is what I call the "resilience road." There's a similar concept explored in *Seven Ways to Build Resilience* (Johnson 2019) that details the psychology behind the model and delves into the issue of mental wellbeing in a far more comprehensive way than is appropriate here. It's a simple concept that I've been using for many years with individuals and groups, and it works best when people are given adequate notice and can record their state over a longer period of time.

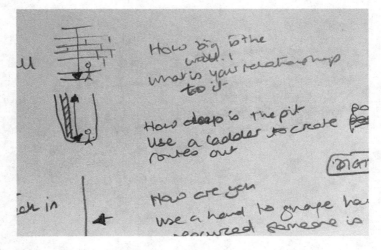

Figure 3.3 A quick sketch of a vertical line to represent a wall or pit

In essence, the graphical process of Resilience Road starts with a depiction of a road—representing forward travel—stretching from the bottom of the page (start of the journey) to the top (present day). This road represents a smooth, comfortable surface, where an individual's resilient mental state allows them to operate in a healthy professional (or personal) manner.

On one side of the road sits a ditch (a metaphor for low energy and dissonance—"Oh what's the point?") and on the other a steep embankment (a metaphor for unhelpful resonances such as rage and anger—"Grr.... I can't believe those stupid morons rejected my idea again!!!"). Sometimes I pre-draw the basic road (Figure 3.4, left), and sometimes I ask the group to draw their own.

I ask the group (as individuals) to depict their state throughout a certain timeframe. This can be done in "real" time, throughout a week or by giving a group five minutes to think back on their journey over a time period and capture it.

Ask them to notice and capture:

- the drifts in their mood across time periods
- the events that caused a marked veering away from the productive centre of the road towards the dissonance ditch or the opposite embankment
- the actions or events that facilitated their return to the resilience highway
- the early warning signs where they knew that they were veering but couldn't control the swerve

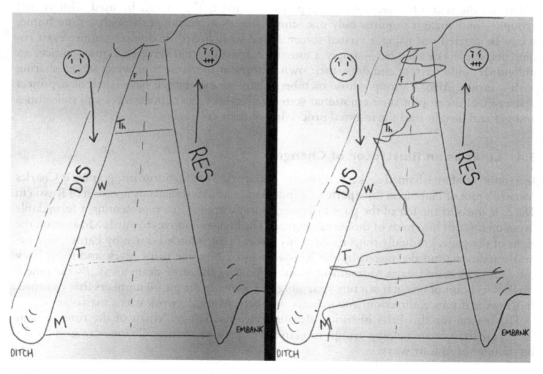

Figure 3.4 The "Resilience Road" before a line annotation (left) and afterwards (right)

The reflection and drawing will result in a traced pathway as shown in Figure 3.4 (right). Such a diagram can be shared with a peer support group or used as a coaching tool, with questions such as:

- What do you notice from the trace of your journey?
- What's the learning for you here?
- What different coping strategies do you have to deal with different types of challenge? How specifically did that reaction or action help?
- What are the early warning signs that allow you to make early corrective steer?

You'll notice that these coaching-style questions are prefixed with "what" or "how" to ensure the focus of the conversation is always practical, concrete, and future-facing. In addition, this coaching questioning approach is useful given that, seemingly, many people erroneously apply the same tool for dealing with different sub-optimal states, even though these sometimes require radically different countermeasures.

A graphical approach (contrasted with, for example, a diary) has distinct advantages. For instance, the act of changing the direction of a line can be enquired after (e.g. so what was the precise moment when things tipped?) and the act of making a mark to the left or right of the center of the road is potentially illustrative in its own right. Also, the ditch and embankment can be enquired after (What's it like in the ditch?; How does it help to be on the embankment?; etc.). That said, as with many of the tools and techniques illustrated in this book, the picture is a starting point for a conversation and not intended to replace it.

One of the real advantages of this type of charting is that it can be used with virtual groups —and since it requires only one simple line that meanders through a time frame, it can be carried out using a virtual screenshared whiteboard. It doesn't require even rudimentary icons or sketches—simply a line trace, meaning that (given adequate notice) an individual could narrate and draw their own journey at the same time whist screen sharing with a group. Also, a group whose members share an experience base (such as a project delivery team) can plot their emotional state against very clear timeframes and milestones and get real insight into the internal processing of their colleagues.

3.4 Lines as an Illustrator of Change

In a moment of unashamed geekery, I'd like to declare that my favourite infographic is Charles Minard's plot of Napoleon Bonaparte's Grande Armée and its disastrous invasion of Russia in 1812. It starts at the left of the page in France, a thick orange line representing a formidable invasion force of hundreds of thousands of men. The line, as it moves towards Moscow on the right of the page, gradually thins to show his forces being whittled down by battles, disease, and starvation, and decimated by the Russian winter. The line turns black and turns back towards France, and starts to fragment as subsections of the army drain away. By the time it reaches its point of origin it is a tiny straggling line showing the pitiful numbers that returned. In showing distance, direction, and military numbers, Minard's work was a masterpiece.

The reason for this brief historical detour concerns change. Much of the time in their work, facilitators are helping groups to plan for or process change. Change can graphically be thought of in four ways:

- Choppiness—a line that moves up and down over time, seemingly at random (like the league position of yo-yo football clubs that get promoted or relegated every other season)

- Variance—a line that is moving in a constant direction but with small ups and downs along the way (rather like a plot of the financial markets in "normal" good times)
- Shock—a line that is moving more or less regularly until (usually) an external event triggers a massive departure from the trend (like a plot of the amount of hand sanitizer bought in early 2020)
- Reaction—a line broadly moving in one direction but with huge actions and counteractions within a given range (like a bowling ball on a tenpin lane with the gutter-guards in place)

The problem with these descriptions is that they only show difference in time—i.e. a departure from a baseline. They don't necessarily show the direction of change, other than simply "up" or "down"; nor do they show the nuances of change (e.g. that things can get better and worse simultaneously). For example, the career timeline shown in Figure 3.1 illustrates two dimensions (time and positive/negative sense of experience). But this is an oversimplification, especially when we expand to consider the process of change within organizations. Two dimensions don't reveal the complexities and interconnectivity of how one thing may affect many others. Which brings us back to Minard and the plot of the Grand Armée—which depicts multiple types of information very clearly and simply.

One of the tools that I (Steve) use with groups who are in the process of change is a positive/negative change plot. In some ways it is a simple timeline plot, but with some useful differences. Figure 3.5 shows a facsimile of a graphic created by three sub-teams (who have

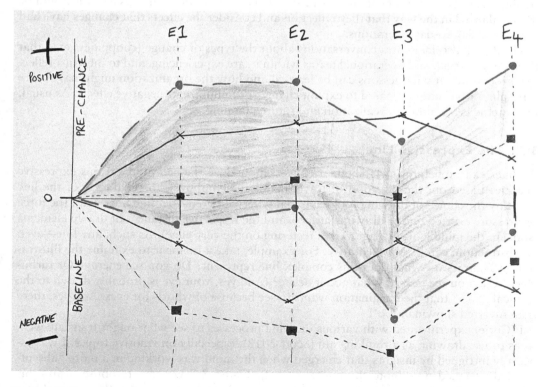

Figure 3.5 A comparative change line plot of (Positive and Negative) for three organizational sub-teams.

different functions) within a department of an organization that had undergone a number of fairly drastic change events in the previous eighteen months.

For anonymity's sake these change events are labelled as E(event)1, 2, 3, and 4. The events were agreed and plotted along a horizontal timeline. I asked each of the three groups to separately consider the positive and negative effects of the changes at each event to allow for the paradox that, with all changes, some things get better, and some get worse. The (fairly obvious) secret of successful change leadership is to maximize the former and minimize the latter. The groups were then asked to mark their positive and negative realizations onto the blank axes and these plots are shown here. The first subgroup is depicted with χ markers and solid lines; the second subgroup with ■ markers and small dotted lines, and the third subgroup with ● markers and large dashed lines. The space between the lines of the third group has been shaded to show its change plot.

The advantages of such a depiction are manifold. Firstly, it facilitates a conversation that allows for the idea that no change is wholly good or bad. This gives validity to the voices who are not necessarily wholly onboard with whatever change programme the organization is undergoing. This facet in itself is surprisingly helpful in that it minimizes the polarity of binary discussion, where change is often labeled as wholly "good" or entirely "bad."

Secondly, it allows comparison of the larger effects of change—in Figure 3.5 this would be the shaded area. The larger the depicted shaded area, the bigger the effect of change. Again, this is useful for a facilitator as it, in my experience, forces groups to temper and be more balanced in the way that they reflect on and consider the effects that changes have had upon their day-to-day operations.

Thirdly, it also facilitates conversations about the types of change (choppiness etc.) that their organization, and operational teams within it, are experiencing, and to inform a reflective process about what lessons can be learned and how the organization might have more foresight, or be better prepared to exploit change, or minimize its negative effects. As usual, the graphic is a conduit to realization and future planning.

3.5 The Expressive Line

All lines can be helpful to facilitate a conversation since they all hold various expressive qualities based on: the direction of travel (as discussed above), the character of the line made by the choice of drawing tool (charcoal is very different to a fine liner pen), the force or pressure exerted on the drawing surface, and the respective distances of drawn elements (some in the middle of the page versus teetering on the very edge). As such, any line—even an abstraction, can be representative. For example, take a moment to examine the illustration in Figure 3.6—what does this complex line represent? Do you see energy? Or turbulence? Can you see peace? What about desire? (And yes, your eye is probably drawn to the comical "face" that the imagination wants to see because of whorls for eyes. And yes, there is an inverted snowman too!)

I (Curie) experimented with various drawing processes to see what might translate well, so as to use drawing as a thinking aid (Scott 2018), especially on emotive topics. I was especially intrigued by insights that emerged when the mind was working in a more "absent-minded" relaxed way (note the quote marks!). Figure 3.7 was my response, using this mind-wandering doodling, to see what happened if I used it to wonder about why I was

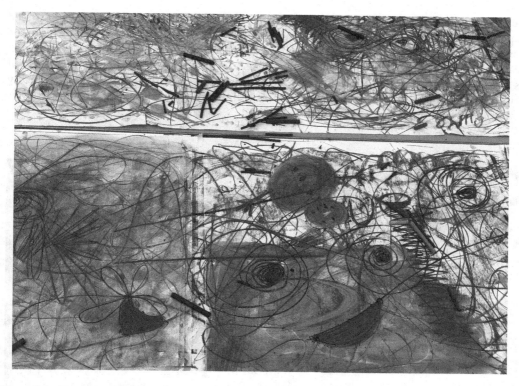

Figure 3.6 An abstract expressive line—but what do you see?

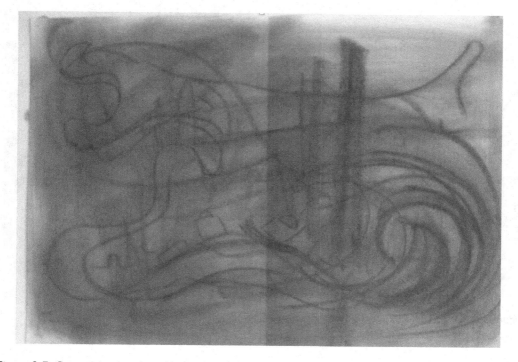

Figure 3.7 Generative mark-making to explore nervousness

feeling nervous about a professional challenge. I used charcoal on a scrappy piece of folded paper I happened to have in my bag. There is an entire story or realization (starting from the bottom left): a heartbeat (as would be seen on an electrocardiogram) represented my heart beating anxiously, and then a suitcase, which was carefully packed but then gained a life of its own (the suitcase starts zooming away to the right) to get lost in waves. This was very helpful, as I realized however much I organized things there were huge swathes of things that I could not control.

Figure 3.8 Large scale expressive line drawings

I have become more confident with this expressive and generative drawing, and now use it with clients and sometimes large groups of people to help them capture how they are (or were) feeling during periods of change. One example was in an online conference that took place during the COVID pandemic lockdowns. There were 75 people drawing at once—all in their own rooms.

I asked them to draw, expressively, how they felt at that time—and then I then asked them to draw how they *wanted* to feel. I then asked them to consider the smallest steps that would help to move them forward to their future vision. This resulted in a rich and powerful session and stimulated vibrant and emotional conversations.

However, these expressive types of drawing tend to be rigidly tight when done in a notebook compared to the opportunities offered by using larger paper.

Offering people the freedom to expand and "go where the line takes them" can be catalytic in and of itself, so don't be afraid to expand the size of canvas if the opportunity presents itself (see Figure 3.8).

3.6 The Line as a Visual Documentary

A neat tool that I (Curie) sometimes employ with groups is to ask participants to create a one-continuous-line drawing to illustrate and document their environment—with the purpose of <u>really</u> noticing what is going on.

For example, in Figure 3.9 is a series of stylized items drawn with a continuous line (notice the connections between different items). I take participants out into their professional environments (i.e. the refectory, the lobby, the play area, the communal spaces) and I ask them to draw quickly, working from left to right with a pencil. I ask them to focus on what is important and capture it in one "take." From Figure 3.9 you can see trees, rooftops, play equipment, and people relaxing.

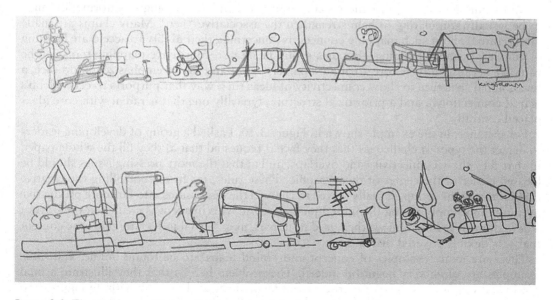

Figure 3.9 The single continuous line as a visual documentary

This type of line drawing can capture an ethnographic sense of place. For example, on looking at the sense of the built environment of an organization, we can ask people to pick a spot and start noticing (and drawing) what is going on in that space. If a group dispersed across different areas of an organization to do this drawing exercise, the atmosphere captured in a line of a large central food hall, the corridors in the executive areas, or the lobby would be very different.

I then ask the group to come back together and share what they have discovered and realized about a place or space. This has important applications when it comes to helping groups to imagine or design new facilities for their organization, or to plan meaningful events and spaces where people will meet and congregate. Moreover, as a technique it helps groups to be observant and really notice what is happening in the areas where they spend considerable portions of their lives.

3.7 Lines to Illustrate Connections and Clusters

Alongside helping groups to create ideas, make decisions, and plan actions, a fundamental role of the facilitator might be to help groups see connections and patterns. For many of the professional groups that we work with, the chief currency is information itself and helping groups to not just depict this information, but to prioritize and show connections and sometimes causality, potentially needs a wide repertoire of graphical approaches.

An obvious start point here for a facilitator might be to try the well-trodden path of spider diagrams, concept maps, or their more rule-governed sibling—MindMaps® (see the work of Tony Buzan—for example MindMap Mastery (2018)). Back in 1949 a Canadian neuropsychologist called Donald Hebb, known for his associative learning work, coined the phrase "neurons that fire together wire together." By this, Hebb meant that every sensation triggers thousands of neural connections, which form a neural network. The more associative triggers we have, the stronger the network. These associations are, of course, linked to all of our senses—not just the visual. However, graphic mapping of information aims to be visually stimulating to help strengthen the associative "net." Many claims are made (and refuted) about such mapping connectors concerning their ability to accelerate learning or enhance memory building—but as a group facilitator, connective mapping tools can be valuable because of their core attributes; namely, color and size to emphasize importance, a lined, nodal structure to show connectivity of ideas (in a way that purports to echo Hebb's neural connections), and a prioritized structure, typically one that is radial with core ideas placed centrally.

For instance, in the example shown in Figure 3.10, I asked a group of developing leaders to depict the types of challenges that they face. I requested that a) they fill the whole paper, b) that they show connectivity and overlaps, and c) that the more pressing issues should be located closer to the center of their graphic. These rules, far from controlling the creative capabilities of the group, actually served to channel the discussions into far more productive avenues than simply asking them for a picture or list. This image was created at the start of a development session and we then used it, in part, as a "visual index" to guide the content that was flexibly covered thereafter.

There are many examples of concept and "mind maps" to be found online, and these examples are often very beautiful indeed. The problem here is that they illustrate a final product as opposed to the messy process that facilitators need to work with. In Figure 3.10 the group in question spent five minutes firing out ideas and jotting them down onto a list

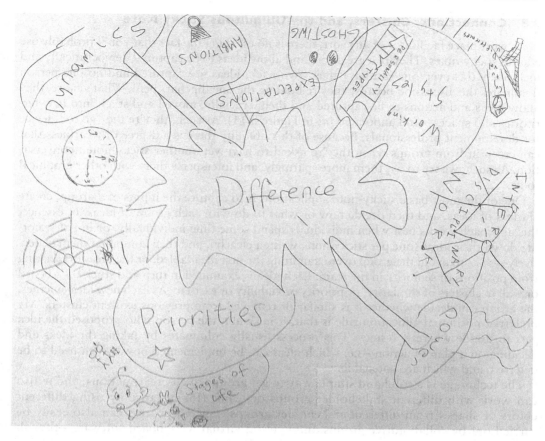

Figure 3.10 Connected "visual Index" for a workshop

before they picked up a marker pen and started to draw. As a facilitator, if you decide on this type of tool, it may be worth asking your group to a) create a proto-list of ideas first, b) then add the 'framework rules' (i.e. central priority, nodal structure and connectivity) at a second stage, and then c) ensure the group has sufficient space (in the form, perhaps, of a larger piece of paper or another whiteboard) to expand its depiction as the conversation grows and evolves over time. With a group whose members are meeting over several sessions, such expansion can also be achieved by photographing their idea map, printing it out as an A3 or A4 image, and then sticking this image onto the center of a larger piece of paper (A1 or A2) to remind the group of previous conversations and then visually expand into new unmarked territory. The notion of creating a map that builds over time can be incredibly powerful for a group that will be meeting regularly (for instance a facilitated learning group or practitioner network), though of course the facilitator will need to ensure that a) these visual efforts can be preserved between sessions, and b) these efforts will stay confidential from the eyes of interlopers. With a fixed team that I worked with over several sessions, I used tape and coloured string to link themes that reoccurred from week to week—providing both thematic connectivity and a reminder that certain things had not been resolved and continued to occur.

3.8 Connections, Clusters, and the Ubiquitous Sticky Note

For a workplace facilitator of any sort, there is no escaping the fact that you'll probably use a lot of sticky-notes. They're a great tool and allow ideas to be captured democratically and inclusively (i.e. everyone can have their own pack, ideas are captured and no one person dominates the discussion because they're holding the one flipchart pen). What's more, they allow ideas and actions to be captured and then, crucially, moved and stuck into new territories and spaces—and annotated (as in Figure 3.11). As such, they're the "go to" device for development professionals. Because of this ubiquity there is a degree of weariness that can creep in from groups when they're asked to have yet another sticky-noted conversation. As such, we try to use them more sparingly, and intersperse them with other graphical tools.

One of the most basic sticky-note applications is to capture the inputs of a group, create clusters of ideas, and then decide how or what to do with each group of ideas. In essence, this approach works best when individuals spend some time individually, or in pairs, noting down their ideas (one per sticky note, written clearly), and then compiling them collectively—so as to avoid the group over-examining the first idea tabled, or the ideas originating from positions of seniority in the team. Each idea is examined in turn and stuck on a board or wall in clusters of similarity, or priority or viability or ease etc. As each new idea emerges, the group can decide whether it is similar or removed from previous existent clusters. My preferred positional allocation rule is that, if in doubt, the person who proposed the idea gets to decide where it resides. This process usually culminates by taking the ideas and deciding on a plan of action—i.e. which ideas can be implemented now, which need to be deferred, and which are untenable.

The technique is a solid and simple way to get groups to co-create actions, and it also can work with different stakeholder groups or teams (for instance by using different colors or shapes from different stakeholder groups). Such a process can also easily be carried out by collaborative groups online using virtual whiteboard software—though groups using software tend to work more slowly and with a focus on neatness, which is not always required. In its rawest, most basic live form, such an idea map is shown below—it looks messy but, in our experience, innovation is stifled by demands for initial neatness.

Figure 3.11 Discussions captured by (many) sticky-notes

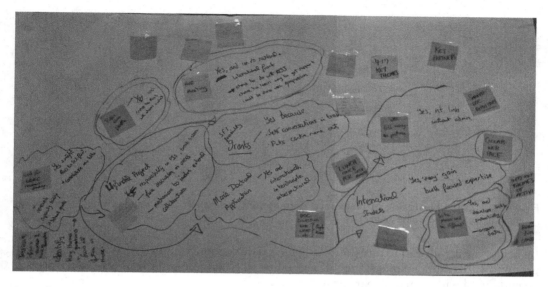

Figure 3.12 Messy, but connected, raw ingredients for future actions

3.9 Beyond Basic Clusters

Moving beyond basic idea clusters, it is possible to make a sticky-noted conversation into something more creative and memorable. For example, asking a group to place ideas and suggestions collectively on a pre-drawn shape, like an outline of a human body (see—for example—health researcher Helena Sustar and team's (2013) brilliant graphical co-design work with stakeholder groups of young people).

Unfortunately the photograph has been lost in the mists of time, but a few years ago I did some work with a client who had identified five areas of priority for their team. I was asked to facilitate an action plan conversation, and so set the room up as a circle of chairs. In the center of this circle I placed a large, washing machine-sized, cardboard box. On each visible side of the box (including the top, but obviously not the base), I'd written one of the five priority areas. Instead of using flipcharts I asked the group to capture their ideas on sticky-notes and then affix them to the correct face of the "idea cube." This meant they had to move and cooperate so they could all see the agenda from, literally, different angles. The client was very excited by how useful and innovative the session had been, but it was a basic technique given only a tiny tweak.

Here, as always, it is worth spending some time thinking about the purpose of the activity rather than just about the process (or worse, just the product). What is it precisely that you want a group to realize or articulate? This is not to suggest that you should pre-ordain the final output of an idea capture session, but it is to ensure that such innovation has a purpose. For instance, it may be that the clusters of ideas are inventive—but have no inherent feasibility; an outcome that makes for an enjoyable, but practically (in the short-term) useless exercise. Before any such process of ideation or generation, I spend time talking with event organizers or managerial higher-ups about what they actually are trying to achieve through this type of creative process. And while this type of process may seem, and start

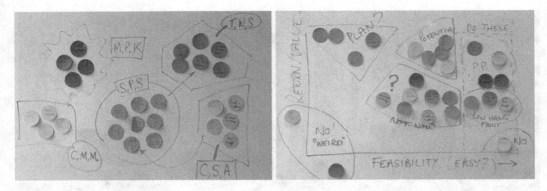

Figure 3.13 Initial clustering of ideas into themes (left) and then later repositioned to identify ease and value (right)

by being, open ended in nature—I usually have a directional "funnel" that manoeuvres the group towards a pragmatic actionable end point. For example—outlined here is a process I recently used with a large departmental group.

The session comprised a number of "phases" revolving around idea generation, and the (carefully anonymized) image presented in Figure 3.13 illustrates a midpoint and the final "result" of all stages of the process. This image is what the client group took photos of at the end of the away day, but an aligned purpose and process was, to my mind, what was useful to the group.

- Phase One: At the start of the session, individuals were given a period of unstructured thinking time to consider a question around future possible actions for the department. (For confidentiality reasons, the question is omitted here.) Each group member was given a pack of colored sticky-notes and asked to add one idea per note.
- Phase Two: Following this initial thinking period, small "subgroups" were created by grouping people with the same colored sticky notes (greens together, pinks together etc.). This was done randomly, but you could use colors to create subgroup homogeneity or diversity. Each group was asked to discuss and then present their collective ideas and these were stuck up on a whiteboard.
- Phase Three: We then introduced the notion of sorting the ideas for feasibility and impactfulness, and drew these as a matrix on the whiteboard. (The notions of feasibility and impact came from conversations with the departmental head, so as to ensure a direction for the exercise.) The whole group were then invited to take the grouped notes and reposition them onto the blank matrix.
- Phase Four: By repositioning the notes into the grid, the group created new clusters and were then asked to assign labels (e.g. "people-pleasers"/"low-hanging fruit"/"just weird") to make them memorable. The group suggested the names for the groupings—though some of the "saltier" label suggestions were edited! Dividing lines were added within the grid to separate the graphic into areas of return ("worth it"/"not worth it") and feasibility ("simple"/"just no").
- Phase Five: The initial subgroups were asked to reflect on the created plot and consider how to increase the feasibility or return of the ideas presented by the group as a

whole—the ethos here being "how could we make this idea better?" These improvements were captured by annotations on the whiteboard (not shown in the illustration) to capture potential improvements in feasibility or potential impact.

- Phase Six: The group as a whole spent time converting the map into a plan of discrete and accountable actions for various group members.

<center>*</center>

The technique of clustered notes can also provide a helpful process towards a targeted outcome by creating upfront scales and marks onto which group ideas can be stuck. For example:

- a blank timeline from the present up until a future large-scale goal or developmental phase allows a group to stick creative ideas at the point in time that they could be initiated or implemented;
- a feasibility frame, that allows ideas to be placed on a scale of feasibility (or expense, or popularity etc.) from "doable" to "utterly impossible without changing the laws of space and time." (As a formal tool, this is sometimes, in an extended form, called Analytical Hierarchy Processing (see Saaty 1980));
- clustering ideas onto an organizational or community map to show where action would be needed.

Sticky notes might be used as a way of ranking, sorting, or filtering an idea process in a democratic way. For instance, in design work, if a group has created a huge range of sketches, drawings, and schematics, these can all be stuck up on a large board and the group can then "vote" by attaching sticky notes to these designs. Different colored notes might represent different voting criteria (i.e. yellow is feasible, blue is cheap, green is "cool") and a decision could be made based on a group weighting.

3.10 Strategic Clustering

Taken to the next level, the technique of sticky note positioning can reveal complexities of both strategic thinking and operational action. Presented in Figure 3.14 is a facsimile created in a real group session. It's been carefully anonymized and the actual goals, targets, and ideas have been removed, but what is visible here is as close as ethically possible to the real graphical output of the session.

The image shows the results of team away-day, before which I'd spent time with the group leader trying to gain clarity as to what was their strategic five-year plan. This vision was shared, by the group leader, with the group at the start of the event and written at the top of a large sheet (represented here with the words "five year plan"). Down the center of the paper I wrote a five-year timeline and created a target of concentric circles leading inwards to the goal. The overall group (about fifteen people) split into three subgroups and I asked them to spend some time thinking both about their ideas for subtargets along that timeline (we labelled these "What?") and the enabling processes that need to be in place in order to facilitate these ambitions and the overall five-year plan (labelled "How?").

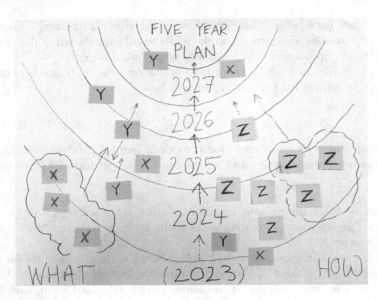

Figure 3.14 Anonymized facsimile of a "Five Year Plan" Cluster Map

After some discussion time I asked the three self-selecting subgroups, which we'll call X,Y, and Z, to present their ideas and stick them to the chart. (Groups X, Y, and Z had different sticky note colors, and these are anonymously labeled as X, Y, and Z in the figure).

I show this illustration, not because the end image is transferably useful (although the group found the real image a vital resource after the event and are still using it to review and plan against), but because of what the placement and clustering revealed. For instance:

Group X (which contained and was perhaps dominated by a more senior team member) had a very strong idea of *What* they wanted to achieve, but little idea as to *How* that could be achieved (note the placement of X's in the first year of the plan and then little until the final year of the plan).

Group Y contained mid-ranking team members who had a sense of where they thought the department could start to make realistic movements and set targets, but again were not ideally informed as to *How* these sub-targets could be achieved.

Group Z contained three administrators, a technician, and an operational manager who hadn't truthfully seemed to be engaged when the five-year goal was being outlined by the boss—but who had lots of short-term improvements that would allow the team overall to become more operationally effective.

The team as a whole spent some time adding arrows and links to the different sets of ideas and moving them back and forwards in the timeline until the end of the conversation, where this "final" graphical plot became the kick-off for an accountable action-planning conversation. The value in this session outlined above was partly in the revelation of the blind spots (both operationally and chronologically) from different elements of the team, but also in allowing all the teams to have freedom to contribute within a framework.

*

References

Adriansen, HK (2012) Timeline interviews: a tool for conducting life history research. *Qualitative Studies*, 3(1), 40–55.

Buzan, T (2018) *MindMap Mastery* (Watkins Publishing Ltd.)

Johnson, C (2019) *Seven Ways to Build Resilience: Strengthening your ability to deal with difficult times* (Robinson)

Saaty, TL (1980) *The Analytic Hierarchy Process* (McGraw Hill)

Scott, C (2018) *Elucidating perceptions of ageing through participatory drawing: a phenomenographic approach* (Doctoral Thesis, University of Brighton, UK)

Sustar, H et al (2013) Using popular culture to enable health service co-design with young people (Conference: Proceedings of EAD 2013—Crafting the Future) https://www.researchgate.net/publication/261081986_Using_Popular_Culture_to_Enable_Health_Service_Co-Design_with_Young_People#pf12

Triangles, Squares, and Other Shapes

When I (Steve) look through my notebooks and slide decks, many of the models and drawings that I create for myself and use to teach groups are based initially on shapes. Square-based models feature heavily (especially the 2x2 square matrix), but triangles, pentagons, hexagons, heptagons, and other shapes with a greater number of sides also appear. For the graphic trainer or facilitator, creating session structure through regular-sided shapes is a good way to contain and regulate conversation and content. It is also a very effective way to ensure balance in a session; if an initial conversation or scoping meeting suggests that there are five things to explore, then a large labeled pentagon drawn onto a whiteboard provides focus and ensures that no one area of discussion dominates or takes too much time.

The other fantastic graphical property of regular shapes is that they, in some way or in some combination, tessellate. This makes them superb building blocks and allows individual participant contributions or session elements to combine in a pleasingly neat and helpful way. The geometrically inclined amongst you will notice the omission of circles in this section. Circles, we feel, are special and we treat them as such in Chapter 7.

In this chapter we'll look at how regular shapes can be used by a graphical facilitator to illustrate, regulate, balance, and combine conversations.

4.1 Triangles and Trifold Relationships

After a basic line, or a pair of axes on a dataplot, the first simple shape that can be used to help groups is the triangle. As well as being very simple to draw (not so nonagons…), triangles have an innate strength and stability. Moreover, triangles and threes form powerful memory aids, hence the rhetorical tricolons used by orators and politicians and the tripartite construction of stories, jokes, and myths throughout time. Though, it should also be remembered here that triangles are commonly used to depict warning signs.

In its most simple graphical form, an equilateral triangle has space for two labeled concepts at either end of the base and one at the shape's apex. However, slightly counterintuitively, we do not see the apex point as more significant or better than the other two. We understand that the triangle can be seen equally from any point. This equity is important, and why the triangle can depict actual, metaphorical, and organizational stability.

However, when the triangle is inverted this stability disappears and the shape can depict imbalance with the slightest pressure on either of the two "top" corners likely to send the shape crashing back towards a flat-based stability. This pressure can of course be an imbalance of issues at a point in the model (i.e. one stakeholder of three who is massively more

DOI: 10.4324/9781003410577-8

demanding than the other two). So before we draw an initial three-sided shape to help contain and regulate a three-fold conversation, we should enquire as to the stability of the system we are depicting.

Nonetheless, the simple triangle sits at the heart of many graphical models used by facilitators and educators (for example the "cost, time, scope" project management triangle or the "heat, oxygen, fuel" fire triangle).

4.2 Pyramidical Hierarchies

Another way that triangles can be used as a graphical framework is as a hierarchical pyramid chart, with layers showing either:

- The significant few at the top, and the many at the base e.g. the Data, Information, Knowledge, Wisdom (DIKW) model
- The basic elements at the base and higher functions at the pinnacle e.g. Maslow's Psychological Hierarchy of Need (Maslow 1943)
- The absolute foundations at the base and other elements that build upon it e.g.Lencioni's Five Team Dysfunctions (Lencioni 2005)

Or, in its inverted form, the downward-pointing pyramid chart can show:

- A decrease in volume or desirability as the levels progress downwards e.g. the prevent, reduce, reuse, recycle, recover, dispose waste management chart
- A depth of strategic thinking with daily tasks taking up much time and space at the "surface" and strategic vision and consideration of meaning and values at the deepest point.

I used this final version of the inverted pyramid model with a small coaching group recently (see Figure 4.1). The group wanted to focus on the notion of finding time to think about the big picture and long-term issues, and so at the start of the conversation I drew an inverted hierarchy with day to day "tasks" at the top and drew in levels depicting "projects," ongoing "roles and functions," their "five-year plan," their career "vision" and finally their "values." (I didn't invent this hierarchy, and I can only apologize to whatever source it is taken from originally. It was shown to me by a colleague many years ago and I cannot find the original.)

I placed this labeled diagram on the table in front of the group and asked them to illustrate—using a bendy stickman figure—at what *depth* they typically operated and what events caused them to dive down to the strategic zones of long-term visioning and meaningful values. I used the bendy figures to preserve the anonymity of the individuals (so we could reuse the image in future sessions) and also because of their tactile, kinaesthetic, and playful attributes. After they'd talked through their experiences and moved the figures I invited them to draw their figure's path onto the chart.

This exercise was invented especially for this group, as they had been somewhat reserved the previous session and I wanted to coax them into drawing through first moving the stick men. However, the resultant graphic formed the central conversation around which future sessions were built.

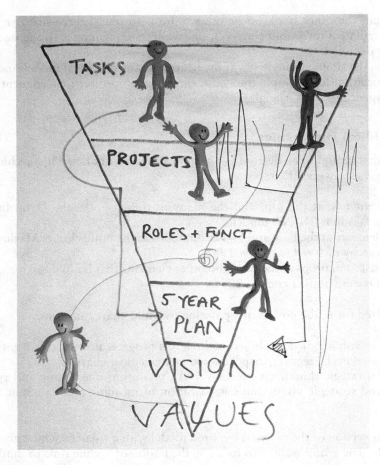

Figure 4.1 Inverted pyramid and bendy figures facilitate conversations on strategic focus

4.3 Triangular Funnels and Filters

As well as a hierarchical pyramid, a triangle also comprises the major part of a funnel. Facilitators are often called upon to help groups make decisions and a graphical filter or funnelling process can be a useful tool to that end. In industrial applications, an "innovation funnel" (see Wheelwright and Clark 1992) is a tool used to narrow down a broad range of inputs and ideas until a viable, economically marketable idea is realized. The approach can be used with other sorts of groups and enterprises who may be searching for new strategies and ideas, though it needs some tweaking and careful thought in order to make it work. What is essential is to ensure that the group doesn't simply pick the "first best idea" that they have, and so in common with other forms of ideation it is helpful to establish some ground rules and frames at the start of the process. I'd suggest a few general steers to help the group filter in a creative, but pragmatic way.

- Ensure the group is clear on the purpose of the exercise, and what "success" might be for the final idea. This process in and of itself often takes far longer than expected and is often controversial.

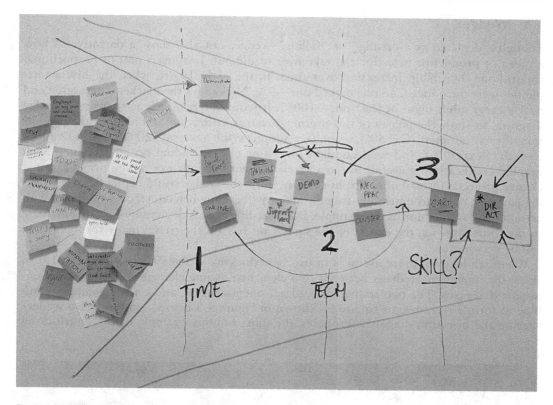

Figure 4.2 The Idea Filter Funnel

- Ensure the group captures and creates a wide range of options. (I sometimes use a timer here to force the group past what I call the "idea desert" where the initial and obvious ideas have dried up. We'll keep thinking up new ideas with no judgment until the timer runs out.) Each new idea should be captured on a sticky note without lengthy explanation. After this initial phase has expired, we may revisit some ideas to clarify the specifics.
- Establish the decision filters. Ask the group to remind themselves of the primary decision limitations by which they are bound. (It's important to suspend this, admittedly vital, step until this point as these filters can constrain the creativity in the ideation phase.) Ask the group to prioritize the filters, which are more or less vital to their organizational realities. These filters could be things such as cost, time, skill, technology, legality, geography, or niche considerations specific to that team.
- Group all the ideas to the left of a whiteboard or large landscape flipchart sheet. Draw the first filter line (in Figure 4.2 above the first filter line is "Time") and interrogate all the ideas to establish which ones make it through the decision filter. Move the sticky notes of those that meet the criteria to the next part of the funnel. I like to mark this movement with a pen, simply to help the group keep track of what is occurring.
- Repeat the process with the other filter considerations. With each repetition, fewer ideas should pass through to the next stage.
- Once all the filters have been applied there should be a very small number of ideas left (in Figure 4.2 there is only one idea that met all criteria).

4.4 Wedges

Triangles, depicted as a "rising" or "falling" wedge, can also show a narrative of how an idea or product or behavior can take over or die out. Imagine a plot of proportional smartphone ownership increasing over time. In the early 1990s, when the first smart-phones were introduced, no one owned one—0%. Nowadays the market is saturated and nearly every adult owns at least one—100%. It would be relatively easy, using a wedge diagram, to show the phases of this journey towards saturation and identify the propor-tion of early adopters (first 5%), secondary adopters (the next, say, 20%), reluctant adop-ters (the next 50%), and semi-Luddites (everyone else, including people like me). Such graphic clarification is useful, in our experience, with groups examining organizational change projects. Instead of smartphone ownership, the wedge could depict flexible work-ing patterns, or environmentally-friendly activity (recycling behavior), or compliance with certain professional norms for example. For a facilitator, this depiction of phased increase or decrease (showing the effects of the significant few on the trivial many through time) can be very useful.

What can be even more useful is to use "interlocking wedges" (see Duncan 2013) to show the interconnectedness between two elements; as one element increases, its coun-terpart decreases. The two triangular wedges, one ascending and one descending, com-bine to form a rectangle or square (as shown in Figure 4.3 below), with the two wedges sharing the bisecting diagonal. Probably the most famous example of the interlocking

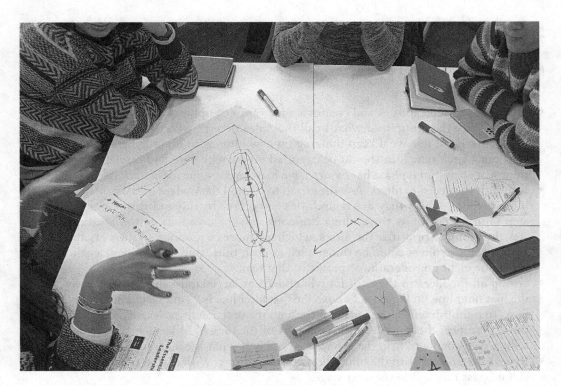

Figure 4.3 Interlocking wedges form the basis of a group conversation.

wedge diagram is the Authority/Freedom Leadership style model, usually called the Tannenbaum Schmidt Model—(see Tannenbaum, R and Schmidt, W 1958). In this framework the authority displayed by a leader is depicted in one wedge, whilst the freedom of followers to act independently is shown in the other. The higher the authority, the lower the freedom.

I use this model frequently with emerging leaders to help them reflect on their leadership style and that of their line managers. I ask them to mark onto the bisecting diagonal their preferred site of leadership style (in Figure 4.3, a dot on the line) as well as their flexible range of behavioral style (in Figure 4.3 the ovals on the line), as well as arrows to indicate how their style might change over time with a team. They then compare and discuss the advantages, disadvantages and situational and cultural appropriateness of given behaviors.

The graphical interlocking wedge approach can also be used with any issues around "balance" in the workplace. For instance, as well as the authority/freedom debate, I find it productive to use the interlocking wedges when facilitating conversations around work/life balance and project quality/quantity.

Ultimately, triangles are useful tools to use when depicting relationships, hierarchies, trends, and balances. However, when I look through my notebooks and photo-records of sessions I have led and facilitated, it is the next shape form that I use the most—the quadrilateral or square.

4.5 Squares (or more likely, Rectangles)

If you've read this far then I guarantee that at some point in the last month or two you'll have drawn a 2x2 matrix on a flipchart or PowerPoint slide. You might even have used them to collate sticky notes from workshop delegates or students. Matrix models (especially 2x2 grids) are so ubiquitous we won't even bother with an illustration. This ubiquity does not, however, reduce their value. The simplicity of plotting two different facets of professional concern against each other and showing the distinct zones created by four possible combinations of low/low, low/high, high/low and high/high can be hugely illustrative. Common 2x2 matrix frameworks include Urgency v Importance (sometimes called the Eisenhower Box), Cost v Value, Effort v Impact, the "Boston Square" or market growth v market share matrix (see Stern and Deimler 2006) and the "Hersey Blanchard" model of situational leadership that plots leadership focus on task against a focus on developing a relationship (originally Hersey and Blanchard 1969). Another version of the 2x2 that can be found on flipcharts around the world is, of course, the SWOT grid (Strengths, Weaknesses, Opportunities, Threats) and its accompanying next step, the TOWS grid (where the four initial elements of the SWOT grid are cross-referenced (SO, ST, WO, and WT) to provide strategic insight.

So, how might we as facilitators go beyond this "seen it before" format—however valuable it might be? One really interesting way that squares (or, more likely, rectangles—since conventional paper formatting tends not to be square) can be used via the mechanism of paper folding; not folding in the sense of origami, but using the characteristics of a blank sheet of paper (two sided and easily foldable on horizontal and vertical axes) to provide structure for learners and delegates.

To illustrate, take a standard piece of A4 paper (or indeed any paper) and fold in in half and in half again. This has divided the space into four equal shapes (and, when the paper is flipped over, another four on the reverse). Using both sides of the page is not a technique that

is often used, but folding the page creates a portability to the finished graphical capture (i.e. it will fit into someone's pocket). Drawing on both sides of the page also creates a visually contrasting illustration of, for example, the good/bad, past/present, current/future or advantages/disadvantages of a debate or plan. This approach requires the facilitator or tutor to formulate and then ask a series of eight questions, each of which provide a stimulus for a very rapid sketch; each sketch should take no longer than 30–60 seconds, so the whole exercise takes between four and eight minutes. After each question the paper is flipped and a sketch is created in the box on the reverse of the page—a diagrammatized version, which provides prompts to help an individual think about their professional development—is shown below.

1. What PROFES-SIONAL strengths and skills do I bring to this role? (Flip to Q2)	3. What PERSONAL strengths do I bring to this role? (Flip to Q4)	4. Which PERSONAL strengths and qualities do I need to develop? (Flip to Q5)	2. What PRO-FESSSIONAL strengths and skills do I need to develop? (Flip to Q3)
5. Who are my champions, sponsors, mentors and allies? (Flip to Q6)	7. What help do I need to achieve my developmental goals? (Flip to Q8)	8. How will I work towards improving my developmental areas over the next X months? (Finish)	6. Where will I find new sponsors, champions and supporters to help me develop? (Flip to Q7)
Front side of paper		Back side of paper	

These questions and the graphical responses that follow can then be discussed and interrogated and annotated if required. If you're feeling very creative, the same approach could be used to make a folded paper "fortune teller" as beloved by children in playgrounds all over the world.

We'll explore folding and three dimensions later in the book, but regulating space on the page through a fold is surprisingly powerful. Moreover, people, unless they are artistically gifted, will innately want to "draw small" since smaller drawings can't be seen and judged by others. Breaking the page down specially regulates and almost encourages this desire and, in doing so, creates a far "neater" end product. This neatness and the foldable portability encourages people to keep the folded drawing as an aide memoire that they can use in the future. This regulated creativity through dividing the page up by folding is shown in Figure 4.4.

Regardless of the mechanism for dividing a rectangular sheet into smaller boxes—either folding or a drawn line—the notion of compartmentalizing a space into smaller areas to create zones in which course delegates, students, or coaching clients can depict neat graphical captures is a hugely transferable one. These zones do not have to be quadrilateral, though—they usually are simply because the initial paper is rectangular and mirror folds are easiest to achieve.

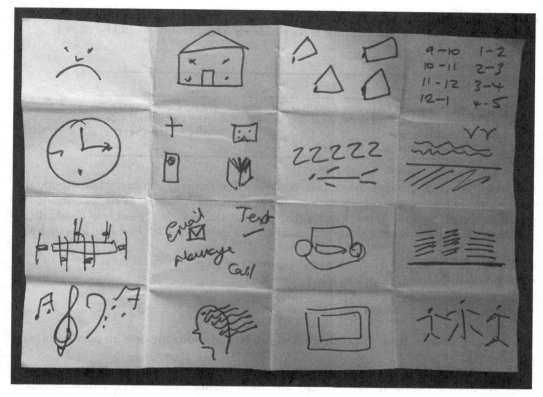

Figure 4.4 Regulated page structure through folding

4.6 Boxed Comparisons

A challenge that we as facilitators and coaches come across fairly frequently is a group or individual who has no clear direction of travel, and perhaps only knows that what they have is somewhat broken or sub-optimal—i.e. "I don't know what we want, but it isn't this." Capturing the reality of a situation, process, or environment in graphical form can act as a powerful stimulus to help shape a future course of corrective action. To this end, a core tool that I use again and again is to ask groups to describe and "swim around in" the discomfort of their current reality. This process helps to amplify the impetus for them to change their behavior to achieve their desired future goals. I then move them towards creating a graphical comparison to both highlight their world in all its messiness as well as show how it could be improved. This is particularly useful in organizational change programmes or when helping a team or individual to change behavior or operational protocols.

The process to facilitate this comparison is very simple indeed. Firstly, take a large sheet of paper (anything from A4 upwards—though the bigger the better) and fold it in half (or bisect it with a line). Then ask for individuals, subteams, or full groups to create a drawing on *one half* of the paper to represent a current reality. (This first stage, of capturing the reality, can even be done in preparation before an away-day or workshop.) This initial stage doesn't have to revolve around what is broken or the negative side of reality—however, the

reason for any kind of development intervention, training programme, or away-day is often because things are not quite working as they need to. This "reality" could be one of:

Table 4.1

Actuality (Examples)	
As things are (actuality / reality) How this new team / system etc. works What is broken? What is getting in the way?	(Ensure blank space on the right-hand side of the folded sheet)

Following this initial drawing the graphic can be used to facilitate a conversation around the reality of the individual or group's situation. Simple, open, coach-like questions (focusing on the practical "what?" and the "how?" rather than the past-facing "why?") can help to add detail and draw out insight from the group or individual. For example, coach-like questions such as:

- So, specifically what does that (drawn) element represent?
- What effect does that (e.g.) block have in reality?
- What are the ramifications of that?
- Where does the process get stuck the most?

The resultant insights from this conversation can be added directly or with post-it notes to the drawing.

A variation on this phase of the exercise is to ask individuals in a team to pre-prepare a single A4 drawing of the reality of things and then, during the session, use these to create a composite illustrative group "jigsaw" collage to open discussions and then stimulate a conversation to create a composite image of a desired shared future direction.

In the second phase, the group or individual are asked to use their drawing and insights to create a comparative illustration that shows the graphical antithesis. This antithesis, using the examples from above, might be:

Table 4.2

Actuality (Examples)	Desired (Examples)
As things are (actuality / reality) How this new team / system etc. works What is broken? What is getting in the way?	As we would like them to be How it COULD work If it was working perfectly If blocks were removed

The resultant image from the second phase of the process frequently (though not always) uses the metaphors, glyphs or icons from the first phase—as illustrated below in Figure 4.5.

The second half of the drawing is often derived much more quickly than the first—and (unless the initial drawer has spent much preparation time or is a talented artist) is also likely to be of higher graphical quality. This is simply because the second part of the drawing uses elements of the first (in Figure 4.5 next page, the conveyer belt and sorting of tasks were simply re-used metaphors). As previously, the "finished" drawing can be interrogated and augmented with coach-like questions to allow the group/individual to start creating a process to prioritize and solve the issues highlighted from the graphic.

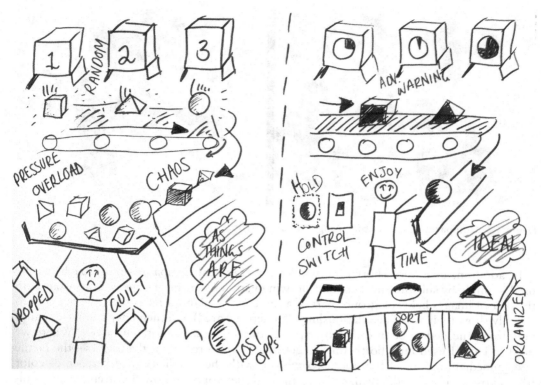

Figure 4.5 A bisected rectangle creates space for an "As Things Are vs Ideal" comparison drawing

This graphically comparative methodology can be used in all manner of facilitative or coaching scenarios. For instance you may wish to elicit a comparison between:

- Before and after
- Actual and ideal
- Positives and negatives
- Pros and Cons
- Drivers and Blockers

Graphical comparisons are not a novel concept. Back in the middle of the twentieth century, Kurt Lewin (Lewin 1951) developed the idea of Forcefield Analysis to illustrate the driving and resisting forces affecting social and organizational change, and this tool has been widely used as a managerial and strategic leadership illustrative tool by development planners ever since (see, for instance, Thomas 1985). Graphical comparisons (especially framed in "sensible" square boxes!) present a way of using drawing in a way that is more immediately "credible" or "professional" and so less risky with more reserved or unplayful groups. Lewin's work simply uses different-sized arrows to show the driving and resisting forces on a line representing the status quo; the larger the arrow, the stronger the force. This style of very simple graphical depiction works superbly using the whiteboard function in collaborative software such as Zoom.

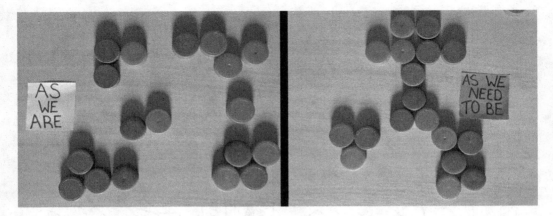

Figure 4.6 Comparative depictions using milk bottle tops

In addition, in a very short time window, a graphical comparative approach can be used—simply by substituting a creative drawing with movement of objects. For instance, in the pair of images below, a group (part of a three-way collaborative project) were asked to initially show their working relationships ("Where we are") and then later compare that to how things needed to be in order to help the collaboration be more effective ("Where we need to be"). I used milk bottle tops to get the group to represent themselves—the tactile and immediate nature of the objects combined with the simplicity of difference of color (they chose who was red, green, or blue) allowed the group to show the strengths and failings of their setup in under ten minutes. (An explanation of why I happened to have dozens

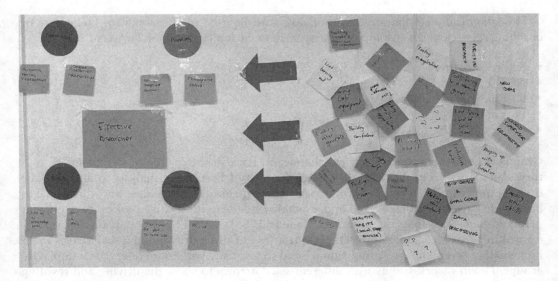

Figure 4.7 Clutter (right) to structured order (left); graphical comparison of the "reality" and the "desired better future."

of milk tops laying around can be found in the book *Playing With Purpose* [Hutchinson and Lawrence 2011]).

As always, the value in this process is not the final depiction or piece of artwork—what is important is the conversation and interrogation that accompany it. The simplicity of comparing two graphical depictions to show a desired changed process means that for a creative facilitator there are almost infinite possibilities in asking a group to use objects (stones and lines on a beach/sticky notes/drinking straws etc.) to "show" a process, a structure, or a relationship. The formula for this approach is remarkably consistent. Divide a space into two equal (usually square) areas; then ask the group to populate the first with the "reality" and then the second with a "desired better future" (Figure 4.7).

4.7 The Square as a Frame—Storyboarding

As well as being a model, a grid or a space for comparators, a square can also act as a frame—or to be more precise, a frame within a narrative. If you've ever seen a cartoon strip or a graphic novel, you'll understand the way in which moments in time are captured as still images, placed within discrete frames and stitched together to create a cogent and apparently seamless story. For a graphic facilitator, the possibilities of creating stories, maps, and timelines are enormous and are explored at length in Chapter 5. However, what is really useful about using squares (or rectangles) as a way of framing an image that sits as part of a story is that the boundary of the shape gives workshop participants, who are not professional artists (indeed some struggle with stick people), permission to make mistakes. If a drawing is a connected contribution to a large mural, one "mistake" can ruin the whole collective effort, meaning that participants may be far more reluctant to draw. Providing the group with large sticky notes or simply A5 pieces of paper means that any image, once created, can be redrawn or moved without corrupting the rest of the work.

Storyboarding is a technique used in filmmaking to help visualize what shots are needed and the sequence in which they are needed. They usually start out in a very rough and ready fashion, which is perfect for workshop delegates who a) perhaps can't draw, b) perhaps lack a vision of a final emerging conversation, and c) lack time. I use storyboarding with groups to help them to tell "critical stories" from their professional environment. Incidentally, a work that helped my thinking enormously in this area is Matt Madden's book *99 Ways to Tell a Story*, which takes a very simple everyday occurrence and tells it as a different graphical story in ninety-nine ways. Some depictions are complex illustrations and beautifully executed, but some are graphically basic and simply clever interpretations of the scene and made me think deeply about how I could use graphical "critical stories" in my facilitation work.

As with this book, before using a tool or approach always consider its purpose—ask yourself what does the group need and what learning or realization are you hoping they gain. Critical stories and storyboarding can, amongst myriad possibilities, be useful to help groups to:

- Understand professional development and the journey of progression
- Illustrate difficult workplace situations such as conflict
- Show "a day in the life of" as a conduit to illuminating workplace culture
- Highlight the pivotal moments in a project or new endeavor (especially successes and failures)

Figure 4.8 Storyboard of combined "critical incidents"—the uncertainty of this group highlighted by the "Eureka" and "Disaster" possibility at the half-way point

Typically, I ask the individuals in a group to think of a small handful (between two and five) incidents or episodes that are critical to the topic under discussion. You may need to steer a little here, for instance—ask the groups to consider "the high points" or the "low points" or the "moments that stuck in their individual memories." I ask them to write these ideas down individually, primarily so that they don't get lost or ignored in later discussions. I then ask the group to share their pivotal moments in a sentence or two each. If the group members are new to each other (for instance delegates on a development programme) this step in the process is vital, but if they are an existing team they'll already have a collective memory of certain events (i.e. "Oh, that time when Sam deleted all the company records?!").

At this point, I introduce the idea of storyboarding and then ask the group to combine their incidents (there's usually overlap) and create a storyboard using a number of frames to graphically tell a story of the project, process, journey, company evolution, or whatever is required facilitatively.

Limiting the number of "frames" (usually between six and twelve depending upon time) helps the group to collate their stories or metaphors and make sure that they have enough space to work and discuss. A simple way to limit the number of frames is to limit the number of large sticky notes or pieces of blank A5 paper that the group has access to—but tell them they can request more if needed; a safety feature that permits mistakes. Depending on the group you could insist that everyone draws or you may opt to leave it to the discretion of the group. I do however insist that the only words used are speech or thought bubbles, which forces groups not to simply write their critical incidents out in prose. Once the incidents have been combined into a graphical storyboard (see Figure 4.8), then ask the group to label the frames (which helps the story to be translated or recalled at a later date).

At this point you could decide to simply ask coach-like facilitative questions ("What was it like in the 'Disaster' frame?," "What did you learn about each other in Frame Three?," "What does this story help you to understand?" etc.), but—depending on the purpose of the activity—you might continue the exercise by asking the group to do one of a number of things, such as:

- Ask the group to "view it from another perspective" (i.e. how would a different project stakeholder view the journey)
- Analyze their story and augment it with sticky notes identifying the "lessons learned"
- Distribute more paper or sticky notes and ask them to "continue the story" into the future (e.g. what are the critical situations that they see on the horizon?).

Storyboarding like this doesn't have to take a great deal of time—the whole process above (prior to extensions) takes perhaps as little as 30–40 minutes to complete. However, creating visual stories can be extended and perhaps even made into the centerpiece for a longer, more immersive programme. For example, given that the vast majority of people have a high-resolution digital camera in their pocket, and most people know how to caption photos or edit them to add speech or thought bubbles, creating a storyboard with photographs taken to recreate a project, journey or event is certainly technically possible—albeit time-consuming. To this end, the potential of groups taking photos (either for printing, projection, or sharing through an online session) or using images that people have on their phones is really rich. For example, a few possible photographic activities might include asking groups to:

- Create a photo-casebook "Tabloid Agony Aunt" story of a problem that is faced by the organization or teams within it;
- Create a virtual (or with access to a printer, real) photo-board of the values that *really* define their organization;
- Create a two-minute image-only montage (set to music) slideshow of their organization at its best and at its worst;
- Create a print advert to highlight the great work that their department does.

As always here, it is the process that the group uses, and the conversation that this process elicits, that provides organizational value—not the finished work. We'll return to mixed media in Chapter 11—"Mixing and Matching."

Regardless of the medium used, whether marker pen or digital photography, it must be remembered that the combination of capturing critical incidents and converting them to pictures and then combining those to create a cogent storyboard is, for some groups, hard work indeed. Perhaps the biggest personal lesson here for me was to rein in my expectations of the artistic quality of the finished product. For all of the times in this book that we repeat the notion that the process is more important than the product, it's still intrinsically far more satisfying when a group creates something aesthetically pleasing. An example that springs to mind concerns a group who created eight captioned frames in a story—each frame with nothing more than a rudimentary smiley, frowny, or perplexed face to illustrate a feeling at each step. Though I was initially slightly irked by this questionable penmanship and lack of effort towards creativity, the conversation that transpired around their depicted feelings was actually very rich. To that end, there are some beautiful examples of how complex feelings can be evoked with simply-drawn icons in the book *A Toolkit for Your Emotions* by the Clinical Psychologist Emma Hepburn.

Essentially, with storyboarding, lower your expectations but make it easy—by using discrete removable frames—for a group to commit an idea to paper without "spoiling" the rest of their story.

4.8 More Than Quadrilaterals—Hexagons and Beyond

Many models in the twin fields of business strategy and personal effectiveness literature are written around numbers; two that come to mind immediately are The McKinsey 7S model (see for example Waterman 1982) and the Seven Habits of Highly Effective People (Covey 2020). As such, pentagons, hexagons, and heptagons can act as immediately recognisable frameworks around which groups can construct or capture their ideas. Moreover, you may wish to use a large, blank, shaped framework (such as the pentagon in the center of Figure 4.9 below) and then fill in details and content around it throughout the duration of an event or programme. This framed and regulated style of content capture works far better in a training or workshop environment where the person at the front of the room has a clear idea of the structure of the day, and what individual content elements fit where on the model (in the case of Figure 4.9, the training course was constructed around five components—hence the pentagon).

Later in Chapter 7 we explore circular "radar" plots, but a model conceived around a pentagon, hexagon, or heptagon can form the boundary perimeter and radii dividers to allow quick comparisons and discussions. In the example below in Figure 4.10, middle managers in an organization were asked to rate the importance of different elements of their job role. Placing differently colored sticky dots onto a pre-drawn framework allowed all participants in a group to contribute very quickly to a conversation, and their differences and developmental areas could be accessed almost immediately. Moreover, placing dots (as opposed to words or even lines) allowed complete anonymity, meaning that people could be included safely even into difficult conversations.

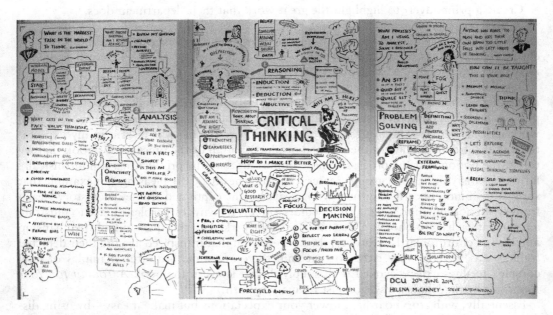

Figure 4.9 Pentagonal scaffold (center) around which training content was added over the course of a one-day workshop

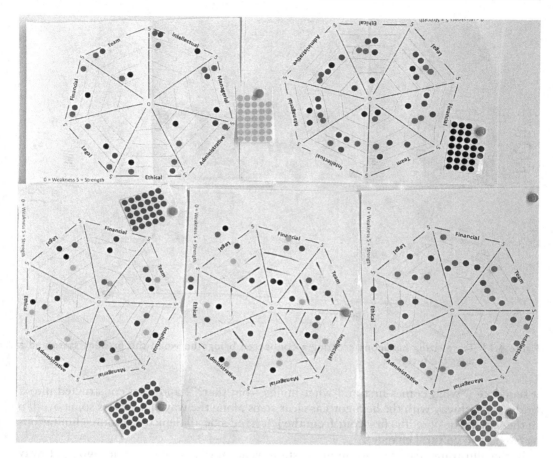

Figure 4.10 Dots placed onto a heptagonal model allowing immediate comparisons between group members

If you're paying attention, you'll notice that many of the illustrations in this book show semi-collaged models and frameworks created by groups using pre-cut shapes. Some are regularly-sided shapes (squares and hexagons), some of these pre-cuts are circles and some are arrows. (To keep the stockpile of shapes full, I can often be found, of an evening, with scissors and colored paper in hand. Time simply flies by....) An advantage that all regular-sided shapes have is that they fit against each other snugly on at least one side, which allows the creation of graphical "roadways," "bridges," and other metaphorical constructions. Participants can draw different elements of a conversation onto different shapes and then these can, in some form, fit together.

For example, Figure 4.11 shows a facsimile (for confidentiality reasons) of a graphic bridge formed from individual icons drawn onto separate shapes. The group here were split into three subteams, and each were given six hexagons. They were asked to identify six "areas of cultural improvement" to help them to take their organization from where they currently are to a future "better" state. These eighteen hexagons were then combined into

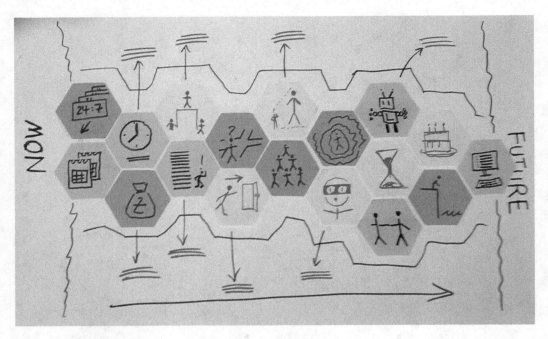

Figure 4.11 Tessellating hexagons creating a connected bridge between the present state and a possible future.

a sequence ("what comes first and what builds from that?") and then constructed into a bridge or pathway with the hexagons as clear steps along the way. There was some overlap in these hexagons (i.e. the first four from the left hand side all depicted resource limitations as barriers to cultural change).

In this illustrated case the group in question went on to annotate the hexagon pathway with specifics concerning the action plans of "how" and "when." These annotations have been removed from the facsimile and replaced with the sets of horizontal lines above and below the "bridge."

Another illustration of the power of tessellation and the connectiveness of shapes like triangles, squares, and, in this case, hexagons is an exercise that I call, "dominoes." It's massively easy to run and works every single time—but it does require a large number (at least a couple per participant) of pre-cut shapes. These shapes need to be about 15–20cms across, to give people ample space to draw and to ensure that the final result is visible and photographable.

I typically start this process by breaking the whole group (either a facilitated or training event—the approach works for either) into small subgroups (twos or threes) and asking them to select a few (about three is ideal) hexagons. I then give them about ten minutes to identify three ideas or answers to a question. In the example illustrated in Figure 4.12, the discussion topic was "good practice in feedback," but could equally be any element of professional practice or organisational component. I ask that the group draw their ideas onto the hexagons using no words. (I also insist that they draw big enough to fill the shape.)

The drawing, as we've illustrated repeatedly in this book, helps the groups to create resonant metaphors, and the conversation about how they will capture complexity in a simple

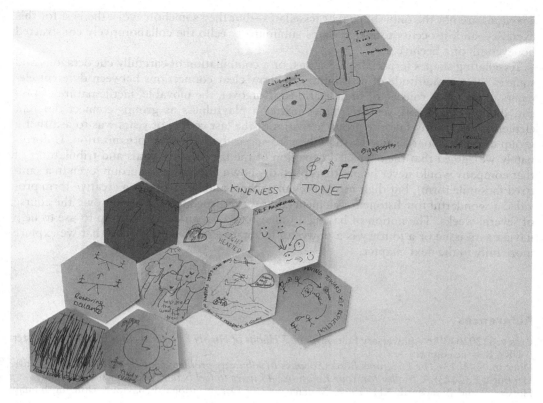

Figure 4.12 Hexagonal connected ideas—or "dominos."

graphic is a powerful memory aid. Once the drawing phase is complete, I then, and only then, ask that the groups label their drawings in a word or two. This labeling helps other groups identify the concepts at a later date.

I then bring the whole group together and ask for a volunteer to lead and stick one of their hexagonal dominos onto the centre of a whiteboard or blank wall. (In a room without wall space or board, a table or even the floor would work too.) This idea is explained by the contributing group—and often their drawing or metaphor is appreciated by the whole group.

I then ask another group for an answer or idea connected to the first. This second connected idea is stuck on the board adjacent to the first hexagon—hence the "domino" label for the activity. Ideas are placed on the board until all groups have exhausted all of their tiles. An illustrated tile can connect to two, or three, other ideas—and as many as six (as in the case of the "light hearted" balloons and heart drawing in Figure 4.12). This helps the group identify what is central and unifying in their discussions. Sometimes, an idea doesn't properly connect—as in the case of the hexagon on the far right. With these, I suggest that the image is placed in proximity to the central mass of ideas, but not tessellating.

Many of the exercises we've outlined in this book need some facilitative skill to help the group extract value from them—but groups seem to intuitively understand the intent and process behind "dominos" and I often say almost nothing at all in review. Of course,

hexagons are not the only shape that tessellates—but they somehow work the best for this exercise—and, it occurs to me, perhaps subliminally echo the collaboratively constructed honeycomb of a beehive.

Tessellating shapes (especially hexagons, or a combination of carefully cut octagons and squares) give a multitude of possibilities to show clear connections between different elements of groups, projects, or organizations. Moreover, the movable, tactile nature of pre-cut, differently-colored, regular shapes invites a playfulness as groups connect different elements. One of my favorite group activities of the last couple of years was to ask that a group created a board game to show how to succeed within their organization. Unfortunately we agreed that their finished depiction of the labyrinthine trials and tribulations of that company would never be photographed or shown outside of the group (even in a sanitized facsimile form), but their use of pre-cut squares and hexagons in a creative form provided a wonderful touchstone for elements that we returned to many times over the course of several weeks. The notion of having a touchstone or a guide for a group to use to help navigate an issue or a journey is a powerful facilitative tool—and it's one that we explore more fully in the next chapter.

<div align="center">*</div>

References

Covey, S (2020 (30th Anniversary Edition)) *The 7 Habits of Highly Effective People* (Simon & Schuster UK); Reissue edition

Duncan, K (2013) *The Diagrams Book: 50 ways to solve any problem visually* (LID Publishing Ltd)

Hepburn, E (2023) *A Toolkit for Your Emotions: 45 ways to feel better* (Greenfinch Publishing)

Hersey, P and Blanchard, KH (1969) Management of Organizational Behaviour: Utilizing human resources (Prentice Hall)

Lencioni, P (2005) *The Five Dysfunctions of a Team* (Jossey Bass)

Lewin, K (1951). *Field Theory in Social Science: Selected theoretical papers* (Harper Torch Books).

Madden, M (2006) *99 Ways to Tell a Story: Exercises in style* (Jonathan Cape)

Maslow, AH (1943) A Theory of Human Motivation. *Psychological Review*, 50(4).

Stern, CW and Deimler, MS (2006) *The Boston Consulting Group on Strategy: Classic concepts and new perspectives*, 2nd Edition (John Wiley & Sons)

Tannenbaum, R and Schmidt, W (1958) How to choose a leadership pattern. *Harvard Business Review*, 36, 95–101.

Thomas, J. (1985) Force field analysis: A new way to evaluate your strategy. *Long Range Planning Volume*, 18(6), 54–59

Waterman, R (1982) The seven elements of strategic fit. *Journal of Business Strategy*, 3, 68–72.

Wheelwright. SC and Clark, KB (1992), *Revolutionizing Product Development* (The Free Press)

Chapter 5

Maps and Mapping

Alfred Korzybski, the Polish-American thinker who developed the field of general semantics, once remarked that "the map is not the territory." By this he meant that the abstraction that we create or derive from something is not that thing itself. Some maps, such as Google Street View, aim to be as realistic as possible. Others—like a US Geological Survey or Ordnance Survey "Landranger"—are stylized and scaled but accurate enough that you can find your way through an area unknown to you. Some—for example Harry Beck's iconic London Underground map of the tube network—are heavily stylized and focus more on pragmatic simplicity and useability than on geographical accuracy. But when it comes to the reality that is being mapped, geography is not the only "territory" that matters. Time, emotion, relationships, structures, strategy, and many other facets of professional life can all be mapped and charted in ways that vary in realness and stylization.

I (Steve) first realized the power of mapping as an idea to help groups when I was running a training course and using sticky notes to cluster questions from a large group. I decided that in order to address all of the group's questions fully, it made sense to draw a graphical map line of the agenda for the course and then place the notes on the line at the point enroute that these issues would be addressed. I was then able to sketch models and ideas and diagrams around the line, working from left to right. The feedback from the group was unilaterally positive, and so this approach became my "go to" way of teaching and training for a while (a later example can be seen in Figure 5.1 next page).

This process of capturing an intellectual or process journey through time is rendered simpler for a group if they have shared experiences of the events they are describing. As a facilitator there are abundant possibilities inherent in using cartography to help groups to explore where they have been, where they are, and where they are headed. This chapter explores just some of these possibilities.

5.1 Cartographic Conversations

Before we expand on the translational maps that can act as facilitative tools, let's start with a basic icebreaker that we both use with groups to get them talking and making marks on the page. It requires a small amount of set-up but is quick and powerful and can be extended in a large number of ways.

Provide the group with a blank basic outlined map of the world. It doesn't need to be accurate, nor does it need to show every individual country—the continental land masses and major islands are fine. There are many of these available online. If you have a large number of participants or students you may wish to have duplicate copies of the map and break the

DOI: 10.4324/9781003410577-9

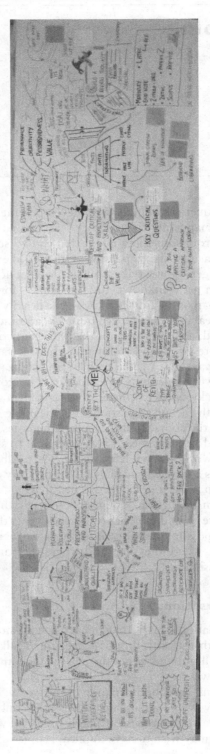

Figure 5.1 A combination graphic of sticky note incidents and questions from a training group interwoven with a diagrammatized map-line running from left to right.

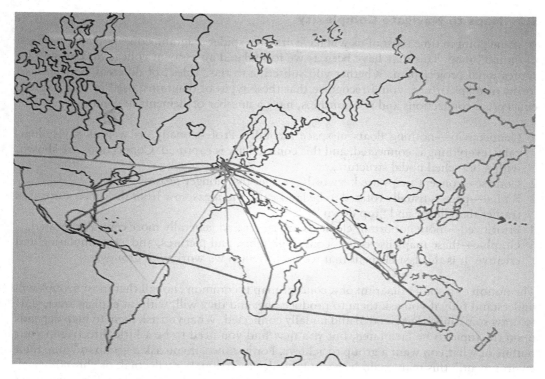

Figure 5.2 Graphical geography as a conduit to conversations on culture

cohort into groups of six to eight. In Figure 5.2 you can see the style of outline to which we are referring. This large outline was drawn onto a classroom whiteboard before delegates arrived into the room. If you're wondering about how this whiteboard map is accurate, the outline was achieved by using the classroom data projector and beaming the image onto the whiteboard and tracing the outline—a useful transferable tip for anyone wanting a neat centerpiece for a whiteboard. (After I'd done this, it reflectively occurred to me that I could simply have just beamed the image and forgone the tracing...)

As the session starts I simply ask the group to mark on, and speak a little about, where they had grown up, and the furthest North, South, East, and West they had traveled from that point. This provokes interest, engagement, and conversation in itself, but (in the case illustrated here) we then set about on the topic of the session about cultural norms and what education and expectation was like from the group's varied perspectives. The opening map allowed easy conversational segues between delegates as we talked about how culture might differ in diverse parts of the planet.

From the same starting point of a blank atlas projection (or screenshare on an online session or web meeting), it is easy to ask groups to share things such as the most memorable place they've been to or the place they'd most like to visit. The value primarily is that everyone talks and holds the pen immediately, but with a little thought the icebreaker can easily be extended to dovetail with the topic under consideration in more detail throughout the rest of the session.

5.2 Maps to Navigate Complexity

At some point in time most of us will have drawn a spider diagram, concept map, or a form of "mind" map. This may have been as we formulated an essay at college, or conceived a professional project plan. Whether you subscribe to the "rules" of different trademarked forms of maps or not, you'll recognize that these types of diagrams, used to help explore conceptual connections and relationships, have a number of elements in common.

1 Connectivity—nothing floats in space mentally. Professionally, as well as psychologically, everything is connected, and this connectivity is captured. Connections are shown, with a branched nodal structure.
2 Concise—concept maps use keywords—rather than longer prose.
3 Radial—page is usually rotated to be landscape and ideas flow from the center outwards (rather than linear and "top down").
4 Prioritized—more important elements are larger and generally more centrally located.
5 Graphic—these maps use color, icons, highlights, and pictures, and are stimulating and creative. It is this last element that we try for when we work with groups.

The notion of a spider diagram or a concept map is common enough that most groups will understand fully if you ask them to produce one, and they will, without explicit steer, start to draw something that is radial and nodally connected. What you ask them to map depends upon the topic to be facilitated, but you may find you need to be a little directive in your outline of what you want a group to achieve. For instance, if you ask a group to "map their environment," this map could be geographical, professional, intellectual, or chronological. If you wish to tap into their creative thinking you may need to provide colored pens and various stationery, or you may need to specify certain rules such as "using no words"—as in the case illustrated in Figure 5.3.

As with all the tools we visit in this book, it is important for the facilitator to consider the purpose of their intervention and select suitable approaches that will ensure a valuable group process and a productive, though not fully predefined, end product. Perhaps a fundamental decision point when choosing an appropriate tool might be whether the group with whom you are working is trying to explore something that is essentially structural or wholly creative—or both. Graphical mapping can be used for both of these options, but the *way* that a facilitator uses them might differ enormously.

Facilitative steer can help a group hugely as they start to draw their concept maps. For instance, rather than hand the group a pen, you might want to give them one minute of individual thinking about the types of issues under discussion. You may wish to extend this thought to a brief "no drawing" period of conversation, where the group might agree that there are (say) five main areas to address—and thus realize that what design they decide upon will be constructed around five (at least) main nodes. It is also worth remembering here that if you search online for the phrase "mind map" the images you find are neat and, in some cases, artistically beautiful. I've never seen a group produce something as neat or aesthetically pleasing as these examples. However, a) some small amount of thought before the group draws will help to create some structural neatness, and b) it is the process of creation that is useful to the group, not the finished artwork. Sometimes, as a facilitator or tutor, you'll need to remind the group that messiness is not a bad thing and a concept map that

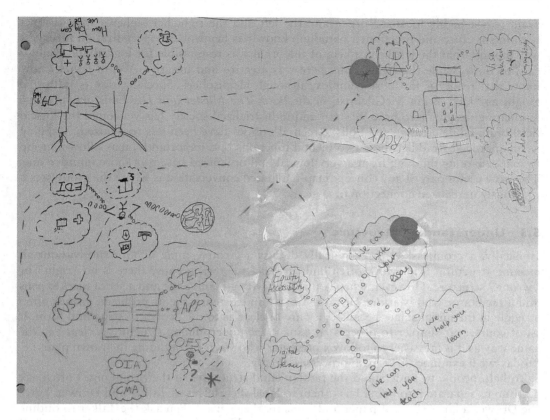

Figure 5.3 A co-created group concept map, showing the interconnectivity of different issues within a professional environment

is closer in appearance to a bowl of spaghetti than to a spreadsheet is potentially far more useful—since neat linear notes and bullet points often hide a world of uncertainty. Or, more succinctly, known unknowns are better than unknown unknowns.

Furthermore, as the group starts to draw a co-created concept map, you'll find questions such as:

- How are you going to represent a specific element?
- What is core and what is peripheral?
- What sort of connection is that (logistical, practical, ideological etc.)?
- What *don't* you understand? (i.e. what is unknown to you?)
- Are those elements of equal importance? (Can you show difference in importance graphically?)

Finally here, without delving into the claims of different trademarked brands of mapping packages, it is worth recognizing that this sort of mapmaking activity is recognized in its own right as a way of soliciting complex qualitative data from groups (See Burgess-Allen and Owen-Smith 2010, or Wheeldon and Faubert 2009). It was once believed that the

brain was a highly localized organ and the left and the right hemispheres were distinct both in structure and function; a paradigm known as hemispheric specialization theory. It was thought that the left hemisphere of the brain was responsible for logical and analytical functions, while the right hemisphere was creative and intuitive. We, of course, now know that reality is far more complex, although Hemispheric Specialization is still often taught as "fact"." Ian McGilchrist, in the book *The Master and His Emissary*, presents fascinating insights into how Western and industrialized society has venerated the logical (left) brain while creative and holistic mental utilities have been less recognized. Mapping as an approach straddles these two mental functions but, importantly, may allow a group to manoeuvre its thinking from a very logical and organized base to a more intuitive one. The most useful part of any concept map-facilitated conversation is where the group sees a previously unrealized connection or synergy.

5.3 Understanding Structure

Ironically, a group asked to graphically discuss a creative topic or an issue without an existing structural framework often finds it easier to start, because there is no "right" or "wrong" structure. However, when confronted with a blank page and a set of marker pens and a facilitator who is asking them to "map" an existent issue or problem, groups often struggle in the initial stages because they are unclear as to the "correct" structural form. It is, of course, far simpler to process an issue if the underpinning structure is clear—in the same way as it is far easier to follow a presenter who starts by outlining their own plan (i.e. "today we'll examine three main processes. Firstly,... etc.").

To help people to understand the fundamental structures in their thinking, I often ask a group to separate into pairs. I ask them to label themselves as Talker and Drawer. I give the Drawer a large sheet of paper and some marker pens. I then ask the Talker to outline the problem or issue at hand, its sub-elements, and how they connect. Simultaneously, I ask the Drawer to ask questions to help them give graphical shape to the narrative that the Talker is relaying. This process takes about five to ten minutes. It's important that neither party gets bogged down—either in details or in "doing it right." Speed is of the essence here.

To give an example of what this might look like, Figure 5.4 shows a facsimile of a real structural outline with detail anonymized and removed. It originated from a real conversation about feedback from system users that, broadly speaking, went as follows:

"Well, I think our problem is because of how Factor X and Factor Y coexist. We know that factor X has three major elements within it (1, 2, and 3) and, of these, it's number 1 that has the biggest effect on Factor Y—probably because of A, B, and C.

Of course, there's a block in the system (Q) which is made up of, we think, S, T, and U. It's Q that causes all the feedback issues we've been getting from [system users]."

After the allocated time elapses, ask the Talker to review the Drawer's diagram and edit and annotate it where appropriate. Incidentally, the approach outlined above also works really well with project students to help them to help each other in formulating project designs or dissertation plans. Indeed, this is how I first used it to productive effect.

Following this paired exercise, bring the whole group back together and ask the pairings to show their efforts. Ask the group to notice commonalities, differences, themes, and

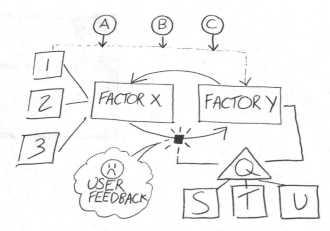

Figure 5.4 Facsimile of a (tidied and anonymized) structural map drawn in response to problem description

structural similarities. These elements can then be used in helping the group as a whole to create a "more accurate" base of a structural map.

However, as already mentioned, structural or intellectual maps cover just a small number of ways that the facilitator might use a mapping process to help a group to move forwards.

5.4 Mapping a Journey

The concept of a "journey" is a notion that seems to have crept into modern-day professional lingo—in the same way that all football clubs now seem to have a "philosophy" of play. Whether this sort of language irks or not, the device of using a journey to graphically explore the challenges and events that employees, students, or course participants may have commonly experienced is a device that always generates interesting results. The most useful thing about the device from a professional facilitative perspective is that the instruction to a group of "map the journey [through employment/career/ qualification etc.]," never requires any caveat or clarification and groups instantly know what is required. Following this simple instruction, groups may then opt for a more chronological timeline-type map, or something altogether more allegorical or Tolkien-esque (the "forest of paperwork," the "swamp of uncertainty") as is comparatively illustrated in Figure 5.5.

Such a graphic mapping exercise can elicit really useful observations and conversations about common difficulties and triumphs that connect a group. The size and scale of the "geographic" features that the group depicts can reveal powerful insights into what their "big issues" are. Moreover, groups very rarely start a map from the start of their recalled journey. Journey-type maps often start with one or two landmarks that stand big in a group's collective professional consciousness. As a facilitator it can pay huge dividends to listen carefully for the moments where all the group members suddenly first share the same memory and collectively translate it into a topographical feature on the page. Such an approach can unlock powerful discussion points for a facilitator or an organizational development professional hoping to instigate, for instance, a change programme or a training needs

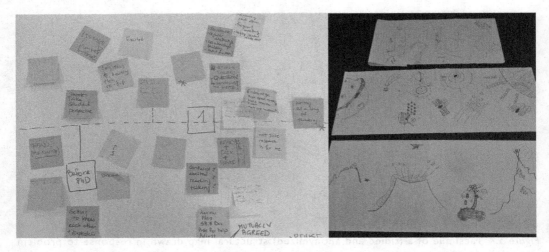

Figure 5.5 Two very different "journey" maps. The left-hand map shows essentially an annotated timeline showing the different events occurring throughout a project duration. The right-hand image shows a highly allegorical depiction of a career journey, complete with metaphorical mountains, volcanos, and interstellar travel.

analysis within an organization. Types of facilitative questions that could be explored from the map might be:

- What were the common challenges?
- What support did you need along the way?
- When and where would support have been most helpful? What support did you get?
- Where would a guide (i.e. a mentor)have been most helpful?
- What formal training would have helped you to (e.g.) climb the "mountain of probation?"
- How would you tackle the journey differently with 20:20 hindsight?
- Looking back, what were the early warning signs for different issues on the map? ("When did you first realise the 'end of year whirlpool?'")

Such a mapped process can also be helpful to share when it comes to manager or supervisor development activities. If managers are aware of the reality (albeit allegorical) of what it means to be a junior employee in the organization, then they can start to identify the early warnings and the relative scale of the trials, tribulations, and motivational highs along the route—and modify their support and challenge behaviors accordingly. Maps shared between different types of employees or between faculty and students can help to create communities that share normative experiences and realize that the road is potentially not easy for anyone. The power of graphical capture here is it facilitates "safer" conversations, between different strata of an organization. The map reflects reality, but is also unreal, making any apportioning of blame or responsibility less raw and thus potentially easier for parties to find common ground.

As an aside, I sometimes use some variety of "map" as a twenty minute to half-hour teamwork or leadership exercise. I give a written brief to the group saying "create a high quality map" specifying what the map should show (a vague brief such as "create a high

quality map of your environment" yields the most interesting results). What the group creates, or their leader instigates, is often fascinating, but the real purpose of the exercise is to see whether they focus on the purpose of the map, who its users might be, and whether they have had a values-based conversation about what "high quality" means. Groups that have an aligned vision and purpose and a shared values set will typically spend less time actually drawing (or measuring, or looking around their locale) but create a far better end product.

5.5 Mapping the Future

A parallel, and often complimentary, way thata graphical mapping approach can be used with groups—especially in leadership development—is as part of what can be referred to as "horizon scanning" or asking people to speculate about what might happen in the future. This future contextual awareness is a priceless professional attribute—but of course it is a highly inexact science since no one knows for certain what the future may hold. A graphical, and thus creative, approach allows groups to raise large and serious issues lightly, with metaphor and allegory; for example, to use my favourite quote from an away-day participant, who looked at her group's future map and pleaded "how the hell do we bridge the Brexit sinkhole of despair?"

Because of the speculative nature of this type of drawing, in our experience groups can take longer to warm to "future drawing" as an exercise and some warm-ups or individual preparation are often required if you want a really engaging exercise and process (See Chapter 2.7 "Getting groups to pick up the pen"). Moreover, if such a future-sight exercise is to work well, it is necessary to give a more well-defined brief than asking a group simply to "map the future." For instance, useful set-up instructions might be something like:

Create a road-atlas to help to navigate the next five years within this professional area

OR

Draw a map of how this organization is to achieve its ten-year plan.

OR

What will this organization look like in twenty-five years' time?

This mapping exercise can be augmented with supplementary addendums such as asking the group to add sticky notes to their map detailing how they'll keep the map up to date, or how they may wish to engage project stakeholders at different stages along the journey. Groups continually surprise us with their ability to take mapping exercises into new directions. For example, Figure 5.6 shows detail from two "organizational roadmaps." The left-hand image shows the labyrinthine confusion that the group identified within the organization. The right image shows a group who created a professional "SatNav map" and then used plastic counters (actually poker chips—which I'd been using for another exercise earlier in the day) as vehicle markers to show how their different projects could navigate the political corridors of power in their organization.

Whether the "finished" map looks like an actual map or not is largely (entirely!) irrelevant. What of course matters is the process of conversation that the exercise encourages and the immediacy of the images and long-lasting metaphors that it creates within a group.

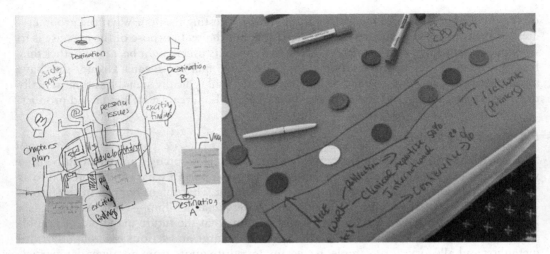

Figure 5.6 Detail from two "organizational roadmaps."

5.6 Mapping an Organization

A phenomenon of professional organizational life that continues to surprise us is just how unaware people are of the connectivity and relationships that are required between organizational teams and departments. For instance, do the sales and design team really know each other well? Do finance and HR have a great deal to do with each other? To what degree do the core elements of the business exist in fairly discrete compartments? Most of the time an organization can function just fine with some low-level knowledge and a hierarchical chart of operations. However, when things go wrong, it is the personal connections between teams and the socialized knowledge that they share that often facilitates a simple solution.

The compartmentalization of organizations was amplified by remote working practices during the COVID pandemic lockdowns—when there were no water coolers or social spaces and all meetings were more formal and somewhat more disjointed. This disjointedness is still a phenomenon within hybrid working environments, where people have a far less "immersive" professional existence, and log on to their computers to simply "do their job" rather than "be at work."

Furthermore, in large organizations or projects (especially interdisciplinary ones), tribalism within discipline teams can result in knowledge silos. If you've ever heard colleagues dismissively referring to other groups within your organization as "they" and your own team as "us" (when the ideal is of course "we"…) then you'll recognize this issue. This disconnect is something that we see a great deal in organizations and institutions where the "core" and "supporting" functions (such as "administration" and "academic" elements of a university) do not always see eye to eye. Getting groups to graphically map their organization in a creative way can be a really useful facilitative tool.

When asked to mentally depict a graphical model of their organization, most professionals will immediately default to a hierarchical model akin to a pyramidical display of king, nobles, and serfs in feudal times past; only with a CEO at the top and not a monarch. The problem with this form of infographic is that it shows nothing of the departmental

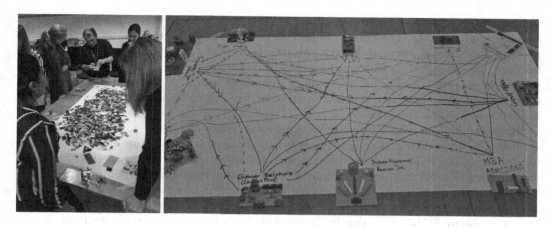

Figure 5.7 An organizational map, created using LEGO® and highlighted with relationship lines.

interconnectivity that is required to allow the organization to actually function. It also does not reveal anything about the strength of any existing synergies or any gaps that exist in the communications between teams or departments. Resolving this problem is, at root, surprisingly simple and powerful. By surrounding a page with different departmental areas, the lines of communication with different areas of the organization can easily be drawn in. While this drawing is occurring, groups will naturally start to have conversations about where these lines of communication and cooperation are strong and weak. In the example in Figure 5.7 groups from different areas of their institute were asked to initially build LEGO® models to represent their function within the organization. LEGO® was used to stimulate guesswork as to what was being represented, since the individual group members did not know each other very well. LEGO® also prevented any temptation to write words or to recreate any aforementioned hierarchical maps. LEGO® is in no way essential for this activity, and a "pen and paper only" version is illustrated in Section 2.3.

Following the LEGO building phase, the illustrative models were placed at the edge of a large sheet of paper and the group was invited to draw in cross-departmental relationships onto the page. At any time, there were three or four conversations occurring around the table, and multiple lines were drawn simultaneously.

In order to enhance this process and to derive the most benefit from it, the group were presented with a number of facilitative questions and suggestions, such as:

- Where are the strong relationships? Draw in and mark these relationships with thicker lines or symbols.
- Where are the weaker relationships? Mark these relationships with thinner or dotted lines.
- Where are the strong structural relationships? Show these distinctively.
- Where are the strong personal relationships? Differentiate these.
- Where are the gaps?
- Where are the priority areas to foster better connections?

The final phase, if this process is going to reveal actual productive value, is to help the group engage in a process of action planning; if the map is the "what?" and the conversations

around the creation of the connective lines are the "so what?," then there absolutely must be a "now what?" relating to future action. As such, either using sticky notes or annotating the map directly, it is essential that the group considers how they will strengthen these connections, who they need to converse with, how they need to formalize interconnectivity, and who will take responsibility for this. Failure to build in time to action plan properly means that the group may have had fun, had interesting conversations, and created an interesting artefact—but ultimately no more.

Organizational (or within a specific working team) mapping is hugely versatile and can be combined and tweaked in myriad ways and with different materials. Just a few days before writing this chapter I ran an away-day where a team was asked to depict their job roles with colored pens on the round paper drinks coasters that the venue had helpfully provided. The connective relationships were depicted with a handful of wooden coffee stirrers that I liberated from the conference centre refreshment station. Although I hadn't planned on asking the group to do this, I felt that it was needed. The whole exercise took less than twenty minutes and became the focal point for the entire day. It is always productive to help groups to show where they could be more than the sum of their parts.

5.7 Mapping Relationships—Networks, Politics, and Stakeholders

As facilitators or coaches, we often use the notion of spatial positioning to help a group or client to articulate and identify where they are situated in relation to other people or entities. Sometimes this process uses an existing map, framework, or grid (a process that is unpacked in Chapter 6), but sometimes the positioning is based around a freeform map of the client's own creation—essentially a way of helping them to position themselves relative to others. These relationships might illustrate, or show a combination of, a professional network, degrees of "political" connectedness, project stakeholder mapping.

For instance, the degree to which people are connected within their network can be elicited by asking an individual or group to draw themselves at the center of a Copernican solar system diagram, and then asking them to plot the various people in orbit around them. They could then finesse their plot by using questions such as:

- Which are the different planets to which you need to make connection? Who needs to know you better?
- Who is in close or distant orbit? (Plot this using longer or shorter connective lines.)
- Where are the strong and weak relationships? (Plot using heavier or weaker lines.)
- Where are the gaps? (People they know by reputation but who they want to connect with.)

As a tool, this can add real value in helping people to identify the quality of connections (heavy lines) as opposed to a purely numerical quantitative approach to networking. It also quickly highlights the density of network clusters (i.e. those that share information or collaborate) and shows the gaps in certain areas. It can also show the "hubs" (i.e. people that know lots of people and can connect disparate groups) and can shed light on the six-degrees-of-separation contacts (i.e. people who can provide links in a networking chain). Although the primary place in which we use this sort of approach is with coaching clients who are looking to develop their networking skills, it also works very well with small teams who are trying to be more strategic in the way they build contacts.

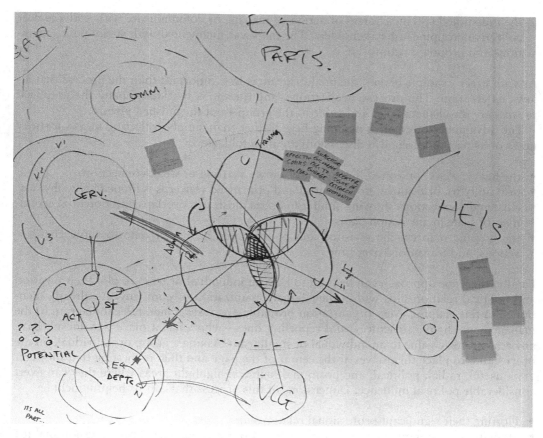

Figure 5.8 Annotated project stakeholder map

Project leaders and managers frequently engage in stakeholder analysis and we often use graphical mapping to augment this process. In essence, stakeholder mapping helps to identify the needs, wants, inputs, output expectations, and types of power that those with a stake in the project hold. An entry point to helping a group to do this might be to provide a model for discussion. This could be done with a 2x2 power/interest, but others might be more suitable—for instance Freeman and Harrison's (2010) interlocking circles model that clusters around Urgency, Legitimacy, and Power, or Peter Block's (2007) Civic Engagement model that compares directional agreement and trust. What is vital is that a group must first classify and categorize the types of issues that they need to engage with for their particular stakeholders. Such classification might occur in advance of any facilitated meeting.

For instance, in the example in Figure 5.8, a group:

i were asked to plot various project stakeholders against three overlapping drives identi-
fied by a project steering group;

ii were then asked to plot the connections and relative force of these drivers on the map.
Dotted lines and heavier lines indicated weak or strong drives and the group identified
connective overlaps in the stakeholder demands;

iii then identified specific courses of action to manage or communicate with individual or collective groupings of stakeholders. The map was augmented with sticky note suggestions and proposed actions.

As with every example herein, the final diagram is less important than the process that allows its creation. The process, realizations, and questions that accompany the graphical process are the elements that add value to the group—not the finished picture.

The advantages of creative mapping here (rather than simply collecting ideas on sticky notes or as part of a freeform discussion) are manifold, since:

• the heavy, weak, or dotted line instantly shows a strong or weak connection
• proximity to, or distance from, central and prioritized concerns is immediately obvious
• clustered connections showing similar interests illustrates overlaps and potential economies of scale in any action plans
• the graphic map can be revisited and re-annotated at a later date to show changes, actions, and transitions over time.

Finally, the same approach can be used to help an individual or team to plot their position and political relationships within their larger organization or company. As already mentioned in this chapter, every organization probably possesses a hierarchical diagram of the management chains, structures, and reporting lines—which has a place but doesn't have any real strategic value to an individual or small team. Asking a group or individual, on the other hand, to place themselves at the center of the page and then requesting that they create a useful, radial, political, and positional map can highlight areas where they can exert considerable political influence. Dimensions of this process that can be helpful include:

• Plotting their significant professional relationships
• Showing the strength of their connections to other departments and decision-making centers
• Identification of the leverage or influence points that they have (or otherwise)
• Illustration of the weak spots and poor relationships

Again, as a facilitator or coach (or facilitative manager), there is not a one-size-fits-all approach to these activities. Nor is there a prescription for a recipe that will work each time. What is vital is to consider the purpose of the intervention and to help the group by choosing the right model, approach, style, and questions—and then, pivotally, to help the group to operate independently of you the next time.

5.8 Mapping Discussions and Group Interactions

In our work we frequently ask groups about the origins of behavioral courses of action or decisions. We want to understand, and more importantly we want the group to understand, from where their decisions come. This need is often more important with a group, or collaboration, where there is no hierarchical structure or clear designated leader. The conversation between us, the facilitator, and the group usually contains a tiny exchange like this:

[facilitator] "So, how did that decision come about?"
[group] "Oh, we just decided."

Of course, this is untrue. Decisions don't just "get made." Someone makes the decision and others follow it so quickly that no one notices the informal leader/follower exchange in the interaction. Sometimes, this lack of clarity doesn't matter at all—but where groups are dysfunctional or in need of a performance boost, it can be very helpful for them to actually notice what is really going on. In organizational development and group facilitation, raising awareness of a process can be an important first step in confronting problems and optimizing processes. Mapping a conversation or group interaction can help to illuminate and demonstrate what is occurring.

Most facilitators, or group observers, have probably at some point drawn a table plan conversation map like the one shown in Figure 5.9. (If you've never done this, carefully try it out in your next meeting, committee, or zoom call—it's often very enlightening). Figure 5.9 shows an overhead view of a (real) conversational path between seven people (initials V, T, J, S, R, P, and JK) taken from a short interaction that lasted just over five minutes. I, as an external facilitator, had observed what I considered to be a "critical" conversation and I quickly plotted it from its starting point (in this case the asterisk by person V denotes the conversational origin) through time.

A cursory glance at this map shows that there were some heavy intra-group interactions (i.e. between T and JK) and some dialogues that were completely absent (i.e. between J and P). It's also obvious that some of the group had interactions with more of their colleagues than did others (for example V had a heavy dialogue path with T—but only engaged with T and JK, and once—lightly—with J). This number of relationships is shown alongside the person's initial. Other details can be noted—for instance, as annotated here, J's sole verbal interaction with the group happened three minutes and twenty seconds into a five minute conversation.

While none of these details are instructive and telling in their own right, it can be hugely helpful to spot patterns that form and trends that repeat. It can also be incredibly useful to have a specific record of what happened when in a conversation. For instance, if a group opines that "we just made that decision..." it's potentially useful to be able to point out exactly who proposed the idea and when, who vocally supported it, and who stayed silent.

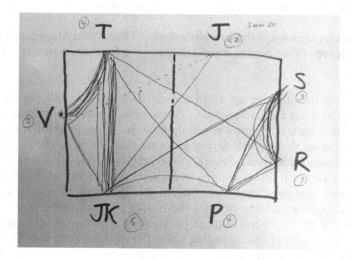

Figure 5.9 Conversational Map illustrating a five-minute group interaction

It can also be useful to display the conversational map to the group after a discussion and ask them to comment upon what they notice or how it relates to pivotal decision moments in their discourse. If a group member is being ignored or is deliberately withdrawing, a visual depiction can be a powerful realization of this. Arrows on the lines showing not just volume of traffic, but direction can make the tool more useful—though the depiction can get very messy, very quickly. Facilitatory or coaching questions that can help elicit value from a conversational mapping process might include:

Before revealing the map

- What do you expect to see?
- Who is leading/following in this group?
- Where are your alliances and differences?

After revealing the map

- What do you notice?
- Were you aware of (e.g. the imbalance)?
- What happened at the start/key decision points etc.?

As with all the tools and approaches we suggest in this book, the value in Discussion Mapping for a facilitator is allowing the group to visually realize what *processes* are actually occurring when they have been focused on the *task* or the *topic* of a discussion. The conversations and questions a facilitator might ask should be aimed at helping the group to articulate these realizations, but the intervention is only valuable if these realizations become future-focused and "useful." To that end, questions designed to get a group to consider how they might behave more optimally might include ones like:

- What might a "healthy" discussion pathway look like?
- What would you like to see more of?
- How do you need to support/challenge/listen to each other more?

There are, of course, many ways that the basic tool of Discussion Mapping can be enhanced or built upon to survey other professional areas and explore different territories.

For example:
Divide a group into two and set up a "fishbowl" activity—i.e. half the group sits at the center of the room and has a conversation or does a task, while half of the group sits around the edge and observes their colleagues whilst making their own individual maps. This serves the function of ensuring that each observer really pays attention to the group dynamic and the individual interactions within it. Furthermore, these individual dialogue pathways can be compared at the end of a discussion (to triangulate the validity of the depiction) or used to stimulate 1:1 conversations about what occurred. This type of activity can be a strong element within facilitation training or train-the-trainer programmes.

With an online group, a conversation can be recorded, and the group transcribes and dialogue maps a small section of the recording using the method outlined. This methodological adaptation has the added advantage that the facilitator can concentrate on other things

while the group are conversing and then transcribing. It may be worth noting which pivotal parts of the conversation are worth the group transcribing (for instance, a key decision that only some of the group agreed to).

A colleague of ours experimented (partially successfully) with discussion mapping using a tablet so the creation of the pathway itself could be recorded and played back—illustrating exactly where the conversational batten was passed and after how long. This is, it must be acknowledged, an approach for the technologically comfortable. A simpler augmentation of this tool is to use colors (a multicolor pen is useful here) and icons to denote certain types of interaction. For instance, it might help a group to understand what type of interactions are occurring and in what direction. For instance:

- Proposing a course of action—Red ink (line represented as →→)
- Opposing a course of action—Black ink (line represented as –x –x)
- Explicitly agreeing with a directive—Green ink (line represented as –! –!)
- Explicitly praising the contribution of another—Blue ink (line represented as –o –o)
- Reframing (R)
- Active listening (L)
- Creative idea (I)

As always, the annotation should be designed to capture the conversational process elements that would be particularly useful to a group—either to reinforce strong elements (inquiry, appreciation, courageous followership etc.) or to expose less helpful elements (over-talking, looped arguments, cliques and factions, etc.).

While it is not "graphic" in a pen and paper sense, Discussion Maps can be created with different sorts of physical objects such as a simple ball of string—where the string is unfurled from person to person as a conversation moves around. This creates a map like a spider web or "cat's cradle" to illustrate the conversational track. If an unaware individual is dominating a group it becomes obvious to all parties very quickly as they run out of fingers to hold the conversational string. I've also drawn conversational pathways on a sandy beach with a group on a seaside away-day—and finally here I'd like here to apologize to the group who sat around holding an unspooling length of toilet roll to achieve the same effect. Sometimes an improvised activity is the most valuable part of a facilitator's toolkit.

*

References

Block, P (2007) *Civic Engagement and the Restoration of Community: Changing the nature of the conversation* (Berrett-Koehler Publishers)

Burgess-Allen, J and Owen-Smith, V (2010) Using mind mapping techniques for rapid qualitative data analysis in public participation processes. *Health Expectations 2010*, 13, 4.

Freeman, RE and Harrison, JS (2010) Stakeholder theory: the state of the art. *Management Faculty Publications*, 99. https://scholarship.richmond.edu/management-faculty-publications/99

Wheeldon, J and Faubert, J (2009) Framing experience: concept maps, mind maps, and data collection. *Qualitative Research International Journal of Qualitative Methods 2009*, 8(3).

Chapter 6

Models and Frameworks

When you work within the fields of coaching, training, and professional or organizational development, you learn very quickly that there are a lot of models that aim to help people to gain clarity of their environment and make managerial sense of huge amounts of complexity. As a facilitator or coach our job is to help people to gain clarity, make decisions, and move towards actions; as a trainer our job is to help people gain the tools to do this by themselves. As such, models and frameworks are a huge part of the facilitator or trainer's arsenal. In the words of behavioral educationalist Paul Hersey "a theory gives you something interesting to think about... a model is a repeatable framework that provides you with a roadmap on what to do."

6.1 The Right Tool for the Right Job?

The other ready-made advantage for a graphical practitioner is that these models tend to be simple to draw—usually being based upon straight lines or simple shapes. As such, they are instantly useable—especially if all that is required is for a group to augment an existent framework with sticky notes.

These tools, however, can be classified and categorized into types—so it's important for a facilitator to consider what type of framework or model to use, as this decision effects *how* a group might engage with it; for instance (references for each of the following can be found at the end of the chapter):

1 Some have distinct labelled areas based on parameter changes (e.g. Czichzentmihalyi's Flow Channel/Grint's Wicked Problems/Block's Stakeholder Engagement) and are useful for helping groups to classify
2 Some provide labels but not parameter weightings (e.g. Hirano's 5S system/Kantor and Lehr's Four Player Model/Adair's Leadership circles) and are useful to help groups to identify action areas
3 Some illustrate a process or a journey (e.g. Tuckman's "Form, Storm, Norm, Perform" or Kübler-Ross's Grief/Change Curve) and are useful when helping groups identify evolutionary phases
4 Some provide a structured canvas to allow problem solving (e.g. Ichikawa's "Fishbone" cause/effect diagrams, Kurt Lewin's Forcefield Analysis)

Choosing the right tool for the right job can make the facilitative process considerably easier and more productive for all concerned—and sometimes simply being able to show a

DOI: 10.4324/9781003410577-10

group a tool they've not seen before will lift a session. I've lost count of the times that I've been on the receiving end of a SWOT analysis and I immediately become slightly more cynical and jaded than usual when I'm asked to do one. As such, the wider your knowledge of frameworks and models, the easier it is to create a canvas for groups to explore, annotate, and strategize in a way that is both energizing and tailored to their needs. To help expand your repertoire, you may wish to draw from a curated selection of pre-existing models—such as those in *Lead: Fifty models for success in life and work* (Greenway et al. 2018) or *The Diagrams Book: 50 ways to solve and problem visually* (Duncan 2013).

However, before examining models and how they can be used, it's worth remembering that, at root, they are a device for making complexity seem simpler—and there are other devices that a facilitator can use to create simple meaning: namely symbols.

6.2 Symbols and Systems and Encoding

One of the few stumbling blocks that we encounter in our work is the challenge from delegates or clients who claim to be unable to draw. Very rarely, though, is this a real problem, since much of the work we do actually involves little need for artistic talent. The placement and movement of a sticky note onto a model or pair of pre-drawn axes requires no graphical flair whatsoever. Everyone can draw a stick figure, everyone can draw a line or a shape, and everyone can position different elements of a picture in relation to other components—whether they want to or not is a different question.

However, it is worth, as a graphical facilitator, having a back-pocket plan and set of low-art tools for groups or individuals who won't or can't (or believe that they can't) engage in what you want them to do. The simplest way to do this is to consider how a group or individual can create a metaphor, or a symbol, or an encoding system in the quickest and simplest form. What elements can be represented in a different form to give a translated meaning that is illustrative?

The realization that this encoding was graphical facilitation in its purest form came to me during the pandemic lockdowns where, due to professional distancing and online teaching and learning, I was suddenly stripped of the ability to use pens, paper, and sticky notes. Many universities and schools (who at the time were core clients) had put in place a policy of "no webcams" so as to protect their students' privacy and mental health—and, as a result, it made graphical conversations hugely difficult. Quickly I realized that it was not impossible to have a conversation based on graphical encoding simply by using the chat bar on Teams, Zoom, or Collaborate. For instance:

- Can participants represent their progress, relationships, or mental health (for example) using three emojis? (Clearly their emoji choices could be asked after and unpacked individually, or with a larger group it may be enough to observe trends.) In the chat bar of Zoom there are well over 1000 emojis to choose from, which, when combined into a group of three, give almost infinite variation.
- Could delegates create their own framework and show their position on a defined continuum by using simple keyboard symbols to "draw" a line and plot a certain meaningful point upon it? For example, plotting their introversion or extraversion preference using E, I, hyphens, and an X, like this: (E--------------------X--I)
- Could the colored shapes and icons in the "symbols" menu in the Zoom chat bar be representative of other elements.? (For example, their team is currently "green square" but needs to change to "blue diamond" etc.)

One of the recurring themes in this book is the idea that graphics and pictures can unlock conversation and realization via a process of translation or symbolization. There is no reason why this symbolization has to be intricate or complex, since it is the process of translation into shape, image, or metaphor that holds so much value.

For example, I recently did some future planning work with a group who professed to be very unartistic, and much of our interaction was conducted online without specialist graphical tools. The group were very technically capable and many of them had science and engineering backgrounds. I wanted them to prioritize and embody the different components of their professional lives that would help them to be promoted and to obtain their next position, and to root this in a need for a healthy work-life balance perspective. Rather than ask them to draw this system (as I might have done in a "real-life" non-virtual session) I simply asked them, in small groups, to share a whiteboard and to create an *equation* that would help them to have a successful professional life. Within minutes they'd used the following encoding systems:

- Letters—to abbreviate different parts of the system (T being time, R being relationships etc.)
- Size—to show relative importance or unimportance of different components
- Color—to illustrate thematic elements (internal recognition of performance being blue, external perception of achievement being red, self-confidence being purple, external life being green etc.)
- Arrows—to show direction and force
- Mathematical symbols (purpose → work + life = happiness)

The group acts of discussion, encoding (including a meta-discussion about what coding systems should be used), capture, and presentation was a very rich process, which resulted in a long and hugely valuable conversation. The semi-graphical task of "form an equation" arose through necessity (i.e. a limiting technical environment and an "unartistic" group), but proved so effective that I then used it again with a live group using pens, paper, and colored shapes.

Ultimately, and in common with other elements of the graphical toolkit, a key question to ask is "what is something 'like?'" What noun, object, color, shape, season, food etc. would represent the subject of the conversation? For instance:

- If this company was a car, what would it look like?
- If this school was a machine, how would it work?
- If this team was a house, what rooms would it have?

These elements can then be drawn, or collaged, or modeled, or moulded (or simply discussed). It is the power of the translation or encoding to a new visual language system and the explanation of this process or product to others that holds a huge amount of power and value to a group. It is this translation that models and frameworks provide.

6.3 Augmenting a Model

As we've already mentioned, with groups that are perhaps resistant to creative or playful or pictorial approaches, the end product of a picture that is worth myriad words can be

achieved through annotation or augmentation of an existing model. Rather than show pictures of dozens of existent models that workshop participants have scribbled on or fixed sticky notes to, we'll simply show one example and then draw a number of transferable lessons from it that can be applied irrespective of the model in question.

While working with a management group to explore the actions required throughout the stages of a change process I chose to use a managerial adaptation of the Kubler-Ross Curve. (This curve model originated as a five-stage grief model set out by Elisabeth Kubler-Ross in the book "On Death and Dying".) In prior discussion with the client, we'd agreed that we'd get the group to explore and capture the professional "states of mind" and then actions required in order to help their organization transition from the "shock" and "denial" phases of a forced change, through the "acceptance" and onto the integration of new behaviors and practices.

The first step was to ask the group about the feelings and states brought about when they had been forcibly exposed to change. In and of itself, this was an interesting conversation, albeit one without a future-facing practical drive. I then introduced the theoretical model by drawing a graphical plot onto the whiteboard (a flipchart would serve well here too, though giving less space for different possibilities) and labeling the different phases of the curve. I split the group into discussion subgroups and asked them to consider practical and pragmatic leadership actions that could be taken at each "step" to help the organization and employees. Colored sticky notes were issued and groups were asked to add one idea per note and to write in large, clear lettering. (It seems awfully prescriptive but I remind groups to write on the note with the sticky side down. You'd be amazed what apparently clever people do if left to their own devices...)

Groups were then asked, in turn, to report back on their conversations by sticking points to the model and outlining how the actions could be valuable to the organization as a whole. (I repeated the exercise in a slightly different form with another group where a whiteboard was unavailable and so we used a flipchart instead. The reduction of page space with the second group resulted in a far more compressed end-image and a near-obscuration of the model. This difference is highlighted in Figure 6.1.)

Much of the process that followed with this group has already been explored generically in the "Clusters" elements of Chapter 3, but ideas were captured, refined, discussed, and

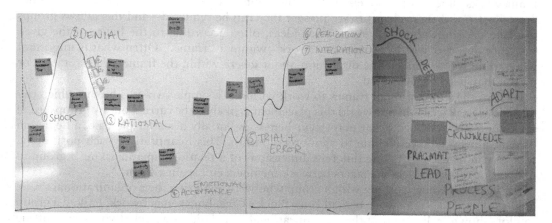

Figure 6.1 Comparisons of two models augmented using sticky notes

added to the original model. Once the model was nearing saturation (and time was getting tight), I photographed the whiteboard to share with the group. We collectively removed the individual idea-notes and spent the last part of the session prioritizing the ideas and converting them into meaningful, specific, and owned actions for the group. It is this last phase of the exercise that separates an interesting conversation and a neat model from an actual productive event. Far too often, in the early part of my career, I would run out of time and sacrifice the part of the event that actually added real value.

The lessons here for group augmentations of *any* model would be:

- Engage in careful conversation about the purpose behind any intervention and choose the best model for the purpose. Don't crowbar the purpose onto your go-to models.
- Stimulate a conversation about the reality of a situation *before* introducing a model. Root the conversation in the concrete before showing a simple abstraction.
- Don't constrain the group by insisting that elements must fit into certain areas or zones of a model. Real-life is far more nuanced than a 2x2 grid.
- Allow the group to make mistakes and then correct them. Sticky notes can be repositioned, where a pen mark cannot. A whiteboard is better than a flipchart for model augmentation.
- Leave space for the group to spread their ideas and actions out, so individual contributions don't get obscured. (If the venue doesn't have a whiteboard, and you sense that a flipchart might be too small, place tables together and use your masking tape (see Kit List in Chapter 2) to create model zones directly on a large flat surface.)
- Leave time for ideas, suggestions, and strategies to be interrogated and discussed.
- Photograph and capture the "final" model before you deconstruct and convert it into specific actions.
- Ensure adequate time to actually convert the model into owned, practical actions. It may be that this element of the process may be undertaken in a separate meeting—but don't ignore this vital final step.

6.4 Using a Framework

Frameworks differ from models in that they don't necessarily have pathways or zones prescribed—or if these elements are present they can be removed—and this allows groups to make decisions about where to place ideas, often according to the limits of the given structure. In other words, groups can "work" within a "frame." Often what is important when using frameworks is the discussion about *where* within the frame an idea, tactic, or person may need to be located.

Perhaps the simplest of all frames to work within is a simple two-axis box in which elements can be placed—in our world this placement is likely to be carried out by groups using sticky notes or symbols. What may occur here is essentially a scatter plot, i.e. a depiction of data but no connective line to show relationship. This quantitatively-rich positioning process can be used by taking different dimensions of a relationship and asking a group to plot various stakeholders/managers/network members etc. against them.

For instance, when working with a group who were analyzing their organizational stakeholders, I used the framework behind Peter Block's Civic Engagement work. I asked a group to plot (shown in Figure 6.2) their organizational stakeholders against two axes: strategic alignment and whether the existing relationship was based on established trust.

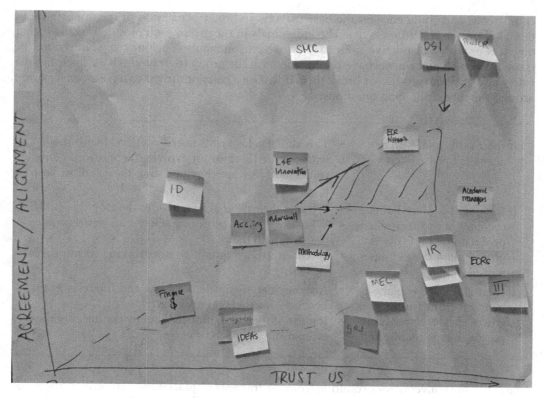

Figure 6.2 Plotting against preordained framework axes

This process facilitated interesting conversations about how the group could communicate their vision and how they could build trust. (As with models in the previous section, sticky notes are useful here since they allow a group to move stakeholders around on the axes without a "final" pen-stroke or mark.) The placement against an axis or continuum also facilitates conversations about what is required (in this case how much alignment or trust) in order for a group to be successful.

The second element that was useful here for the group was to explore the framework areas of the plot that were significantly below or above the "x=y" trend line that can be drawn at a 45degree angle from bottom left to top right of the frame. (It is this line that is the site of Csikszentmihalyi's "Flow Channel," or any frame model such as a cost/benefit plot that has an optimal middle ground). What was important with the group here, as usual, was the realization and articulation by the group that certain stakeholders had different logical and emotional relationships and agendas. Of course, at some level the group already knew this, but the symbolic positioning of data onto a frame resulted in a deep conversation and then resulted in a meaningful strategic action plan.

I also use this X=Y line framework plotting with groups to help them think about career planning. I ask them as a group to list twenty transferable or portable skills that they may need to have to succeed in their career. If time is short I provide a list from which they can choose the most relevant to them. I then have them draw a two-way frame that plots their

competence and confidence on the base (x) axis and their perception of the importance of that skill up the side (the y axis). The individuals in the group each plot their skills (either on cards or with a distinctive color to show which contribution belongs to whom) onto the frame. When all placements have been made I ask the group to draw the X=Y line onto the frame and I ask the groups (or break them down into pairs or threes) to have a conversation around the three following questions:

If their skill card is on or near the line	• This skill level is professionally a good fit—but what will keep it there in an evolving professional environment? How are they updating their skill to keep it current?
If their skill is placed above the line (in the area where professional necessity is greater than their competence level)	• What is their clear action plan to develop this skill? • Who are the mentors/teachers/trainers/resources that can help them? • What will they commit to undertaking to improve, by when?
If their skill card is placed below the line (in the area where they are more competent than is required)	• Are they deploying their talents and interests in the best way for their progression? • If most of their skill plots fall below the line, are they even in the right job or career?

Again, it is the conversations resulting from the framework placement that provide the value to the group. The drawing and plotting are simply a conduit to the conversation. To this end, when using frames I use the general principles that keep the conversation productive:

• Keep the frame simple so the group doesn't get bogged down in complexity. The more complex the basic frame, the more group talk about whether an idea should be placed in box a, b, c etc. or not—which ultimately doesn't matter at all.
• As with models, start a conversation about concrete reality before drawing the frame. Root the conversation in the real before translating to an abstract.
• Leave space and allow the group to make changes to their initial placements.
• Annotate the frame to illustrate possibilities and actions. (For example in Figure 6.2, the group had started to add their own annotations and areas to remind them of tactics that would give them leverage.)
• As with models, photograph the "final" framework illustration before it is deconstructed and converted into action plans. Ensure you leave time for this final step.

6.5 What are You Trying to Achieve?

Essentially, models and frameworks have a great deal in common and there is a large overlap in the way that they both can be used by a facilitator. While it is important to choose the right tool for the right job, it is also vitally important for a facilitator (or coach, or manager) to consider the underlying purpose behind any intervention. This sounds like common sense, but is sometimes difficult when a group professes to be "stuck" or "just needs

Table 6.1

Purpose	Types of models and frameworks that might be useful
Solve Problems	**Fishbone or Ichikawa Diagrams** (Cause and Effect Analysis). Devised by Kaoru Ishikawa, as a quality management tool in the 1960s. Allows groups to identify the causes and subcauses behind states of being (usually problematic states, but can also be used when identifying reasons for successes, to help recreate them). **Cynefin** (Pronounced "ku-NEh-vin" from the Welsh for "habitat." "Habitat" Framework—helps classify problems by their "knowness" and level of complexity (See Snowdon and Boone 2007).
Make Decisions	**Decision Trees** Decision trees areas show the "roots" of an issue in the past (where have we been), and come to a singularity in the present (where are we now), and then allow groups to create "branches" into multiple future possibilities (where could things go now?). **Balanced Scorecard** The Balanced Scorecard displays four major business elements: Financial, Customer Relations, Learning and growth, and Internal Processes. It's useful to help make strategic forward-looking decisions. (I've used it with groups and used "sustainability" as a fifth balance measure.)
Improve Process	**PCDA—Plan-Do-Check-Act Circle** Sometimes called the Deming Cycle, this model originates from the field of Quality Improvement—it's useful for helping groups to analyze their process and Iteratively improve it in connected stages. **5S Pillars** From Japanese manufacture improvement thinking, the 5S model (see Hirano 1995) helps to identify areas of productivity that can be enhanced—regardless of whether a group or individual has a "production process." (The translation from Japanese of the 5S's are: Sort, Standardize, Shine, Set in Order, and Sustain.)
Capture or Cluster Data or Responses	**WordClouds / Bubble charts (Qualitative)** Word clouds (especially with online groups) and Bubble Charts (where the size of a bubble illustrates the relative size of an issue or a response) are useful for capturing information and showing qualitatively how it is weighted. For quantitative data, bar charts, histograms, or pie charts could be used. **Affinity charts / Clustering** We've already explored clusters in this book, but combining them onto a framework can unlock insight into where there is professional affinity between data inputs.
Analyze change / strategy	**Forcefield Analysis** Kurt Lewin's model that helps identify the magnitude of factors driving and blocking change decisions. (We explore this in Section 6.6.) **McKinsey 7S Model** Developed by the consulting firm McKinsey, this model helps to examine organizational effectiveness through seven S's. These are the so-called "Hard" elements of Strategy, Structure, and Systems, and the "Softer" elements of Shared Values, Skills, Staff, and Style. Useful with groups or organizations that are in transition or wanting a tune-up. If using the 7S model I'd typically start with a Heptagonal Radar plot and deal with each element in turn.

(Continued)

Table 6.1 (Continued)

Purpose	Types of models and frameworks that might be useful
Identify Opportunities and Priorities	**MoSCoW Analysis** With its origins in Software development (engineer Dai Clegg at Oracle), this tool was created to help teams prioritize tasks (in terms of **M**ust Have / **S**hould Have / **CO**uld Have / **W**on't Have) during product development. It can however be used transferably, with organizations investigating new possibilities. **Opportunity Scoring Model** Opportunity Scoring (or Gap Analysis) groups or stakeholders are asked to rate the importance of and the satisfaction with certain elements of a larger entity, product, or service. Elements that are high in importance are the areas to target and prioritise. (In essence helping groups to identify what is truly important to their success.) Targets and mandalas can also be used as a prioritization tool to help illustrate the proximity of opportunities (in terms of ease to achieve or closeness to "core" business).
Prioritize actions	**Two by Two Grids** Typically prioritization of activities tends to be a place with 2x2 matrices such as the Kano Model (customer delight vs implementation cost), Probability vs Impact Matrix (to analyze and thus prevent risk), or a Value/Effort grid (to identify time sinks and quick wins). **SWOT / TOWS Grid** Strength Weakness Opportunities Threats analysis has been around since the 1960s and is probably the most (over?)used facilitators tool. Recombining the four (SWOT) elements to identify the intersection between SO (where Strength meets Opportunity etc), WO, ST, and WT is an interesting graphical tweak on a classic.
Clarify process	**Flowcharts** Flowcharts use symbols and text combined with lines and arrows to show the "flow" of activity through an endeavor. They enable the illustration and modeling of processes, events, problems, and decision centers. They're ubiquitous and require no set up explanation for a group—and a simple instruction to "draw a flowchart that explains X, Y, Z" will get a group discussing and drawing immediately. (An example of how this tool can be used is shown later in this chapter.) **From / To Charts** From / To Charts look complex, and I use them only rarely but they are designed to show the relationships between myriad points or areas. The familiar use of a From / To Chart is the mileage chart in the back of my road atlas that shows distances between towns. These charts, whilst unwieldy, can be helpful in identifying quantitative metrics (i.e. distance / volume / yield between areas of a plant). I use them to help groups identify feelings and relationships between different parts of their organization. Rather than a number I ask groups to populate the model with cross referenced words on sticky notes (i.e. the relationship between sales and manufacture might be "mistrustful," but between sales and marketing is "cosy").

(Continued)

Table 6.1 (Continued)

Purpose	Types of models and frameworks that might be useful
Analyze past events	**Time Lines** As we've seen already in Chapters 3 and 5, timelines and past maps can be a helpful way of getting groups to look back in time. To provide structure here, it may be worth drawing a (e.g.) blank project duration timeline onto a long piece of paper and asking a group to annotate the key historical points. These can then be discussed and interrogated. A variation on this theme that I use from time to time is ask a group to find their original project timeline or Gantt chart that was produced at the initiation of the project. I project this image onto a whiteboard or large sheet of paper and then ask them to draw the actual reality of the project on top of this projection. **Radar Plots** In Chapter 4 (and later in Chapter 7) we examined Radar plots as a way of identifying a group's historical performance (or future potential) in any given number of areas—and then comparing these. Their graphical plotted scores can be identified and discussed with a view to learning lessons from the group's past outputs and efficiencies and behaviors.

something to help with things"—which are both common starting points for facilitation work. Again, the deeper your toolbox, and the more proficient you are with your tools, the more likely you are to be able to choose one that will help the group in the best way. Here we present just a few suggestions (of literally thousands) as to the models and frameworks that work in a graphical session—and lend themselves to being set out upon whiteboards, covered in sticky notes and scribbled on with marker pens. If you want to take your thinking further here, we'd suggest Scott Berinato's (2019) *Good Charts Workbook*.

6.6 From Model to Reality—the Big Fat "So What?"

Of course, for a model or framework to be useful to a group, the facilitator must help them move away from an abstract framework back into the realities of their daily business. This, I'd suggest, can be achieved in three ways:

1 Firstly, by asking coach-like questions that are powerful and future-focused and designed to elicit specific actions. For instance:

 "So, you've identified a priority area—what will actioning that area actually give you?'
 And then
 "What could get in the way of that succeeding?"
 And then
 "So what specifically are you going to do here?" (By when? Who will take responsibility? Etc.)

2 Secondly by allowing groups sufficient time to action plan—rather than just discuss and create a pretty (or messy) drawing or model. Failure to allow time here is the biggest of facilitatory traps.
3 Through testing the model—i.e. showing whether the group have created a valid tool.

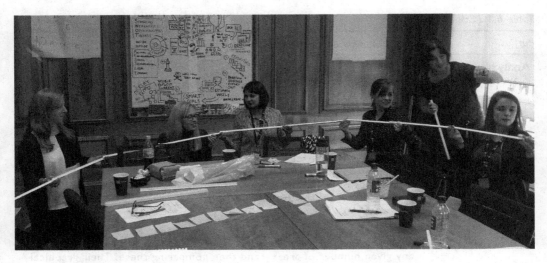

Figure 6.3 Graphical process flow chart conceived and laid out with sticky notes—and then implemented and tested practically

Demonstrating the validity or otherwise of a graphical model in reality is obviously straightforward if you are seeing a group on multiple occasions. It is a simple facilitatory component to help a group create and draw a model, action plan, and then build a reality test review into a future meeting.

However if you, like me, may only see a group once, you might need to create a small microcosm of reality where the group can actually put a theory into practice. For instance, imagine that you are working with a group to help them to be more effective in their working practices. As part of the process you ask them to create a flow-charted problem-solving model that they can apply transferably. They may design something that includes all the "right" answers (i.e. understand objective, obtain data, filter and discuss information, make decisions, plan, apply, review) but unless they can test this model in any way, they have no way of appraising the validity of their model. It is thus a necessary educational step to move from a "plan" model to a "do" action that can then be reviewed. Giving the group a short subsequent task (e.g. "Create a map of the surrounding environment," see Chapter 5.2) allows the group to "model the model" and review their performance in the task against it.

An example of modeling the model is shown in Figure 6.3. A group on an away-day event had designed a flowchart model using sticky notes, of how they were going to streamline their processes and make them more efficient and effective. We could immediately test the efficacy of their model by seeing whether they could roll marbles down a track created from several shorter pieces. Yes, this exercise is a cartoon of reality, but it allowed the group to refine their flowchart model so that it became more "practically" useful.

6.7 Beyond Models—Creative Interpretations

As facilitators we find that often we are helping a group to ride a wave or walk a wire between exploring the creative *possibilities* of a situation (i.e. the divergence of "what could be") and tightening the *actualities* of a solution (i.e. a convergence towards what must be

by when). Sometimes the tension between possibility and delivery occurs at the absolute start of undertaking, but far more frequently the facilitation conversation is framed by a pre-existing state within an organization and a future state that may be still unknown. In common parlance, this process is called "change." A graphical or visual approach to helping groups to deal with change has many potential applications, from providing an illustration of the current situation, to envisioning a desired future, via plotting a change journey and the forces acting on the transition process.

Such a change process might be well illustrated using a mapping approach (the journey of the change) or a more mechanical depiction of vector arrows towards a desired future target. But, as mentioned elsewhere in this book, an oft-used tool for understanding the forces acting on a change process is a Forcefield Analysis (originally from a social research tool, see Lewin 1951) diagram. With this approach, change can be depicted as an imbalance between driving forces and restraints or limiters. (With groups we sometimes refer to these forces as "accelerators" and "brakes.") All of the myriad drivers and restraints are depicted by arrows of different weights and lengths to illustrate the size of the force (for or against change) acting against each other. By understanding these forces, a team or organization can start to identify where they can strengthen the drivers or remove the restrictions ("take the handbrake off!") and thus catalyze a change process. As a tool that uses size (of "force") and direction (of arrow) it is by nature a very graphical approach, and moreover it has long been used by organizations with regard to formulating strategy (see Thomas 1985). This makes it a simple "gateway tool" for a facilitator who wants to help a group to be more graphical and creative in a low-risk way. Sometimes a group just needs to work in a way that is comfortable and safe, and Forcefield Analysis requires no artistic skill whatsoever but culminates in a graphical basis for a plan or strategy that can be "shown" rather than "read." In addition, as a tool, it can be easily adapted to suit other types of problem-solving or communication issues—for instance asking a group to graphically balance the "forces" of "pros" and "cons" of an issue, or the "for" and "against" of a debate, or the "known" and "unknown" of a problem.

However, where we find interesting facilitatory areas to explore is where groups move beyond the constraints and limitations of a "business school" model and start to interpret creatively and take ownership of the process. For instance, Figure 6.4 shows the work of a group who had been shown forcefield analysis and asked to use it to depict forces "for" and "against" professional resilience. I'd anticipated that they'd illustrate their discussions with a simple line and arrow model. But the group quickly realized that the place where these forces met ("the field") was akin to the place where storm clouds met sunshine and thus could be represented with a rainbow. They took this metaphor and ran with it and in the image you can clearly see the storm cloud barriers to resilience (left), the self-growth (tree) drivers on the right with the rainbow bisecting them. Days and groups like this make feel like I have the best job in the world and serve as a reminder that groups can surprise and innovate in amazing ways if stimulated and given space and freedom.

There are scores of managements, process-finding, decision-making, and change models out there, and many facilitators become wedded to a few of them that they "know" are going to "work." Moreover, they may become very attached to the notion of using *any* existent model per se as their default strategy (i.e. "if in doubt, use a model"). This, as a professional philosophy, we believe to be somewhat problematic. A much-respected colleague recently told me that a series of "change consultants" had tendered and pitched for

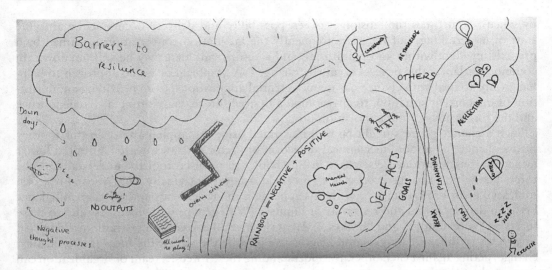

Figure 6.4 When is a Forcefield Analysis not a Forcefield Analysis? A creative interpretation designed and owned by a group.

work within his organization. Several consultants brought with them "change models" and a pre-defined and glossily-presented PowerPoint recipe for how they wanted to approach the organizational development process. The last pitcher of the day, though, came to the meeting with a large sheet of blank paper and a pen—sat down and asked the executives present what they wanted to achieve, why they wanted to achieve it and by when. Their answers were captured diagrammatically and reflected back to the panel. Disagreements and inconsistencies were highlighted and the meeting, apparently, became very heated. This was a high-risk approach and required real skill and confidence. But it was this professional that was awarded the contract to help the organization to make the changes it needed to. Models can be very helpful. Models and graphics and drawings can be even better. But nothing beats actually listening to people and reflecting their hopes and fears and schemes and dreams in a tailored and personally meaningful way.

*

References

Adair, J (2006) *Leadership and Motivation* (Kogan Page)

Berinato, S (2019) *Good Charts Workbook: Tips, tools, and exercises for making better data visualizations* (Harvard Business Review Press)

Block, P (2007) Civic engagement and the restoration of community: changing the nature of the conversation. Online booklet, https://conversational-leadership.net/paper/civic-engagement-and-the-restoration-of-community/

Csikszentmihalyi, M (1992) *Flow: The psychology of optimal experience* (Harper and Row)

Duncan, K (2013) *The Diagrams Book: 50 ways to solve any problem visually* (LID Publishing Ltd)

Greenway, J, Blacknell, A, and Coombe, A (2018) *Lead: Fifty models for success in life and work* (Capstone)

Grint, K (2005) Problems, problems, problems: the social construction of "leadership." *Human Relations*, 58, 1467–1494

Hirano, H (1995) 5 Pillars of the Visual Workplace: Sourcebook for 5S implementation (Productivity Press)

Ishikawa. K. (Lu, DJ trans.) (1985) What is Total Quality Control? (Prentice-Hall Inc.)

Kantor, D and Lehr, W (1975) Inside the Family (Jossey Bass)

Kübler-Ross, E (2014 Edition) On Death & Dying: What the dying have to teach doctors, nurses, clergy & their own families (Scribner Book Company)

Lewin, K (1951) Field Theory in Social Science (Harper and Row)

Snowden, DJ and Boone, ME (2007) A leader's framework for decision making. Harvard Business Review, 85(11): 67–68

Thomas, J (1985) Force field analysis: a new way to evaluate your strategy. Long Range Planning, 18(6), 54–59

Tuckman, B (1965) Development sequence in small groups. Psychological Bulletin, 63, 384–399

Circles

Looking through the vast numbers of photos we've taken of our courses, seminars, and away days over the years, it seems that they can be classified into a number of categories (much like those of envisioning leadership strategies as set out in David Sibbet's excellent book *Visual Leaders*). The groupings here would include facilitative outputs resulting in lines and grids as well as free-form drawings, but the type that often produces interesting conversations and results are those stemming from circles. Circles are, we'd suggest, under-used by developmental and facilitative professionals—not least of which because they are difficult to draw neatly. (For what it's worth, carrying a piece of string in one's bag that can be tied to a marker pen and that can serve as an impromptu compass to draw any radii of circle around a central point, is a useful kit addition.) But circles can represent so many different forms of information. For instance:

- Intellectual or professional proximity to a core idea can be shown as a target
- Time can be represented as the hours around a circular clockface
- Direction can be plotted using a circular compass
- Unification and equality can be represented by the connection of a circle where the whole circumference is the same distance from the centre
- Distance from an ideal (whether professional or intellectual, or in the case of, for example, economist Kate Raworth's Doughnut Economics (see https://www.kateraworth.com/doughnut/)— financial) can be holistically plotted on a range of connected topics simultaneously
- Proportions of a whole (for instance work life balance, or a team's professional activity balance) can be represented as a Pie Chart
- Overlapping agendas (for instance with project stakeholder mapping) can be represented as a Venn diagram
- Integration can be shown with a mandala containing all relevant elements within a joined-up whole
- Success, accuracy, or value can all be plotted on a conventional "bulls-eye" target
- Involvement of a group can be represented graphically (or physically by "stepping in" or "stepping out")
- Complementarity (or interconnected opposition) can be conveyed through a yin-yang symbol
- Scope boundaries of project activity or ring-fencing can be drawn around work areas or resources
- Emotion can be shown quickly as simple human faces (i.e. with basic emojis)

DOI: 10.4324/9781003410577-11

Some of these intentions and ideas are very simple, and require very little explanation, but all of them can be enormously powerful in helping groups and individuals to depict an entity that is more or less complete and the centrality of components within. This section unpacks just a few circular possibilities.

7.1 Targeting—Illustrating Proximity to What is "Core"

Perhaps the simplest way that a circle can be used as a facilitative tool is by corralling clusters of ideas to show proximity to a core idea or value. For instance, illustrated here, on the left hand side of Figure 7.1, is an anonymized facsimile of the final stage of a team away day activity. The team had split into working groups to suggest themed ideas (themes A, B, C, D—linked to the overall mission of the organization) and then present these back. Once collected, the whole group were asked to suggest where on a target of concentric circles they would want to place each idea. The target illustrated five levels of priority (absolute, required, nice, park for now, cut) and each of the ideas was placed onto the target board in turn. The conversation around the proximity of any idea to "absolute necessity" was very enlightening.

As a development to this tool, it is very easy to introduce "rules" to the placement —such as limiting the number of ideas in each zone, or insisting that each theme of idea (A, B, C, D) has to be equally represented in each zone. As, however, is the case with all the material in this book, the tool is designed to stimulate thinking, enquiry, and conversation—and in this case the group needed no help in recognizing that not all ideas had to be absolute priority actions.

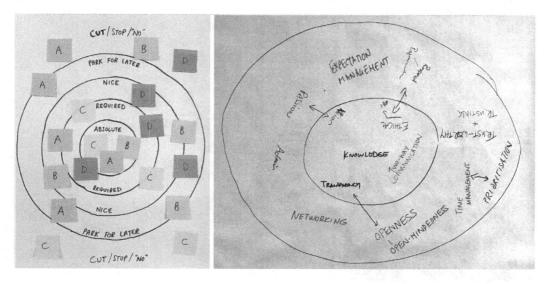

Figure 7.1 Prioritization Targets—an anonymized facsimile of sticky-noted target (left) and a "real" free-form target (right)

7.2 The Circle as Clock Face—Event Countdown

If you've ever seen the "Doomsday Clock" (the symbol representing humankind's closeness to global catastrophe—currently showing ninety seconds to midnight) then you'll be instantly familiar with the idea of using a clockface to show something other than absolute time. When asked to depict time as a graphical entity, groups often draw a time "line" (as in project timelines or even tools like Gantt charts), but most of the time this isn't really how we "see" time. Time is usually drawn as a clockface—which has the decided advantage to a graphical facilitator or trainer of being a closed system. By this I mean that if time is shown as a straight line, and (for example) a deadline is missed and a group "runs out of time," then it is a simple cheat to lengthen the line and just add time. With a circular depiction this workaround is just not possible. Once the minute-hand reaches midnight, there is no more time! Moreover, a line that gets added to repeatedly becomes potentially messy and need demands that it may fold in on itself. Finite circular time prevents this messiness—as groups understand the limitation and typically plan their thinking a little more carefully.

This "finite time" can really help a group to focus on capturing what is important at different stages of a process or journey. If the facilitation process is to augment a planning of an activity then "circular time" encourages so-called Backwards planning (i.e. starting with a final deadline and working backwards), and if the facilitation is to assist in reflection and learning throughout a process, it gives freedom for a group to immediately give equal weighting to elements from any point in the process.

For instance, illustrated above is a group creating a timeline to show the stressful journey towards speaking in public at a large conference. Often such a discussion focuses purely on the final few minutes before the presentation start, but this group used a clockface analogy to show all the stages from the initial invitation through to curtain up on the big day.

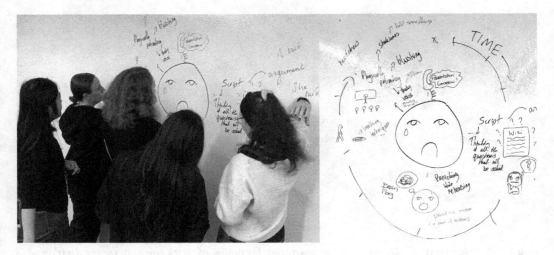

Figure 7.2 A clockface-countdown journey

7.3 Unification and Equality

The component of a circle that is most useful to a group facilitator is that its perimeter is equidistant from its center at all points. This means that, unlike other shapes that are harder to draw accurately, a group of people can be placed around the circumference and be potentially equally involved in whatever graphical process follows. For example, as a very quick icebreaker for groups I sometimes ask them to sit around the edge of a large circle (pre-drawn onto a large sheet of paper) and then to draw their journey to the venue from their home (at the edge of a circle) to the central point, which represents where they have convened on that day. This encourages them to a) think graphically—which is useful if we are about to engage in any sort of drawing endeavors, and b) gets the individuals to consider how they will represent different elements of their journeys and whether there are any overlaps with their colleagues'. I sometimes add the instructional "rule" that their route drawings must converge at exactly the same time—and that they may wish to plan how to allow the different lengths and complexities of journeys to synchronize. This very quick icebreaker (as shown in Figure 7.3 below) also encourages conversation about their lives and commutes and the sometimes tortuous routes with which their working days start and conclude.

The concept of circles representing a group that are initially equal can be a powerful facilitative tool for helping groups to have conversations about commitment and engagement, or indeed any other movable parameter where "more" is beneficial. For example, when working on residential team development programmes I sometimes conclude a day-long set of activities by asking a group to stand in a loose circle, to close their eyes, and then to simultaneously a) step in towards the center to show the amount that they feel the team has become closer and performed better, or b) to take a backwards step if they feel the team

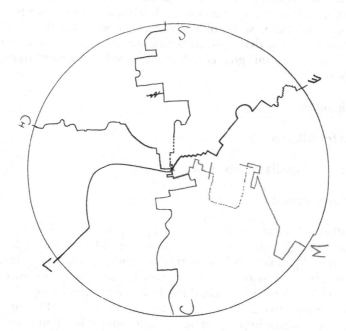

Figure 7.3 Mapping individual journeys to a shared central point

has regressed. Once the group has collectively moved they open their eyes and we have a conversation about the shape that they have created. A uninformedly-tighter circle is clearly a "good" end point to a developmental day, but different amounts of movement, or regression from the initial circumference baseline, are conduits for powerful conversations. This circular process is an effective way of "getting at the honesty" in a group (see Hutchinson and Lawrence 2012), since any sort of anonymous (eyes closed) movement is revealing and the simultaneous movement prevents any "drift" towards a bland consensus. This approach can also be used with a circle of rope or a line drawn in the sand of a beach, which can be useful if there are a number of subteams working at the same venue and it is considered useful to allow them to explain their development or progress to each other.

7.4 Compass and Direction Finding

The idea of circles forming a lens for seeing a whole "big picture" is quite a common one. For instance the Copernican heliocentric universe map (the way the Solar System is commonly illustrated), or the diagrammatized depiction of an atom with a central nucleus and electrons in orbit, or perhaps like the Mappa Mundi (see https://www.themappamundi. co.uk/)—an historic cartographic projection where Jerusalem lay at the center of the known world and everything else fitted (to modern eyes, almost comically so) around it to the edge of a circular world. This "way of seeing" from a central point outward can be facilitatively helpful—and it forms the basis of a tool that I use with groups to help them engage with issues from different perspectives or through the eyes of different stakeholders.

Start with a pre-drawn circle on a large sheet of A1 flipchart paper (personally I find taping two or more sheets together gives the space needed for a group to engage with this tool properly). Then identify (through conversation, ideation, or via prior scoping) a number of different lenses, perspectives, or stakeholders that are apposite for the group or project in question. For instance, let's say that an organization was about to embark towards a certain goal. The ultimate success of this goal could be measured and viewed through a lens that was determined by:

- Financial profitability
- Sustainability
- Environmental friendliness
- Ethicality
- Community or social media engagement
- User feedback
- Artistic or aesthetic appeal

Or many, many others; there are myriad ways to capture "success." Select a handful of these (say between four and eight) and write them around the edge of the circle —rather in the way that the directional points would be marked around the edge of a magnetic compass.

The group members stand at one side of the circle and look to the area directly opposite to them. The circle can then be rotated to allow the group to "view" the issue from a number of different perspectives. Ask the group to spend a similarly limited amount of time viewing the things from a certain perspective. (This technique is tonally similar, if mechanically different to the approached outlined in Edward de Bono's Thinking Hats—see de Bono 1985). With each view, certain advantages or disadvantages or elements worthy of note can

be added—directly to the map or using (different colored for different "directions") sticky notes. You may wish to add a "larger issue, larger writing" clause here to emphasize the visual immediacy of the plot—or alternatively provide differently sized sticky notes for major and minor points. By the time the circle has been rotated to all points of the "compass" the completed plot may contain a huge amount of data and ideas from different perspectives—which can then form the basis for further conversation and action planning. A facsimile (for reasons of anonymity) is shown in Figure 7.4 below.

In this example (illustrated as if three quarters complete) the arrow represents the alignment of the group who are, hypothetically, considering viewpoint "C." Viewpoints "A" and "B" are complete and if the circle is rotated 180degrees, the group can consider viewpoint "D."

The reason why we find this tool to be helpful is that it forces (sometimes near-painfully) groups to stop and give thought, and professional empathy, to different perspectives. Moreover, it gives disparate areas of concern equal weighting—if only for a short time, meaning that, metaphorically, even if the organization always looks North, this tool forces them to at least consider East, South, and West as options.

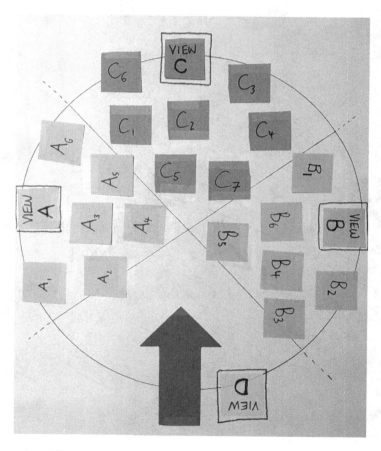

Figure 7.4 Capturing different perspectives

A similar process can be constructed by creating signed compass-bearing stations (complete with flipcharts) around the edge of a room and asking subgroups of two to three people to spend five to ten minutes in each station adding ideas or information to each one. This approach is much more suited to larger groups and can be used (with a big enough room and enough stationery) for scores of people at once. Such a process would need to include time for the information from each "station" to be compiled and reported back in plenary.

7.5 Holistic Comparisons

As facilitators we are often employed to help groups to make decisions, and this frequently requires that they are able to weigh up a number of elements and to compare them holistically. Circles, in the form of "Radar" or "Polar" Charts—which allow a visual comparison of multiple situational elements—can be enormously useful in this process. Start by identifying a small handful of attributes or elements that would be useful for the group to engage

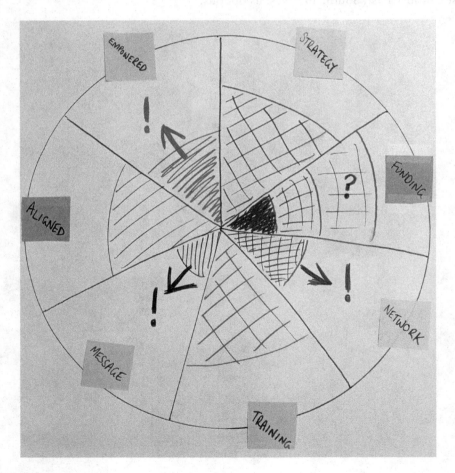

Figure 7.5 Circular radar plot

with; these components can arise from discussion with the group or from prior scoping, or from a pre-existing model (such as a "PESTLE" analysis or something comparable to Mintzberg's 5Ps (see Mintzberg and Quinn 1992)). We find that about five to eight comparative areas are about the right number; less than five somehow makes the tool feel too complex for a simple comparison, and more than eight just becomes unwieldy. Each of these areas is placed around the circumference of a circle (we tend to stick to a circle since regular pentagons and heptagons etc. are difficult to draw without a protractor) and forms the label to a wedge-section of the circle. A measurement scale is identified and marked on to the wedge where "high" or "good" (or equivalent) is closer to the circumference of the circle and "low" or "bad" (or equivalent) is closer to the center. Other scales might be subjective—such as "strength," "engagement" or objective—such as "cost" or a simple numerical count. An obvious advantage here is that the scales don't have to be the same for each wedge—thus allowing multiple disparate facets to be measured and compared against each other. The group is then invited to mark the current standing of their team, product, organization, or performance against each criterion and, by filling in the resultant wedge of the circle, create a comparative plot. An example of a completed plot is shown in Figure 7.5.

As well as being simple and easily readable to even the most data-phobic group, this form of contribution plot has a number of advantages. As mentioned already it allows qualitative/quantitative or subjective/objective comparisons to be made simultaneously—which is helpful when the group in question have different individual remits, expertise areas, and priorities. Furthermore (if tweaked to use a number or labeled radii rather than a number of wedges) it allows different projects or elements to be overlayed and compared in their entirety. (We'd urge caution here—as this adaptation can get very messy, very quickly). Finally, the plot can be used as a reflective tool after a period of change or project to illustrate positive or negative "before and after" shifts in a number of areas.

*

References

De Bono, E (1985) *Six Thinking Hats* (Penguin Publishing)

Hutchinson, S and Lawrence, H (2012) *Playing with Purpose: How experiential learning can be more than a game* (Gower)

Mintzberg, H and Quinn, JB (1992) *The Strategy Process* (Prentice-Hall International)

Sibbet, D (2013) *Visual Leaders: New Tools for Visioning, Management and Organisation Change* (Wiley)

Chapter 8

Freeform Graphics

Unless provided with ready-made materials, most facilitators need to design and plan their sessions. This is also true for any individual setting up a workshop, session, or programme from scratch. To this point we have offered suggestions such as using lines, clusters (Chapter 1); different shapes (Chapter 2); mapping (Chapter 5); frameworks (Chapter 6); and circles (Chapter 7). For the novice facilitators experimenting with drawing, you may feel "safer" working with a particular physical or process-driven graphical format. However, the examples in this chapter use an unrestrictive, more open, or freeform structure.

As a note of caution, we explored already how graphical techniques are thought-provoking and can be rapidly revealing. I (Curie) see this rapidity as a strength, since this can help a group or a series of groups "get to the point" more quickly. Visual depictions and the metaphors captured therein can, and frequently do, catalyze awkward conversations. These conversations can be about—amongst a myriad of other things:

- Whether people feel that they are valued within an organization
- Difficult relationships between team members or with people outside the team
- Stereotypes and beliefs (for instance "'we' do it this way and 'they' do it that way")
- Lines being crossed and potential misconducts
- Challenging situations and the "difficult" elephant in the room.

Experienced facilitators will already be adept at navigating the conflict that can come from such depictions and conversations, but if you are nervous about what might "come up" using graphical techniques, it's a topic that I explore fully in another work about using images to deal with sensitive topics (Scott 2024i).

8.1 Less Framework, More Freedom

Like "freewriting" (a technique designed to warm people up to the process of creating prose), the most important element of Freeform Drawings is that there are very few rules and constraints. Images can grow organically on the page, starting from any point, and may have images and text together. This is not to say that as a facilitator you provide no framework at all. There is still a structure but with fewer constraints—such as a time limitation and the edge of the paper. It's worth saying here that this freedom may in itself raise a potential problem as people may want to check whether they are doing it "right." Again, reassurance and encouragement may be all that is needed. There are two steers here that may make any freeform graphical exercise work more effectively. Firstly, it takes some

DOI: 10.4324/9781003410577-12

people considerable time to warm up to the process. This (as we've already explored) can be accelerated, with graphical warm ups—but it still requires considerable nerve to let a group struggle without pulling the emergency brake and changing exercise before anything interesting has happened. The second piece of advice, if asked by a group how to engage with a freeform exercise, is to suggest that they are just honest. Ultimately if what they create is a true reflection of their feelings or situations, then it is right and good and proper, even if it is ugly and poorly drawn. The physicist Stephen Hawking once said that there is "no unique picture of reality"—but if your participants and groups are honest, then they can create something that uniquely depicts their real state—and that is potentially very powerful indeed.

8.2 Collaging (2D)

When working with adults, one of the first blocks to graphic facilitation is the cry that "I can't draw." There are numerous debates and ways to answer this claim, which we dealt with earlier in the book. However, a simplistic way around this is to use an activity where no drawing is needed. Collage is my (Curie) number one freeform graphic facilitation "go-to" as it does not require any drawing or artistic skill whatsoever. As a tool, it is especially since collaging is a familiar practice to most people—think, for example, of mood boards, developing a Pinterest board or collaging photographs for a digital album. People are less concerned creating a "good" picture, as whatever is produced is a composite. As such, they start to see the wood rather than the trees. However, in my experience, participants may make comments along the lines of it being "childish" so the process may need some gentle encouragement. Furthermore, there is no pressure to draw from one's imagination and this reduces any guarding and hesitancy—simply looking through images can trigger thoughts, ideas, and insights. As such, it is worth having a stockpile of images, or collecting old magazines and newspapers for people to sift through.

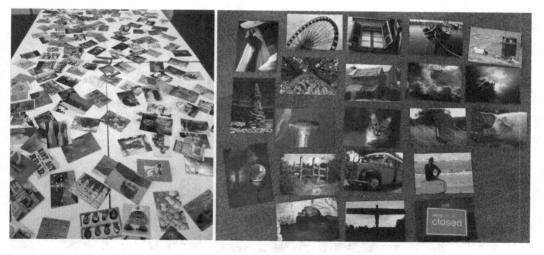

Figure 8.1 It's useful to have a stockpile of ready to use images from which learners can create metaphors and collages

The obvious downside to collaging is the resource requirement for an in-person event—at the very least you'll need magazines, card (paper is too flimsy), scissors, and some sort of sticking medium (tape/glue/sticky tack). You'll also need time and to cover your workspace to prevent it getting messed up, and leave time to clear up.

Collages work for many prompts and work especially well to help groups to explore nebulous concepts in order to discern specifics. Here are some examples:

- What does a successful team look like?
- What does wellbeing at work look like?
- What is the perfect brand?
- What is illness?
- What are the elements of "good" (customer service/patient care/research etc.)?

This section concerns two-dimensional collage, but it can also be done digitally and in three-dimensional sculpture form (which are dealt with in later chapters); but the principles are the same. The approach is based on the images "speaking" or "attracting" a person's attention and, as such, using a more intuitive thinking process.

I find that it is helpful to set up the room properly beforehand and I get people to collage whilst standing to encourage movement (but ensure chairs are provided for those who wish to sit). I scatter torn out images or magazines or postcards around a set of tables or on the floor. I offer the core prompt (as above) and invite people to walk around the tables, sift through images, and collect by taking out any pictures that "pull" or "draw" their attention.

I encourage them not to think too deeply, just collate a pile of images. I tend to set a time limit of five to ten minutes for this, which works well. It is at this point I give out pieces of card and glue sticks (or sticky tack if you want to reuse the postcards). Card, as a substrate, tends to work much better than paper, but the size of the page can be adjusted. I've done this quickly with postcards, A4 card, or A3 card as well as larger composite collages (Figure 8.3). Another ten minutes to place images on the piece of card and adjust works well.

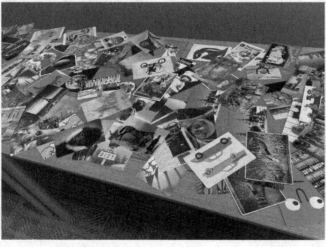

Figure 8.2 Scattered materials and participants moving to explore

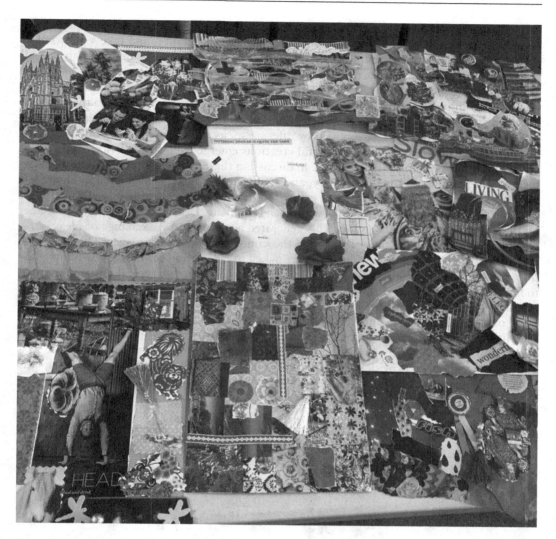

Figure 8.3 Larger composite collage

I suggest that they cover all the white of the card (to be honest, this is just aesthetically more pleasing!) and keep shifting images around until they feel satisfied. This is subjective but calling out regular time intervals helps people keep to time. Once they are ready, the images can be stuck down. Depending on how much time is available, the collage can be stopped at this stage. However, I tend to invite people to draw on the top with linking lines or embellishing their collage. For example, by denoting which aspects are more or less important, we identify what areas need to be further developed by the team.

For me the ideal is that the activity engenders insight and conversation. At the very least, I ask the group to quickly scribble some reflections on what has emerged for them from the activity with a date. This can be on a piece of paper, sticky notes, or an audio/video note using their smart devices. If the group or individuals are going to take their collage away with

them, I suggest that the reflective note is stuck on the back of their collage. Depending on the context, I ask people to put this up somewhere they can reflect on it and take a photo of it.

If there is time for discussion, depending on the context, this can be done in pairs, small groups, or between groups in plenary. A good provocation is the simple phrase "tell us about your collage." Be warned! People like expanding on this so you may need to give them a time limit. I like displaying the collages either on tables (Figure 8.4), so they act as a "collage carousel" for everyone to walk around, or on the walls, which turns the place into a pop-up gallery. This can be expanded by offering sticky notes for people to add questions or comments. It is amazing what beautiful creations emerge from this activity!

As with other drawings, there is value in discussing these, but this is the facilitator's judgment call depending on time, sensitivity, and set purpose. The collage created in Figure 8.3 was in a large art studio setting, with a group of thirty-five people within a longer two-hour session. Therefore, no discussion time was given but, instead, there was a display of collages on tables for people to walk round. This generated a more natural exchange of ideas.

Digital collages, on the face of it, sound the same—a collation of images. The difference is that they are not random if individuals are asked to collate and select their own images—they are not drawn to random images but search for them through logical thought. That is, to find a particular image people will use a search engine and a text-based search term. This does not invalidate the process, but it does change it. One method may be to collect a digital bank of images and ask people to visually scan and collect images that they are drawn to, but the compiling of such a resource bank is labor intensive. A workaround might be to ask a group to each collect "twenty interesting images" in ten minutes, upload these to a Padlet, and only *then* provide the provocation or topic for collaging. Twenty participants each providing twenty interesting images gives an image bank of 400 images that can be saved and reused in the future.

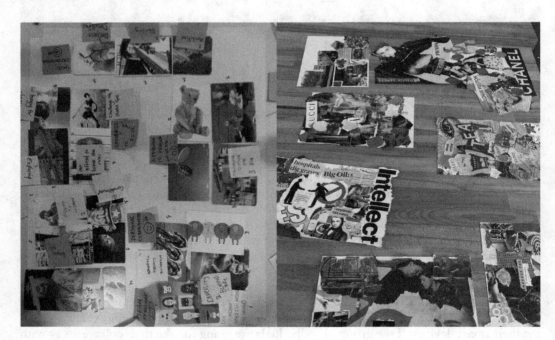

Figure 8.4 Displayed collage "carousels"

We'll revisit collaging in Chapter 10 as we move away into the Third Dimension of facilitation.

8.3 Creating Vision—Picturing Success and Seeing the Future

Professional management development programmes frequently emphasize the importance of leadership vision, and a graphical approach can be a great way of raising this somewhat esoteric concept with groups—either in a formal training, personal development, or group facilitation scenario.

In many ways, the medium (pens/collage/picture cards etc.) doesn't matter in order to achieve the desired outcome. What is important is the notion that a group will create metaphors and illustrations of the *unknown*. These images can then be unpacked and discussed and make powerful reminders of conversations and aspirations. As is the case throughout this book, a picture is worth a thousand words—since the notion of success can be vague and subject to multiple interpretations within even a small group.

For instance, in Figure 8.5 (left), as part of a culture change programme, a group were asked to create an illustrative depiction of *"what they wanted to see 'more of' within their organisation"*. The group were not particularly artistically adept, but illustrated areas such as "collaboration," "accessibility," and "equity."

Their discussions around elements such as "so what does accessibility look like?" (in this case an open office door of a manager) were more fruitful than a quick word on a flipchart and a discursive sidestep to another topic. The time it takes to draw even a simple figure may seem like time wasted, but it allows a group to:

- Interrogate what a named concept or behavior actually means
- Democratize the contributions of all group members

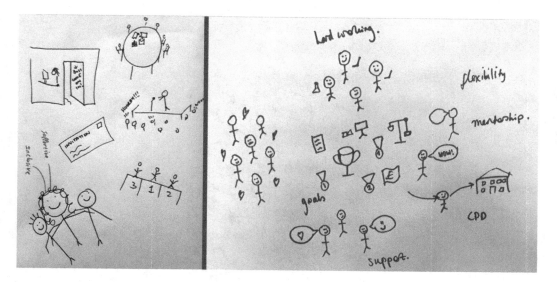

Figure 8.5 Freeform responses to the questions: "What do we want 'more' of?" (left) and "What is Success?" (right)

This democratization means that every group member is able to add richness ("draw a podium where everyone wins") whether they can draw or not and whether or not they are holding the pen. Also, because unskilled drawing is thought to be something of a child-like activity, it means that the junior members of the group often end up holding the pen and controlling the narrative. More conventionally, of course, this inclusivity of ideas can be achieved by asking individuals to write down their own thoughts before sharing them in a group (in the words of Matthew Syed in the book *Rebel Ideas*, it is important to "protect cognitive diversity from the dangers of dominance") but such pre-preparation is not always possible and graphical sharing adds a degree of play and good feeling to the activity. Most groups will reach this point of democratizing a discussion quite quickly—and (after a small initial wariness!) more so than in a conventional creation of a group list.

The notion of "picturing success" can be adapted to fit many agendas and can be set up with many different questions. For example, in Figure 8.5 (right) a different group were asked to draw "what is success for this team?," and a conversation ensued around the balance of areas that they agreed to focus on. Again, as previously, the different success indicators were unpacked (e.g. "You show success as money and trophies. Is that everything or does that mean more?")

A similar freeform envisioning approach can be used in many types of facilitation activity. For instance:

- What would be the "ideal?" (For instance, in Figure 8.6 a group of doctoral researchers were asked to envision the "ideal supervisor")
- What sort of culture are you trying to create?
- In an ideal world how should we be engaging with each other?
- What does "equality" (or any concept such as "professionalism," leadership etc.) mean to this organization?

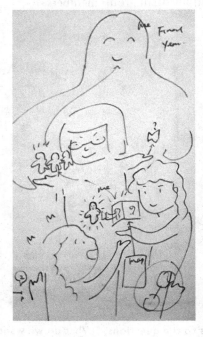

Figure 8.6 Picturing the Ideal; in this case the ideal supervisor

The lack of rules, the lack of a framework (other than the page) and the lack of pre-existing structures often means that groups are slow to start and to get going with this sort of activity, but the results—and more importantly the conversations—are almost universally productive and powerful.

8.4 Freeform Drawing for Writers: Visualizing "Flow"

Many of the graphic facilitation examples in this book are to help a group explore, clarify, and discuss abstract concepts. However, graphics can also help individuals distil and develop their ideas for written work and presentation. We use drawing during facilitation centered on developing writing skills, such as academic writing, and for longform writing such as dissertations, reports, and book chapters.

Though I use drawing to help people to think, for the following example (ironically in a chapter I was writing for a book about establishing a drawing community of practice), I didn't follow my own process and I forgot to use drawing! After many stop-start rounds of generating text for the chapter, I became frustrated and suddenly remembered to try a freeform graphical approach!

The aspects I already had in place, which will be familiar to all non-fiction writers, wre the theme of the book, my chapter title, an abstract, and a word count. As the chapter entitled "Drawing Edges" spanned a ten-year professional journey, I was struggling to distil the main elements. I started, however, with this kernel of a "long journey" for this freeform graphic. Figure 8.7 was the visual drawing result on the topic of developing a community of practice (Scott, 2024ii).

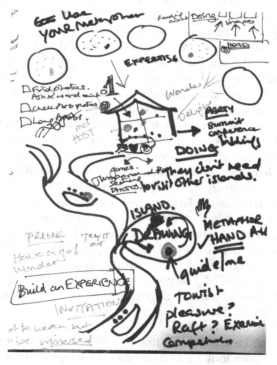

Figure 8.7 A freeform "long journey" as a catalyst and conduit to writing

Unusually, but helpfully, I chose to start at the bottom and decided to work with the metaphor of a river trip heading upwards on the page. I drew onto large cartridge paper, had marker pens in different colors with the paper positioned flat (but if preferred the page can be stuck on a wall). A collaborative or participative drawing can be created, but for simplicity a drawing by a single creator is discussed here.

The river could have started anywhere, but here it starts at the bottom and ends at the top with two big aspects emerging: the island on the right, the meeting place in the middle center (equating to the monthly meetings), which was fed by different types of modes of inquiry. The one on the left was ultimately redundant. In this situation, drawing that has no specific drawing "code" is enabling (in that the pen-holder can create as they wish), but this does mean that the drawing is likely to be meaningless to anyone else. Here I simply found that the "flow" of the river (especially working from the base of the page upwards) allowed me to create natural movement from idea to idea. This activity took twenty minutes and allowed me to note down the key concepts and structure of the chapter. It's subsequently an approach that I (and Steve) have used with writing groups and when coaching "stuck" authors. (The idea of a graphical river that flows in an exploratory way is discussed as a collaborative graphical tool in Chapter 11).

8.5 Observational Drawings

Finally, for a book on graphic facilitation, it seems remiss not to mention what people generally think of when we mention "drawing." This is a drawing that has a likeness to an original object or scene and is known as objective, observational, or representational drawing. I would argue that ALL the graphical methods in this book are, in some way, representational. That is why we use them. Producing facsimile through observational drawing inculcates a focused way of seeing. Various methods are used to help people draw in this way. A short paragraph does not do justice to the skills necessary to create or render drawings. Training is best delivered in in-person workshops by artists, though other options are videos or specialized books on observational drawing (such as Betty Edwards' [2008] book). Observational drawing skills include learning about line, tone, perspective, shape, and when relevant the sense of touch (the haptic sense).

Certain techniques used for accurate representational drawing can work well for graphical facilitation, and drawing from "life" has utility in some organizational setting where "observation skills" are part of a competency set. For example, Observational Drawing is used with medical students, for whom clinical observation is a vital skill—in that they need to be adept at noticing, recognizing, and spotting patterns to help them diagnose patients' conditions. Observational drawing has a close relationship to slowing down (some might call it "mindfulness") to *really* look at the details. Training sessions for aspiring doctors are often co-facilitated by external artists whose remit is training people to use "artistic" ways of seeing to create observational drawing. For example, Shapiro (2024) and Wright (2017), both artists who use observational drawing with surgeons, demonstrated that close observational drawing directly improved surgeons' observation skills and accuracy.

In the context of this book, some of the techniques used in warm-ups for observational drawing are light and fun and can be used to orientate participants to other graphical approaches, especially if they are nervous.

One such example that I use is "blind" drawing (Figure 8.8). Each participant focuses on an object and draws without looking at their page. This type of drawing is created in under

Figure 8.8 A blind drawing of an easel (in **30** seconds)

a minute with a continuous line (i.e. the pen or pencil does not leave the page). Be warned: people will cheat! I then distribute the images around the room and see whether people can guess what the object is. I use this technique for breaking up the working day, having mini wellbeing breaks by shifting position, and raising questions about noticing what we see in terms of patterns and the realities of peoples' day to day professional existence.

*

References

Buzan, T (2018) *Mind Map Mastery: The complete guide to learning and using the most powerful thinking* (Watkins Publishing Ltd)

Edwards, B (2008) *The New Drawing on the Right Side of the Brain* (HarperCollins)

McGilchrist, I (Reprint 2010) *The Master and His Emissary: The divided brain and the making of the western world* (Yale University Press)

Scott, C (2024i) Practical ethics guidance on using drawing for sensitive topics. In Lyon, P and Scott, C (Eds.), *Drawing in Health and Wellbeing: Marks, signs and traces* (Bloomsbury Publishing Limited)

Scott, C (2024ii) Drawing edges: exploring the boundaries of drawing practice and research. In Devis-Rozental, C and Clarke, S (Eds.), *Communities of Practice in Higher Education: Informal spaces to co-create, collaborate and enrich working cultures* (Routledge)

Shapiro, L (2024) Touch and drawing to enhance spatial awareness in medicine: the Haptico-Visual observation and drawing method. In Lyon, P and Scott, C (Eds.), *Drawing in Health and Wellbeing: Marks, signs and traces* (Bloomsbury Publishing Limited)

Syed, M (2021) *Rebel Ideas: The power of diverse thinking* (John Murray Publishing)

Wright, J (2017) *Extending the field of drawing and its relationship to surgery and developing medical technologies and procedures.* Unpublished PhD thesis, University of the Arts, London.

Chapter 9

Space and Movement

Most of this book centers on two-dimensional graphics on a flat surface. This section expands the frame and canvas, and physical space becomes part of a large-scale drawing.

As we discussed in Section 1 of this book, physical space (lighting, furniture layout, room temperature, etc.) impacts the process of facilitation. For example, I (Curie) used to teach nursing students who said they found it easier to "tune in" to the scientific subjects in the specialist clinical skills room (a room with books, posters, and plastic dissection models to hand) compared to the blankness of corporate-style seminar rooms.

One way of using physical space is to relocate the group to a different location. Simply taking the group outside of the room they've been in all day can have a catalytic effect. To move too far, or to opt to work off-site entirely (such as the beach sessions outlined later in this chapter) requires a high level of administrative autonomy and facilitators are often allocated a fixed space. However, wherever I work I try to adapt the graphic techniques to the environment. On occasion I can plan specifically for the location (e.g. a field center or a beach) but, mostly, I improvise (e.g. such as collaging in a tiered lecture hall) by changing the size of the page, complexity of instruction, and the drawing materials.

Before we move to a large scale, we'll start with limiting the space on a page with a boundary. There are similarities to working with triangles, squares, circles, and models or frameworks (Chapters 4, 6, and 7) but instead of abstract shapes the basic graphical boundary has linked connotations (such as a body outline).

9.1 Using a Template

Using templates to boundary space on the page works well as it precludes fear about drawing ability. Templates work well for a summary, memorization, or distraction tool. Figure 9.1 was the "handout" (literally a "hand" out) of a two-hour workshop on building up ways for developing continuous professional development (CPD) opportunities to embed at work.

The content of the session fitted into five areas: what, when, who, why, and how (WWWWH), which provided a natural framework of the number five that deftly equates to the five fingers of the hand. I asked the group to use their dominant hand to draw around their non-dominant hand. This is an easy drawing to create and then writing was added into each finger. We went through each question area and they applied the framework to their context to make continuous professional development "effortless." The first time I ran it, it was an improvised activity to accommodate a blended live and online group, but it worked surprisingly well!

DOI: 10.4324/9781003410577-13

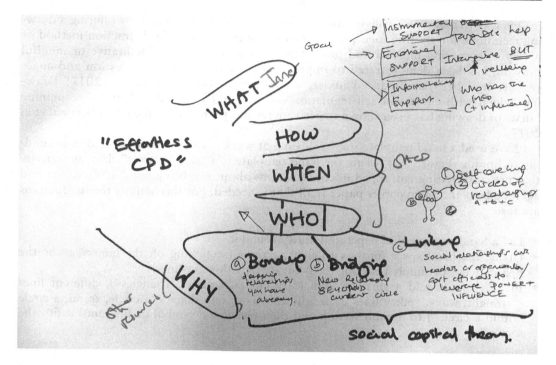

Figure 9.1 Using the templated "space" of a hand to facilitate professional development conversations.

Obviously, if using a template such as a hand, then it is useful to have subject matter that is readily divided into five parts (or six including the palm). For this situation, I knew the "who" would take more time, so I consciously positioned that one on the "index finger," which was naturally surrounded by more space in which to work. Each person created their graphic finger by finger, which I think added a little mystery, but it also works well as an end-of-session visual review of the content. The other value of adding the "why" as the thumb was to help participants stay focused on the purpose of any action—as fingers and thumb work best in tandem. We now continue with the hand as a template but used in a very different way!

9.2 Mindful Drawing to Aid Wellbeing at Work

Workplace wellbeing is an area that many organizations are both investigating and investing in. How they do it is reliant on the value bases, power dynamics, hierarchies, and focus of the institution. People management training or leadership development affords an excellent opportunity to bring about conversation on stressors in the workplace. Conversations about identifying signs of burnout, how to ask staff or co-workers about their mental health, or identifying strategies to reduce physical or cognitive load should be productive in terms of reducing days off work, improved relationships at work, and increasing staff retention. However, these are emotive topics and need to be handled with care, and facilitators that work in the broad remit of wellbeing will probably have advanced facilitation skills.

One way to make such conversations less stressful (or distressful) is by offering a drawing technique for shifting focus, to escape overthinking, and as a distraction method or a way of becoming mindful and present to the session at hand. Meditative or mindful drawing has been demonstrated to improve mood states such as depression and anger (Archer et al 2015) and reduced anxiety during cancer therapy (Altay et al 2017). Drawing helped with emotional self-regulation (Dresler and Perera 2019) and three-minute bursts of drawing has been shown to activate reward pathways in the brain (Kaimal et al 2017).

I have used a hand template for "wellbeing at work" workshops as a mindful grounding technique (Figure 9.2). Using the hand template is a good "starter" drawing activity that prevents getting entrapped in conversations about not being good at drawing. And again, a biro and plain copier paper is all that is needed. For this activity the instructions are fast:

- Lay a hand on a piece of paper and draw around it.
- Divide the hand space into six to eight sections (sectioning off the fingers, using the "palm lines" or simply bisecting the palm space with wavy lines).
- Invite them to add a small symbol ("try circles, squares, triangles"), different lines ("straight, wavy, spikey lines"), or adjustments of one shape ("a circle, spiral, a circle within a circle") to a palm section and then repeat the symbol or line until it fills the section.

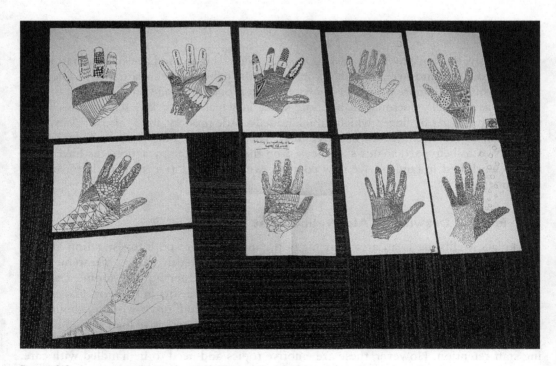

Figure 9.2 A group exhibit of mindfully doodled hands

The activity is usually placed at the beginning of a session or after a break, as people are trickling back into the room and can take no more than about five minutes. It is a quiet activity and the shift in the atmosphere is palpable. I invite people to "tune into" the sense in the room after five minutes or so, or invite them to call out words to describe how they are feeling. Words have included "peaceful," "settled," "bored," "rested" etc. I ensure that I leave time for them to "show your hand."

As an activity, it can also be extended to "accompany" difficult conversations as people talk about their challenges and stressors and may take far longer than five minutes.

You will notice in Figure 9.2 that the diagrams, with the same instructions, differ a lot. For me, the key thing is that they have experienced a drawing technique that they can easily do again and again with few materials.

There may be contexts such as where a simple written guide to "draw around your hand, divide into sections and doodle" with basic materials will help people feel calmer in high stakes, such as in waiting rooms or space outside an assessment. If a new group is arriving to a room, or for those who find social situations awkward, this type of mindful activity can be laid out as an experiment explicitly, as people start trickling in. For instance, as people arrive, invite them to chat or do a doodling activity with something like "Welcome, I'm interested in seeing if having some scribbling helps whilst we wait for everyone. Feel free to chat or doodle." Some people (like me, Curie) would happily chat to strangers, whereas other people (Steve!) may find it useful to do something like doodling. This engenders a subtle social centring in a group setting, that is, gathering the collective focus of the group members, who are settling into working together. Taken further, a collaborative doodling output can result in a larger co-created design to decorate the workspace, such as a painting, or wall mural. This sort of large-scale drawing project occurs more in schools; however, I think it has the potential to improve the sense of belonging in organizations too.

This mindful form of drawing can be actively used as a meditation. For example, I was part of facilitating a half-day workshop with a team who were reflecting on the whole year and then setting goals for the next. The flow of the event was organic, with different people leading. I was asked to lead a gratitude practice (this practice offers positive benefits for organizations, see Newman's (2017) summary) but I was not expecting (and therefore had not prepared) for the group to be lying on yoga mats, rested, and barefoot after a yoga-based meditation led by someone else! Instead of moving everyone to tables and getting them to draw round their hand as planned, I gave out paper and pens in situ and asked them to draw around their feet and doodle in the same manner as outlined with hands (above). The difference was that, as they doodled they were able to say something about why they were grateful for their feet. The drawing process was therefore symbolic of a centered or prayerful activity, and continued for forty minutes as each person shared their reasons why they were grateful for their feet. By the end, they realized their feet had enabled a lot of "walking" into and out of situations and appreciated time to be thankful for things they usually took for granted.

Mindful drawings can extend way beyond doodling patterns in a hand or foot (See Scott 2020 and Greenhalgh 2015 for other examples). Letting the pen wander as the mind wanders (as in Figure 9.3) can produce a mesmerizing drawing of lines starting from the center of circles reminiscent of tree rings or cartographic contours.

I appreciate that this practice may not seem directly transferable into organization learning and development. However, I think more humanizing practices will become integrated

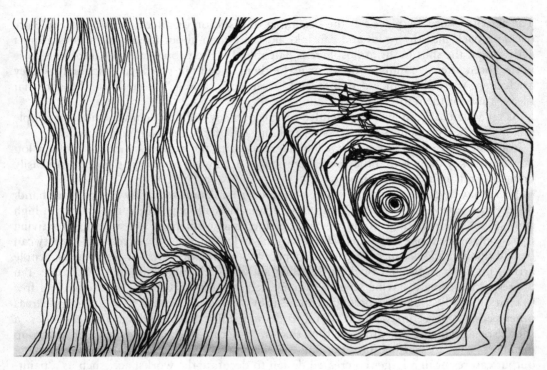

Figure 9.3 Mindful line drawing

into work through the newer field or "Positive Organisational Scholarship." Graphic facilitation for gratitude-based conversations to proactively appreciate one another (essentially by saying more "thank yous!") offers a relational process to humanize the workplace and improve wellbeing (Devis-Rozental and Clarke 2020).

9.3 The Face or Body as a Spatial Template

Templates may help boundary thought and discussion. Professional development often interrogates the qualities, attributes, or characteristics of an individual, a team, stakeholders, or the organization. This lends itself to visual characterization to a face, body, or physical structure. For example in the education sector, I (Curie) led and taught the PGCert in Education for university lecturers—essentially a qualification to equip HE teachers with a certified range of teaching skills and, as programme lead, I also wanted to encourage them to gain skills for safeguarding their wellbeing and knowing the HE system(s) adequately for their career progression.

So activities I run include questions from the individual to institution level:

- What are the attributes that graduates (i.e. their students) in your discipline need to have when they qualify?
- Drawing upon your own life experiences, what are the skills and attributes of the best teacher?

- What are the attributes of the worst supervisor/manager?
- What is your ideal confident "self" at work, you at your best?

Essentially, this is a list-generating activity, but providing a body outline meant that they could position their contributions metaphorically in body-based zones ("compassionate" might be aligned to the heart, "intelligence" to the brain). Each individual or group can be given a body template to augment. However, you can see in Figure 9.4 that when I gave out a pre-printed outline with a prompt to "draw," what transpired was a series of labels (either because writing is easier or more often the expected form). That was a learning experience for me.

From this basic point I started to adapt and expand the frame and space. One example was to draw the outline by using a physical body as an outline. A volunteer is required to lay on (large!) paper, or if outdoors, use chalk to outline on tarmac. The group then add to the drawing. Since they've "drawn" around the volunteer, they tend to keep drawing rather than revert to the written word.

Another adaptation is to ask people to create caricatures or full body cartoons that incorporate exaggerated parts of the body or characteristics. For instance, in Figure 9.5, notice that the ideal employee at the organization in question has three arms, a small cricket-like conscience on the shoulder, and computers instead of feet (illustrating a foundation in IT skills).

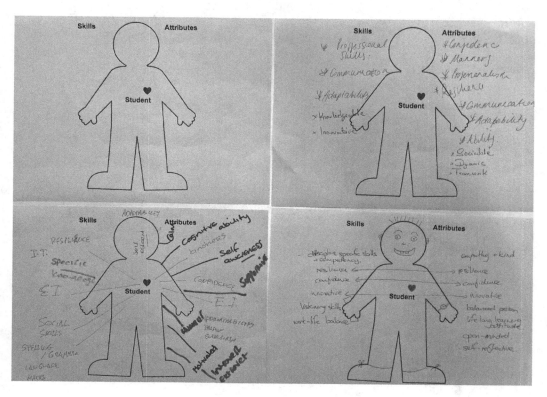

Figure 9.4 Body outlines illustrating "graduate attributes"

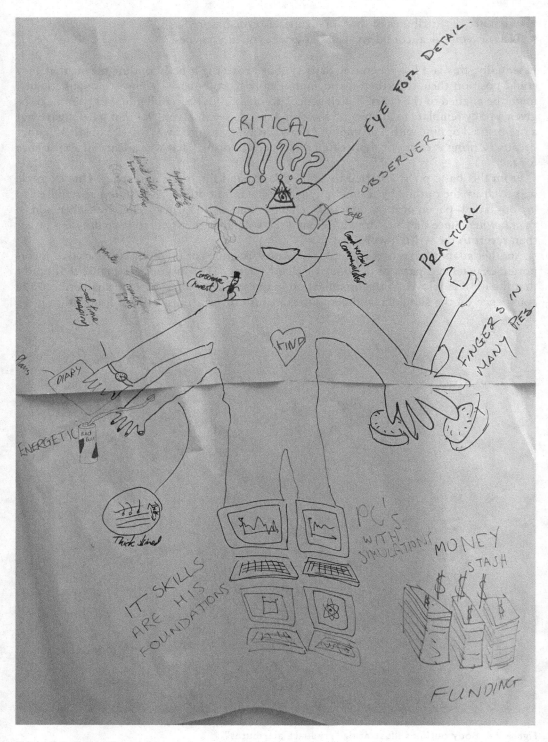

Figure 9.5 Full body representation of an ideal employee

9.4 Physical Movement and Visual Position

While many of the tools and techniques that we practice and detail in this book involve a degree of movement—usually of a line in relation to time, performance, or another variable—there are of course many other ways that movement can help a facilitator or teacher to aid a group in conversation or decision-making. For a group or individual to move an object, card, or even their own physical selves, requires that they decide what such a movement signifies and then commit to it.

For example, a very simple technique that I (Steve) frequently use is an approach I call "visual voting." I write the words "Agree" and "Disagree" on large sheets of paper at either end of a room. I then read statements to the learning group and ask them to move to the "agree" or "disagree" spaces—to indicate whether or not they agree or disagree. The statements to which the group respond can be linked to the focal topic of the event or away day (e.g. "this group is effective in the way that it shares information") or more centered on values and beliefs to elicit responses on more fundamental issues (e.g. "Honesty is always the best policy"). The group move to their respective position and debate or argue with their counterparts in the opposite group, so as to try to persuade them to move.

It is, in itself, a technique that stems back centuries—but is consistently effective because the individuals have to commit physically and kinaesthetically to their views and opinions. Moreover, with a less mobile group, or in a room with fixed furniture, a similar commitment to a position can be achieved by asking individuals to write their own name on a sticky note and then physically placing it on the "agree" or "disagree" areas. Asking them to mark their position with a named post-it note can produce a highly memorable, and photographable, map of their positions. Moreover, a sticky note can be placed on a wall at a number of points between the "agree" and "disagree" absolute positions—creating a visual Likert Scale on one or (using different colored sticky notes) more issues.

This approach, based on physical movement, can be simply extended by converting a training room (or meeting space, or playing field, or beach...) into any given managerial model using masking tape, chairs, rope, or a real line in the sand and asking people to physically commit to an area of it depending on their lived experience.

Moreover, such a technique can be further enhanced by using a physical model mapped out on the floor to create "stations." For example, create a two-by-two matrix on the floor

Figure 9.6 Using the physical space in a room as a graphical aid

of a room, using masking tape or rope, to illustrate four discrete stations. The specific matrix here doesn't matter; it could be created using any two given axes—high to low, easy to hard, good to bad etc. For generic simplicity, I'll refer to these as stations one, two, three, and four. Asking some of the group to stand in each station and tackling a question or issue through this positional lens can reveal new and creative possibilities. The group at station one may have totally different insights to those at stations two, three, or four. Groups might record their thoughts on a flipchart located in each zone. An activity might end here, but easily be extended by asking the group to rotate around the four stations and spend a short amount of time in each space.

As with all facilitatory tools, the value herein is not the activity per se, but the enquiries and conversations that follow. For example:

- What's the worldview from that perspective?
- What are the advantages and disadvantages of that position?
- What would you say to people from the other position?
- How does this difference present itself in reality? (i.e. in your actual team etc.)

The commitment to a physical movement or the embodiment of a position can also be counter-effective, since sometimes people don't want to commit, or perhaps feel that a public display of honesty would be professionally imprudent. Even here, a graphical approach based on movement can still be carefully employed, but it's important to build in ambiguity and places where people can commit to a position safely.

9.5 Ordering Ideas and Information Using Space

I (Curie) was working with a group on the topic of assessment with a colleague who brought forward this technique, which enabled the group to see the differences in opinion (rooted in different philosophical stances). It sparked conversation and controversy across people in different academic disciplines. Twenty-six statements (labelled A to Z) about assessment were typed out, printed onto A4 paper and laminated. The group were asked to come to a consensus: to order the statements on a scale of "most important" (one side of the room) to "least important" (the other side of the room). Through the activity, people realized that different things are deemed of greater or lesser value (and therefore according variance in marks) contingent on the prevailing discipline. This activity sparked conversations as people debated and challenged each other's positions.

Linked to this, one of the earliest additions to my (Steve's) professional toolbox was the "diamond nine." This tool has existed for a long time and there are many examples and templates online—but it's worth mentioning here because it's a great example of how movement can contribute to a low-risk, high-impact tool to help start conversations and help groups prioritize thoughts and make decisions. I start by creating a list of nine ideas or options—this task can be done by individuals first, or by a whole group or subsets of a group. Alternatively this list can be pre-compiled and presented. Create nine individual cards or sticky notes—one per item. For example, nine areas of skill in which a facilitator needs to be proficient are illustrated in Figure 9.8.

Then ask the group to re-arrange the cards according to a specific prioritization request (e.g. most important, or hardest to learn, or most undervalued etc.) and have them place

Figure 9.7 Spatial ordering of information to facilitate conversation

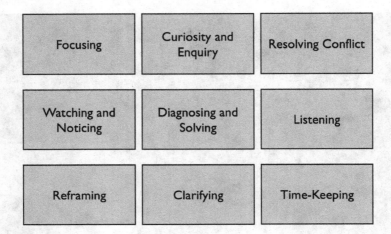

Figure 9.8 "Diamond Nine" starting position.

the cards into a diamond formation of a single choice at top and bottom, then two cards followed by three (the widest part of the diamond) before reversing (see Figure 9.9).

The act of moving the cards around has value in that the group must commit to a decision, but the notion of having two or three flexible "spaces" for mid-ranking ideas allows a group to compromise and reach agreement without becoming entrenched as to a specific position.

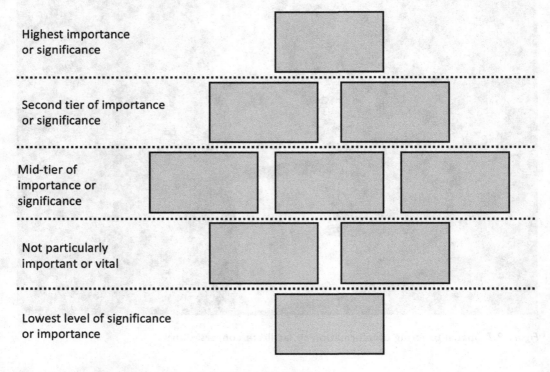

Figure 9.9 Diamond Nine—the 1-2-3-2-1 finishing position.

There are different ways to adapt this activity. For example, for greater flexibility, I often give the group a blank "joker" card that they can use to replace one of the starting cards. They can write their own new idea on the card and fit it into the diamond formation at a place of their choosing—provided they remove another first.

Another idea is to ask the group to keep a "diamond" formation to their answer but to physically distance the cards from each other to show relative differences in significance. It may be that one answer is above all others that are somewhat bunched, and this can be easily illustrated with actual distance.

The opposite is to NOT keep the rigid format but to create a "looser" diamond and simply to invite people to make choices about what matters most and least to them. This can form a powerful technique in individual as well as group coaching. I (Curie) work on Women's Leadership programmes with successful women who describe the pressures of guilt, especially when they are gaining a higher qualification and therefore juggling studying with work and family. I provide a large number of different cards to signify different parts of their professional role and ask them to move and prioritize the cards according to importance (Figure 9.10). I use this method as a "reality-check" for the course delegates to show that they cannot do all things at 100% and must make conscious choices on how to prioritize based on their capacity.

An interesting variation is to ask a group to rearrange the cards, but not to specify the criteria that they must use (even if they ask you to clarify). This ambiguity produces potentially very rich results and I've seen groups present answers where the diamond formation can be viewed physically from North, South, East, and Western perspectives with a different prioritization filter illustrated from each point of the compass—and the central card of the nine being pivotal rather than bland.

Again, the value in such an exercise or approach often comes from the questions and enquiries that accompany it, for example:

- Was the ranking decision unanimous?
- What's the significance of the distance between cards?
- How does that positioning show up in real life?
- How would you choose to lay out the cards if you were unconstrained by the diamond formation? Why didn't you?

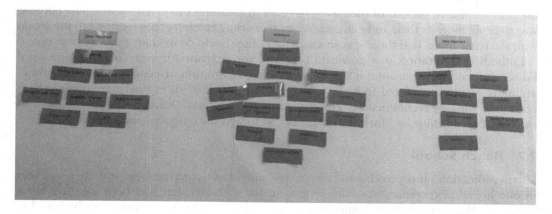

Figure 9.10 Loose diamond ordering to assist prioritization

9.6 Drawing with the Body: Embodiment Practices

I (Curie) was leading a small mixed group of staff in a grand building. The session was to facilitate conversations on diversity and the interplay of our many selves in the workplace setting. Traffic problems in London on the day caused a fifty-minute delay to starting the half-day workshop. I had planned to do a timeline looking at work and life experiences as described in Chapter 3. However, I could sense agitation and irritation. Therefore, I flipped the activity into one with more movement.

I gave everyone, including myself, 2.5 metres of string, which became their timeline. I placed my string in a straight line, specifying that the position I was at (one end of the string) was "now." I walked to the other end, which signified the start of my working life, including any training time. The length of the string was therefore a timeline of their work life. Walking alongside the string line, I asked people to express with their body something that captured that period of time and note how it felt. You can see how it would be helpful to see this modeled in action first! For example, I mentioned that my first professional training was at medical school. I went to the "beginning" end of the string timeline, I crouched down, shrinking my (already small) frame into a ball. As I did that, I got the sense of being a shy mouse, not cowering, but curled up and watching. I shared this insight with the group. Moving along a bit and portraying my increasing confidence through training, I stood and mimed putting on a white coat with a stethoscope around my neck and then walking with head upright (as if I was walking through the ward). I continued to punctuate different parts of my story through body positions, narrating alongside.

Since I had plenty of room, I explained the activity and then each person went into a chosen area such as a large staircase, a wide hallway, side storerooms, or along one side of the room. The tension dissipated as people worked in a more private way than normal and could move for the activity. To put it metaphorically: they had been "trapped" in traffic but were now "free" to move and explore.

When using graphic techniques, I tend to avoid a demonstration as (generally) people then produce something similar to my output. But this exercise involved body-centred (or embodied) work, which I was starting to bring in as a newly trained embodiment facilitator. Ultimately participants were asked to express, through a body gesture or position, something that encapsulated certain work periods of their life, walking along the timeline represented by a long piece of string. I went to each individual in their allotted space to learn about their experiences. The point was not for each person to share in detail as I had done, but rather to "re-live" the embodiment of periods of their lives, in order to re-connect to "past" selves. The purpose was to bring more of their authentic self/selves to work. Therefore, they returned to the group with the realizations that there was so much more they could do to enjoy their work better.

Embodied facilitation is a powerful tool and can activate an array of emotions—and I'd recommend incorporating it into your existing facilitation or coaching practice. There are more examples, related to being a lecturer, in Scott (2024). Furthermore, an excellent book that I highly recommend is *The Body in Coaching and Training: An introduction to embodied facilitation* by Mark Walsh (2021), who was my embodiment facilitator trainer.

9.7 Beach School

Finally, sometimes it is possible to bring space, movement, and the graphical form together in one holistic experience. As a finale session for a cohort that had been together for a year, I (Curie) wanted to try something really creative. I was lucky enough to be based in an institution close to the sea, and so with a colleague I put together a series of activities

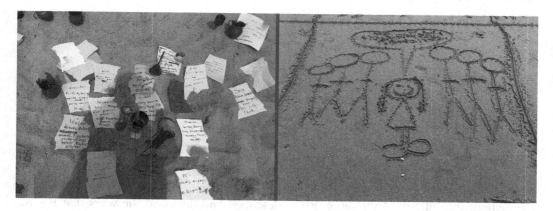

Figure 9.11 Beach School activities included haikus (left) and sand storyboarding (right)

that we called "Beach School." This event incorporated similar activities to those described in this book, but using found beach materials. We centered on education practice, but the event was light-heartedly framed around sea-based themes, such as trying to find treasure as pirates, writing haikus using feather quills about teaching and learning (Fig 9.11 left), and drawing large storyboards in the sand with sticks (Figure 9.11 right).

You may not be located near the seaside, but as facilitators you may be asked to run away days in interesting locations. We've run sessions at, amongst other places, an art gallery, a museum, an arboretum, a football stadium, and a zoo and each time we've tried to incorporate the place and space and movement into our graphical facilitative work. There's simply no point in using an interesting venue if what occurs within could be done in any meeting room back at organizational headquarters.

<div align="center">*</div>

References

Altay, N, Kilicarslan-Toruner, E, and Sari, C (2017) The effect of drawing and writing technique on the anxiety level of children undergoing cancer treatment. *European Journal of Oncology Nursing*, 28, 1–6. doi:10.1016/j.ejon.2017.02.007

Archer, S, Buxton, S, and Sheffield, D (2015) The effect of creative psychological interventions on psychological outcomes for adult cancer patients: a systematic review of randomised controlled trials. *Psycho-oncology*, 24, 1–10. doi:10.1002/pon.3607

Devis-Rozental, C & Clarke, S (2020) *Humanising Higher Education: A positive approach to enhancing wellbeing* (Palgrave Macmillan Ltd.)

Dresler, E and Perera, P (2019) "Doing mindful colouring": just a leisure activity or something more? *Leisure Studies*, 38(6), 862–874. https://doi.org/10.1080/02614367.2019.1583765

Greenhalgh, WA (2015) *Mindfulness & the Art of Drawing: A creative path to awareness* (Ivy Press)

Kaimal, G, Ray, K, and Muniz, J (2016) Reduction of cortisol levels and participants' responses following art making. *Art Therapy*, 33(2), 74–80. DOI:10.1080/07421656.2016.1166832

Newman, KM (2017) How gratitude can transform your workplace. *Greater Good Magazine*: *Science Based Insights for a Meaningful Life*. https://greatergood.berkeley.edu/article/item/how_gratitude_can_transform_your_workplace

Scott, C (2024) The embodied realm of teaching. In King, H, *The Artistry of Teaching in Higher Education: Practical ideas for developing creative academic practice* (SEDA Ser)

Walsh, M (2021) *The Body in Coaching and Training: An introduction to embodied facilitation* (Open University Press)

Chapter 10

The Third Dimension

Throughout the entirety of this book we've described and discussed the ways that we ask groups to create, and then discuss for the purposes of realisation, decision, and planning, graphical depictions of their reality. Thus far, the majority of our examples and exercises have been two-dimensional. On occasion, however, our instructions or guidance to create graphically are interpreted in unexpected ways. One such "surprise" is when groups take the brief and start to build backwards, inwards, or upwards. Of course, if the material we provide is Lego or clay or naturally sculptural materials, this invites people to build beyond two dimensions but when their collages or maps, which are usually flat, start standing up, or twirling and dancing, this reveals a very different energy and enthusiasm. For example, in Figure 10.1, a

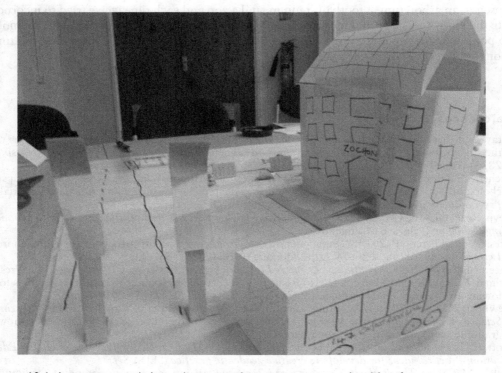

Figure 10.1 An unprompted three-dimensional response to a graphical brief

DOI: 10.4324/9781003410577-14

group were asked to create a "high quality map of their environment." We use this prompt as it stimulates valuable conversations about what "high quality" means as well as what "environment" actually comprises. One subgroup, utterly unprompted, decided that the only way that they could achieve the requisite level of quality was to build away from the page—creating depictions of buildings, public transport, and street furniture.

As well as the serious outcomes of a graphic approach (e.g. democratization, the ability to use metaphors for sharing sensitive or taboo topics, generating ideas very quickly), one of the reasons for using graphics in facilitation is that groups are continually surprising, which keeps things fresh and, dare I say it, fun for us as facilitators! In this chapter we explore the third dimension, and how graphical facilitation can deliberately move away from the flat plane.

10.1 Collaging in Three Dimensions

As we explored in Chapter 8, collage is generally about combining images on a flat surface, but sometimes quirky models can arise that stimulate powerful group discussion. For example, in Figure 10.2 below, a group were provided basic flat materials and were asked to depict "an ideal post-pandemic future."

The group decided that the only way to depict the holistic, socially united, and connected nature of their utopian vision was to move to the third dimension. The conversation this

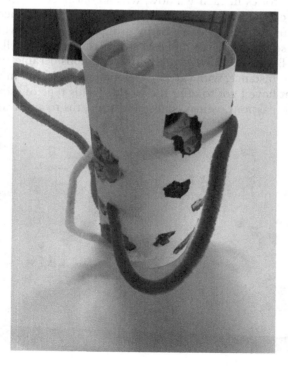

Fig 10.2 Impromptu sculpture collage created to "envisage the ideal (post-pandemic) future"

switch facilitated was so powerful that we now sometimes *insist* that groups collage and create in three dimensions.

Collage, as an artistic term, includes the media of "montage," "assemblage," and "bricolage"—and all can be useful to help move groups forwards. A montage is a display of interconnected images in a single "work" (as discussed in Chapter 8), whereas the other two are more likely to be built constructions of disparate everyday items (assemblage) or materials that are to-hand (bricolage). All can be used in a training room, as opposed to an artist's studio. Regardless of label, this bringing together an array of visual images and objects provokes strange associations and helps groups (and coaching individuals) to invoke rich narratives since, in the words of Kathleen Vaughan (2005, p. 6) it "deliberately incorporates nondominant modes of knowing and knowledge systems."

A simple, but sometimes beautifully ornate and complex, way of using three-dimensional collage is to have groups or individuals create a form of an "Artist Book." As an artistic object these books are often painstakingly made by artists to "speak" to the person who physically handles and engages with them, since they are "part narrative, part object, part performance" (Bolaki 2016, p. 53). For our purposes, these "books" are not fully book-like but folded sheets that share the properties of a real book (i.e. content revealed and obscured by physically turning a page) to stimulate the imagination.

To illustrate, Figure 10.3 shows an Artist's Book I (Curie) created during a workshop. We all started with thick watercolor paper (card would also work) folded into a concertina. This folded three-dimensional page reshaped how I interacted and created with the page: you can see little frames, torn images, and parts cut out to create silhouettes. It was a format that invited different stories in each window, which continued on the next "page." Once completed, the book can be folded and stored for "reading" at another time.

This form can be used by individuals or by groups—where teams must collaborate to identify the different sections and the different stories they want to tell on each page of the book. Folded Artist Books do, however, require both considerable time and open-ended question prompts. For instance, with career development sessions, I invite people to collage to the question "what have I got to offer the world?" This type of esoteric prompt usually helps them connect to passions, values, skills, and strengths to assist direction. This folded

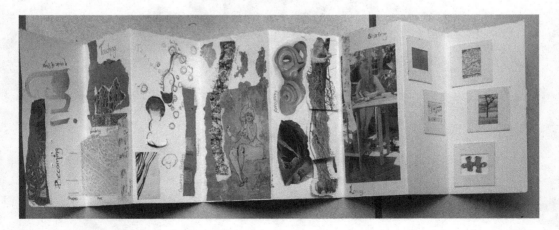

Figure 10.3 An artist book created by Curie

format can be used for considering personal "selves" that appear at work and perhaps to identify what sort of professional or leader they want to be. The folded book mechanism allows facilitative prompts around the ideas of "what do you reveal and what do you keep hidden?" in a both figurative and literal sense. As such, in the right environment, folded collages are clever conduits to help mutually-supportive people to discuss areas such as self-confidence vulnerability, professional legitimacy (e.g. what gives you the "right" to lead?), "imposterness," and authenticity.

10.2 Origami Insights

Moving to the third dimension through the act of folding paper brings us neatly to origami, the art of creating objects through paper-folding; starting with a square of paper and using no cutting or glue. Unlike most of the ideas in this book, this technique actually needs a modicum of technical skill. That said, some models, such as a basic boat or fortune teller, are simple to fold. As an aside, it is worth noting that origami is an artform I've enjoyed since childhood. It was only more recently that someone suggested I could incorporate it as a creative educative practice. So it is worth considering how activities you already do outside work might link up with your facilitation work. I use origami to facilitate reflective practices, but origami has utility in Maths, Science, and Medical Education (e.g. satellites, aortic stents, and bridge prototypes (Scott 2018a)). But since origami is uncommon, certainly in the UK, I start any origami session by upending a pile of pre-folded examples (see Figure 10.4). This tends to generate a lot of "oohs" and "ahhs" due to their color and vibrancy.

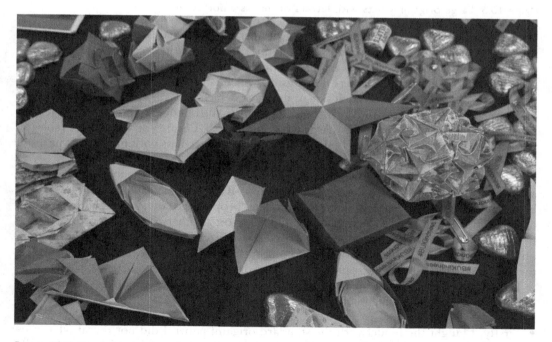

Figure 10.4 Pre-folded origami examples to inspire a group

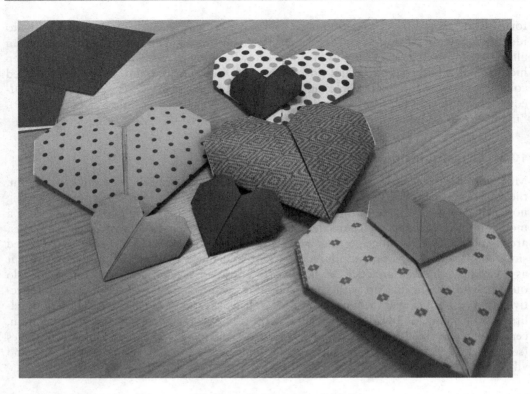

Figure 10.5 Large origami hearts with letters of thanks enfolded in

Origami can be done with regular white copier paper cut into squares. But, from experience, I'd suggest investing in origami paper (or "kami") that comes in boxes of 500 differently colored paper sheets. As well as being pre-cut into squares, the paper is lighter and thinner (60gsm) than regular copier paper (80–90gsm), which is crucial for some models. "Duo" paper has a different colour on each side of the sheet, which adds pizzaz to the activity! Serious "origamists" use "bone folders" (tools originally made of bone) to create sharp creases, but plastic out-of-date shop loyalty cards work just as well. Ensure you have stable tables to work at, and a clean flat surface. I take my dining table placemats with me for this purpose when I do group origami.

As a facilitator, with origami you need to be really confident with the model you choose, and watch closely so that you don't "lose" people as if they miss a teaching step. It is worth being mindful of the audience and the environment: people need some manual dexterity and concentration. They need to be able to see and hear you as otherwise people get frustrated. In some sessions with more people, I have used a visualizer that projects what I am folding onto a bigger screen. Other options are to link to videos so people can (a) follow at their own pace; (b) fold more of the same model later (origami is rather addictive!).

The origami hearts, illustrated in Figure 10.5, were created by employees as part of a "kindness at work." Outlined here is the process we used:

• Firstly, I taught the model with the standard origami paper. I did not reveal what they were folding beforehand. (This is probably just because I enjoy their delight, especially with the heart model, as you cannot tell what it is until the end.)

- Once I knew they were confident with the steps, we repeated the process using heavier and larger paper.
- Midway through, I stopped the group so that they could write a letter of thanks on the inside of the partially-formed origami heart to someone who had shown them kindness (either at work or outside).
- We then returned to the folding and continued until the heart was finished.

I encouraged them to gift the heart, with the hidden message, to their colleague who had been kind or post it to the relevant person. This activity was more powerful than letting people know the benefits of kindness and gratitude at work, as it was enacted and had a legacy. It was wonderful going round campus in the weeks following the event and seeing colorful hearts on desks and noticeboards. The other unexpected thing for me was seeing the repercussions: people teaching their colleagues who had not been at the event, or their family members.

Origami can also have a powerful collective impact for a larger group. The lotus shown in Figure 10.6 was created as part of a storytelling event in an academic "Play Festival," an event that took place outdoors in a large tent! Each lotus flower comprised a number of sheets of paper (equal to the number of people in the group) and each person folded a piece of paper on which they had written the name of someone who inspired or helped them in

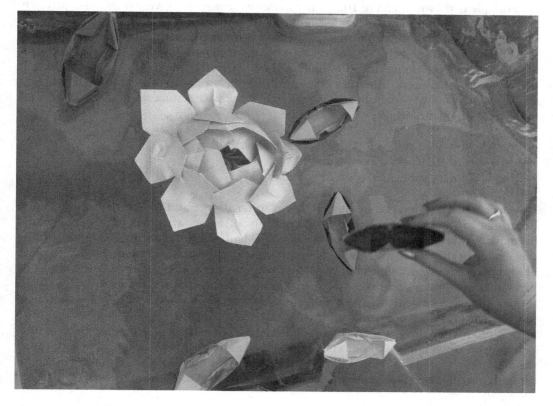

Figure 10.6 Lotus flower co-created by a group to illustrate the transformative power of interpersonal support

their career or course. Whilst folding, we shared stories of these people. Each piece of paper was separate and no one knew what the group as a whole was creating. At the end of the folding and conversation process we stacked the sheets and shaped the individual petals to complete the lotus flower. We then floated (in a tub full of water alongside origami boats from a different facilitative exercise).

The group watched the closed lotus as its petals opened—a powerful visual metaphor of the impact of the people who help us all along the way. We finished the session by asking people to write their feedback on sheets of paper, fold paper aeroplanes, and throw them down to the front to see which one flew the best!

10.3 Masks—What People Show and What They Don't

In my work examining drawing for health I designed, facilitated, and researched using different forms of drawing to see if they enabled people to talk about growing old (they did!). Aging is a sensitive topic and therefore (as with other agendas we explore in this book) a graphical conduit proved incredibly helpful. One of the prompts I used with the groups I worked with was the question, "When you are old, what do you want people to see or know about you?" To help people elicit their thoughts and ideas they were given a bare white paper-mâché 3D mask and provided with crayons, pencils, scissors, glue, and magazines. The group was invited to create a mask to depict the elderly version of themselves that they wanted to share. An example is shown in Figure 10.7. Participants were invited to wear their mask privately and to reflect on what they had created and realized. Sitting together afterwards, each person shared the meaning of their mask and answered questions from one another.

As a facilitative tool, the idea of creating masks is simple and quick, but powerful. It requires careful prompting to get people to think carefully, but since the process is clear (make a decorated mask) it allows concentration solely on what the individual wants to show (and also not to show). In a "professional" workplace setting the type of prompts for mask creation might include:

- How do you want others to see you (at your best)?
- What sort of leader do you want to be?
- What does the confident version of you look like?

However, mask making can be quickly taken to far deeper and more insightful territory. Returning to the group exploring the perceptions of aging, after one person had shared his mask, he (brilliantly!) flipped it over where he had added more images. He shared that the outside of the mask (which was the only surface that others had used) displayed things he was open or comfortable about sharing (essentially, his "public" face). On the inside, he had represented things that were private to him and his closest friends and relations. This was startling as I simply had not remembered that there is more to the third dimension than just the face that the world can see. There is also hidden territory.

This hidden territory in masks can be leveraged in professional development setting, especially in conversations about vulnerability and authenticity, by asking people to invert the mask they've already created showing their "best" or "public" face and asking them to carefully reveal their vulnerabilities. Prompt questions such as these are powerful:

- What are your professional fears?
- What do you professionally keep hidden?

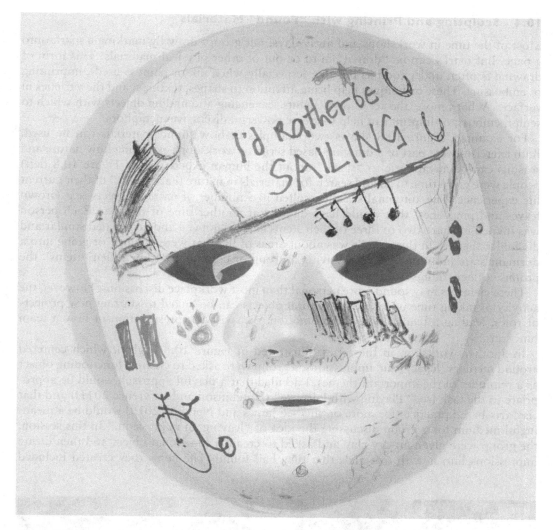

Figure 10.7 Paper mâché mask as a 3D drawing surface

- What don't you share until it's too late?
- If we could find out one thing about you that would help us understand you, what would it be?
- What are the things about working here that you think but never say?

Clearly, clearly, this is sensitive territory and as a facilitator or coach (or therapist) you need to be hugely careful to ensure a safe space and to build trust and confidentiality before you go to the hidden side of the mask. You also need to able to work with discomfort and heightened levels of emotion. The public persona that someone depicts on their mask is a quick, simple, and powerful facilitative tool. The "inner-self" mask is something we'd only recommend for very experienced practitioners.

10.4 Sculpting and Printing with "Found" Materials

Most of the time in workshops and away-days, our groups draw by marking a mark onto a page. But marks can be "drawn" in-to or out-of other physical materials. This form of drawing is often understood as printing (especially when ink or paint is used), imprinting or embossing. These techniques help bring attention to shapes, textures, and the varieties in surfaces. What's more, the act of participants scavenging and finding objects with which to sculpt, emboss, or imprint can help to create powerful discursive metaphors.

For example, Figure 10.8 shows two examples of how found materials can be used. Both exercises were part of a drawing-based series of workshops exploring how nature and seasons can be metaphoric to "speak" about the human experience. In Figure 10.8 (left) people were given time to go and search for materials in nature that "spoke" of their current life experience. The autumnal season resulted in a number of natural objects (e.g. brown leaves and pinecones) that would have differed at another time of the year. Each person was invited to share two to three of their items and we noticed and articulated similar and dissimilar themes. In this case, it was about areas of life that were "dying" or going into a dormant state (autumnal leaves), leaving a group or community (the "fallen" items), the promise of new things (seed pods).

These elements may sound more personal than most workplace discussions. However, the activity of taking time to forage for natural objects can be linked to starting new projects or roles, leading a team, going for promotion, or a visual representation of how a team functions.

In another workshop in the series (illustrated in Figure 10.8 (right)), which centered around memory, legacy, and impressions, a group were asked to create a functioning object as a reminder of the important themes. I decided that a playful approach would be appropriate to the task (see "Playing with Purpose" (Hutchinson and Lawrence 2011)) and that clay arts-based practice (for more on this see James and Nerantzi 2019) would be a meaningful medium for a group discussing the idea of "leaving an impression." In this session, the group were given air-dry clay and asked to create a functional object and then create impressions into it with materials that they had found. The items they created included

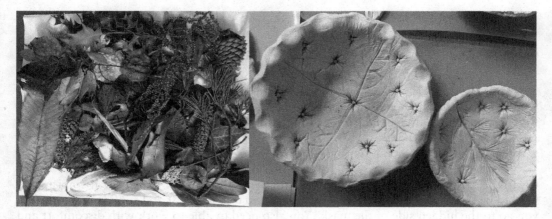

Figure 10.8 Sculpting (left) and printing (right) with "found" materials.

shallow bowls (as illustrated here) as well as pendants, a cup, and a wall plaque. The use of air-dry clay meant there was no need for an expensive kiln or much protective table coverings, and the items dried before the end of the session. This "impressed object" remained as a visual reminder of their conversations which, after a workshop, is often absent. The functional nature of the object meant that people used it in their day-to-day lives and so the conversations and learnings stayed activated and at the forefront of people's minds for longer—thus sparking other realizations. This is another powerful reason for using graphic methods: there is potential for reflection on the item and other ideas to emerge.

Again, this approach can be tailored to a more "business-focused" environment by asking the group questions like:

- What sort of impression do you want to create?
- What's the legacy you want to leave in this organization?
- What impresses you about the leaders you admire?
- What's it like to be on the receiving end of you?

This type of workshop tends to be a catalyst rather than an end-point in itself; with the example given here, two people contacted me months later to share the longer term effect. For me this is what "learning" in its various modes is all about.

10.5 Building Blocks and Lego® Sculptures

One of the simplest graphical facilitative tools in the third dimension is to use children's building blocks such as Lego® to create quick and meaningful depictions and to help groups create metaphors and illustrate patterns and connections. Over the last twenty years there has been a large amount written about the value of Lego® in playful education and systems thinking (see for example Gauntlett 2015, and Nerantzi and James 2019) and we'd thoroughly recommend investigating the wealth of literature and practical material written around Lego® as tool for Serious Play® (e.g. James 2013). We certainly don't have the space here to add anything theoretical to the wealth of existent material.

However, when it comes to actively encouraging a group to move to the third dimension, both of us frequently break out the Lego®, and so we thought it fitting to share just a few ideas we use that work quickly. You don't need a massive stockpile of kit (though many organizational development departments have their own toybox now), and neither of us carry around more bricks than can fit into a large shoebox.

Connecting building blocks can replace any sort of creative graphical exercise (i.e. one without words) as a near like-for-like substitute. For instance "draw a vision of how you'd like this organization to be" becomes "build a vision..." (as in Figure 10.9), "sketch a storyboard or cartoon" becomes "build a diorama," "draw a diagrammatic representation of this team" becomes "build a model of the connectivity of this team." As with other approaches in this book, it's important to guard against groups being over-literal; an instruction to build a "model of this team" that results in a series of blocky action figures is no use to anyone.

Lego® or equivalent has many obvious advantages—its simplicity, its innate playfulness, and its modular connect-ability (meaning that individuals or subgroups can build and then attach their efforts to a larger, plenary, whole) to name just a few. However, there are

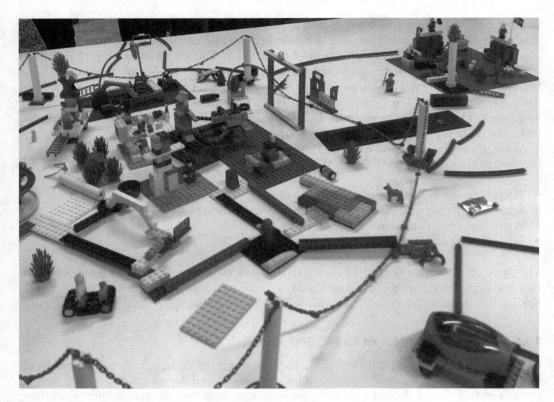

Figure 10.9 Lego® used to create, in his case, an envisioning sculpture

disadvantages with using Lego®—not least its lack of portability once in "finished" form. This limits usability with "repeat" groups unless you have a secure area to store the Lego® model and are supremely careful about moving it. Based on experience (Steve's) we'd suggest taking lots of photos of the "product" that a group creates—both to enhance memory and to insure against the effects of a catastrophic dropping incident...

The other drawback of using Lego® or equivalent is that it commits the facilitator to a course of action that is very difficult to change. If you lay out pens and papers on the table, intending to do a "drawing" exercise, and then you get a feeling that a group won't be responsive, you can pull-out and revert to a discussion captured with writing. If you've covered a table in Lego®, your course is set and unchangeable. As such, Lego® is something we tend to bring out after lunch, or in a second session with a group, when we're sure it's "right" for the group.

Finally, Lego® or equivalent can be used in combination with other techniques, (i.e. by creating models on top of a paper table-covering, which can then be drawn upon to show connectivity and annotated to capture any actions resulting from conversations that occur in the building activity. We present examples of this in the next Chapter—Mixing and Matching.

References

Bolaki, S (2016) *Illness as many Narratives: Arts Medicine and Culture* (Edinburgh University Press Limited)

Gauntlett, D (2015) The LEGO system as a tool for thinking, creativity, and changing the world. In *Making Media Studies: The creativity turn in media and communications studies* (Peter Lang), https://davidgauntlett.com/wp-content/uploads/2014/03/Gauntlett-LEGO-tool-for-thinking-chapter.pdf

Hutchinson, S and Lawrence, H (2011) *Playing with Purpose: How experiential learning can be more than a game* (Gower Press)

James, AR (2013) Lego serious play: a three-dimensional approach to learning development. *Journal of Learning Development in Higher Education*, 6. doi: 10.47408/jldhe.v0i6.208.

James, A and Nerantzi, C (2019) *The Power of Play in HE: Creativity in tertiary learning* (Palgrave Macmillan Ltd.)

Nerantzi, C and James, A (2019) LEGO® for university learning: inspiring academic practice in Higher Education. doi: 10.5281/zenodo.2813448.

Scott, C (2018) Origami for Science Maths and Education International Meeting. Blogpost, September 14 2018, https://microsites.bournemouth.ac.uk/flie/2018/09/14/origami-for-science-maths-and-education-international-meeting/

Vaughan, K (2005) Pieced together: collage as an artist's method for interdisciplinary research. *International Journal of Qualitative Methods*, 4(1), 1–21.

Chapter 11

Mixing and Matching

In this chapter we start to combine forms and ideas from previous chapters. You'll find that the more tools you have, the more you can combine them and the better suited any given process will be to any given group that you work with—you'll be able to reflexively adapt. We both find that we "chop and change" as necessary, but if you are newer to using graphical methods then you may, as every novice in every area, need to spend more time planning and defining which different methods to choose. There are times mixing and matching happen spontaneously and where we use the resources and space available at the time—such as in Chapter 2 where Steve asked trainee engineers to design and build something using coffee stirrers, cups, and napkins—and Curie invited hospitality students to share photos from their phones of meals they had made and then formed an impromptu digital collage. With increasing confidence as a facilitator and a large toolkit, your mix and match possibilities are endless!

11.1 String Theory

In Chapter 10 I (Curie) outlined an embodiment exercise where people recalled their professional history and walked a string line whilst locating body gestures and postures that "held" certain pivotal moments for them. One person described that they struggled to use their body in this way, so they started fiddling with the piece of string. Quickly, they realized that they could express how they felt during different parts of their work trajectory using the string itself.

The string became a character—full line with tangles, taut stretches, and languid whorls, which described how that person was feeling. This outworking of a personal history through string slowly brought remarkable realization and resolution. More than this though, it illustrates how one technique (animate embodiment along a timeline) can be mixed with another (the shaping of an inanimate object) in the same room at the same time to suit the needs of different participants or groups.

String can be a powerful facilitative aid since it can be changed, moved, and reset. Once a group has plotted a line (timeline, feeling line, highs and lows line, performance line etc.) with string and agreed on a "final" form, this basic line can form a canvas onto which other tools are applied. For instance:

- The string line can be traced onto paper and annotated with sticky notes, words, or images
- The string line can be formed across a floor and people could stand at certain points and talk about their reason for choosing that space on the line
- The string line can be walked (like a tightrope) and people reveal where they felt vulnerable or in need of support, or grateful for the support they received

DOI: 10.4324/9781003410577-15

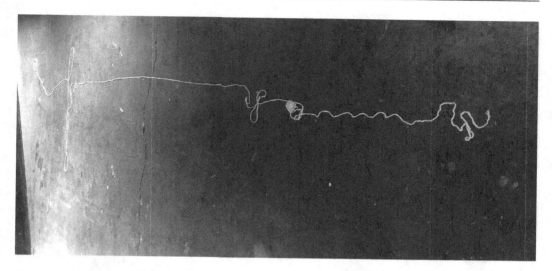

Figure 11.1 String shaped to capture subjective work experiences

Similarly, string (as mentioned in Chapter 5) can help to "map" a conversation or discussion, or could be used to create movable, flexible boundaries around clusters or idea groups. Instead of thinking of string as a physical entity, think of it as an infinitely movable line that doesn't require erasing in order to change its placement and many mix and match possibilities suddenly occur.

11.2 Mixing Graphics, Shapes, and Directions

Combining very simple techniques can be a powerful way of getting a larger group to invest in a plenary discussion. The example shown in Figure 11.2 shows the finished "product" of a large group exercise where individual graphical responses to a prompt question are linked with arrows to illustrated how the reporting process "flowed."

The individual graphics were created following group discussions to a prompt question (in this case concerning leadership behaviors that the group admired) with different coloured A4 paper for different subgroups to help identify contributions later. I asked subgroups to draw first and then add labels second (to "force" a graphical response). I ensured that every person in the whole group had to create and take ownership of an image. As the whole group came together in plenary, images were stuck to the display wall one at a time and an arrow was added by each speaker in turn to show connectivity in terms of how ideas were connected. Thus, the "direction" of the plenary conversation can be plotted by following the arrows from image to image. This ensured that the whole group took ownership of the large display, since they had to listen and consider how they were going to include their own personal contribution. From the initial subgroup conversation (about ten minutes) to the drawing phase (about five minutes) to the placement of the images and the reportage (about thirty minutes), this exercise took about forty-five minutes, but became the touchstone that the group returned to repeatedly throughout a longer session.

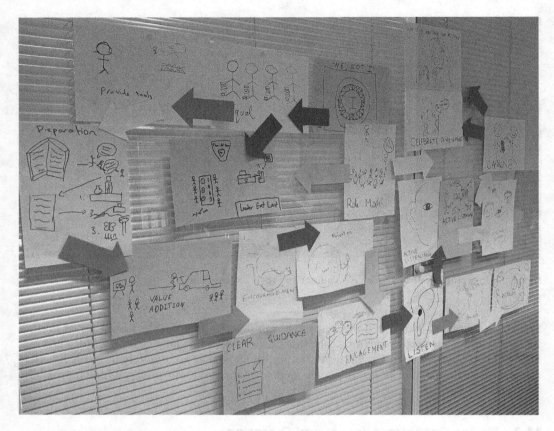

Figure 11.2 Mixing individual graphics with arrows to illustrate the "flow"= of a plenary discussion

11.3 Mixing and Matching the Written Word with Graphical Form

The written word and the graphical form can be combined in powerful ways—especially through shape and color. For example, at the start of a four-day retreat I (Curie) produced a large, simple charcoal outline of a figure and invited the guests to walk around the image. This activity was designed to "center" (see Walsh 2017) the group; that is to help them slow down and "land" from the busyness of life to the slower, deeper introspection of a retreat. I asked them to choose colors that resonated with how they were feeling and to add words into the shape of the figure. This both helped people express but also offered a gauge (for me as the facilitator) the emotional temperature of the group. It also acted as a relatively easy way for a group of people who did not know each other to share how they were feeling without verbal words.

As with many tools, this prompt activity invites courage and vulnerability so may or may not be appropriate for the group you are facilitating. However, the principle remains: draw a large outline of something related to the discipline and invite people to walk around adding their contributions and words tend to beget more words. It can be adapted by adding a voting element, so that if people resonate with certain words, they acknowledge this by

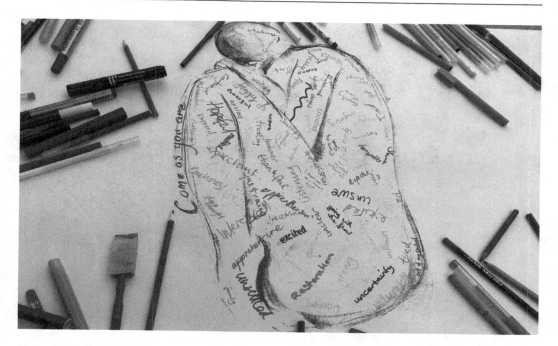

Figure 11.3 Graphical capture of words to describe feelings

drawing a symbol next to them (e.g. a tick, a star), or add a sticker. The advantage of this resonating adaptation is that things move beyond simply a "transmit" exercise (writing) to a "receive and transmit" exercise (reading, thinking, contributing) since people need to pay attention to others' contributions to see if they agree in order to vote. The disadvantages to such a method are that you need a relatively big space for comments and a bigger space to walk around. I put the image up somewhere visible for the first day and we revisited it at the end of the retreat framed as a "then versus now" conversation generator (i.e. "I was feeling unsettled but after these four days I am ready to take on the world"), which was done verbally as, by then, the group had grown in trust.

As we noted in the opening of the book, silence is a powerful tool that offers the opportunity to process and reflect. It may be especially useful for introverts, internal processors, and those who need additional time to translate material. Mixing and matching a graphical approach with writing and silence can yield an interesting result. For example, after another activity of reflecting, discussing, and debating the notions of educational inclusion, I asked a group to pick up the key themes and simply write them onto a large whiteboard. This as an approach in itself is not particularly innovative. However, six pens were in circulation, with individuals writing their contribution and connecting it to another idea before passing on their pen to someone else. But, vitally, the entire process was conducted in silence.

This resulted in deep thought, contemplation, and the group identifying synergies and connections and building on each other's silent inputs. Certainly, the final whiteboard looks somewhat chaotic, but the silent graphical process allowed individuals to experience different perspectives—not least the educational experience of students who are deaf or hearing-impaired.

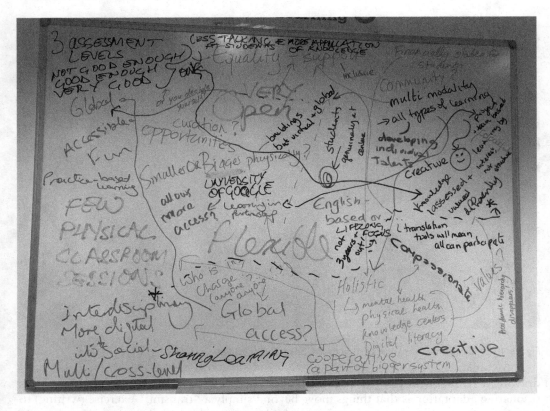

Figure 11.4 Silent collaborative discussion capture

11.4 Annotated Sculpture

Mixing and matching drawing, writing, and the third dimension can produce interesting depictions as they require different cognitive processes and allow the different talents of a group to come to the fore. We typically start with the building element of any combined form—simply because it's easier to write or draw around a central construction than it is to build large-scale over a flipchart full of words and drawings.

We typically start by sticking a large sheet of paper down onto the table, to ensure it does not move (always disheartening if carefully designed models slip off the table and break mid-activity). An alternative that can be used is a paper tablecloth, though it's worth checking beforehand as some of them are plasticized, so they are not easy to write on. Also, for either option, it's worth doing a test to check that any pens you intend to use later will not bleed through and mark the table underneath.

Sculpting material can then be spread on top of the paper. This material could be LEGO®, as explored elsewhere in the book, or art supplies such as colored paper, card tubes, buttons, lollipop sticks and pipe cleaners. (Two such arrays are shown in Figure 11.5). The group can be assembled around the material and a prompt provided for the "building" conversation. For example, in Figure 11.5 (right) a group were asked to envision strategies for team development over the next year and constructed a model train. This was, to them,

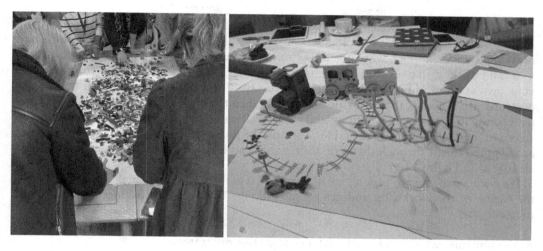

Figure 11.5 Mixing and matching media—LEGO® laid out on paper ready for annotation (left) and a "finished" combination of three-dimensional sculpture and drawing (right).

symbolic of how they wanted to journey together with some members on or off the train, some actively driving and some providing other functions.

The tracks and destination (and pipe cleaner tunnel...) were added in drawing form as the facilitated conversation moved to encompass the destination and proposed journey over the forthcoming months.

With the LEGO® such as in Figure 11.5 (left), a newly formed group can be asked to build individual depictions (like the mapping process laid out in Chapter 5) and asked to depict their area of expertise or professional practice. Once the models are built (which in itself stimulates playful conversations), the group can be asked to explain their work and then mark on the synergies and potential collaborations etc., using pen strokes on the underlying sheet of paper. The group can then start to peer coach and ask each other questions about strong relationships and ties and potential areas of opportunity within the group. Alternatively, the group could be prompted with questions such as:

- What can you learn from each other?
- What are the challenges that you all collectively face?
- Where can you help or support each other?

And the group could draw (or use colored string) these lines or clusters of support onto the page (or annotate the sticky notes) to show the web of connectivity between an absolutely brand new group.

To transfer the context, this process can be achieved at an outdoor education center by foraging the supplies (e.g. a pinecone represents a customer, and a seashell represents a service). The later steps of connection can be achieved with branches and twigs or a ball of string. Everything in this exercise can be achieved on a beach with no resources whatsoever, by building sandcastles and sand sculptures and simply drawing in the sand and using pebbles and driftwood.

11.5 Annotated Images

As you'll have noticed, we are both advocates of people creating their own metaphoric narratives. However, a quick way of getting "to the point" visually is to use pre-made visuals. You can buy these in packs (do a search for "mindful cards") or alternatively you can hoard your own stash of old postcards. You can also save discarded collages and cut them up to postcard size. There is always an air of intrigue when the images are lying around. I (Curie) tend to use it as an opening activity and so have either a projected slide with a question on screen or guided prompts on the tables. I scatter the images purposely overlapping so people are tempted to sift through them, or scatter them on the floor so images can be seen more clearly, as in Figure 11.6.

We both ask people to pick a "small handful" (i.e. three to seven) images that work with the theme of the workshop and get people talking. These include asking them to collect images that...

- Demonstrate what you hope to achieve from this programme
- Relate to the best bits of your current role
- Sum up your character/values
- Define career "success" for you
- Speak of the team you want to lead
- Connect to the vision you have for your professional development

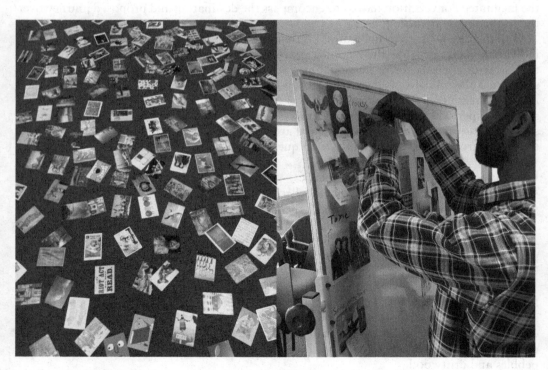

Figure 11.6 Various postcards scattered (left) and then chosen, displayed, and annotated (right)

Sometimes we let the whole group share individually but this takes a long time, so I ask them to share in small groups. There are other tricks that can be employed here like "verbal dominos" (i.e. one person shares and then the next person must be able to connect their image with the first). The activity can stop there or, what we find more dynamic is to use these images as "building blocks" for a more in-depth activity to create more complex narratives, by displaying the images and then drawing, annotating, and clustering to create a composite whole (the process underway in Figure 11.6 (right)).

Mixing and matching annotated images can add color and life to models and frameworks—as shown in Figure 11.7. During a strategic away day, a central circular model was drawn onto a huge sheet of paper and displayed in the central table of a room. As the day progressed participants were asked to add images and sticky notes to it, based on certain conversations around areas of the model—you'll notice that the headings of the model are written both the correct way up and inverted, so the group could approach the model from both sides of the table.

In coaching, facilitation, or development, it is frequently the case that many issues and problems in professional decision-making, building culture, or interpersonal effectiveness can be traced back to the values that an individual holds and the alignment (or lack of) with other team members or the organization as a whole. This is particularly the case in leadership development and much of our time as coaches is spent helping individuals to act in a way that is aligned with both their own values and those of their organization. Values, while hugely important, are however often wholly implicit and unstated until such time as an individual or team are in conflict. It is thus important to help an individual or group to articulate the underlying pulls and pushes that sway their professional and moral compass.

One way of doing this is to employ annotated and linked images to aid an individual or team in realizing and articulating their values and then plotting these in relation to a

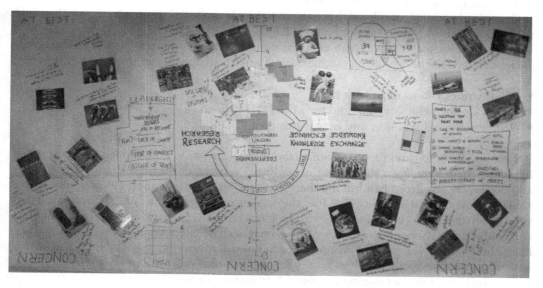

Figure 11.7 Framework model annotated with image cards and drawings

different entity (such as the organization as a whole). Prior to introducing the images (as above) you may need to facilitate a conversation about values, what they are, and how they influence decisions, personal drive, culture, or whatever the overreaching context of the professional intervention may be. I (Steve) start by spreading the image cards out and asking people to choose four or five that illustrate their values. You may wish to prime this, by asking them to list a handful of values in advance of the session. Curie runs a similar process but asks people to make a collage from a range of magazines but, of course, that means this part of the process will take considerably longer. As always, encourage individuals to be allegorical or metaphorical wherever necessary. In many ways, the image itself doesn't matter, but the connotations that it holds for the chooser are paramount.

Ask the individuals to create a hierarchy of personal values by sticking the values images up on a flipchart or whiteboard. The most important value to them personally should be at the top. You may wish, depending on time, to get participants to annotate their hierarchy with keywords or doodles of situations or instances from where these values have originated or shown up in their professional life—essentially asking them to personalize the hierarchical image-bank that they have created.

In a development session, it may be productive here to have individuals discuss their personal hierarchy and (more importantly) how these values are manifested in their day-to-day behavior—in short, how do they walk the talk? In a 1:1 coaching setting, this "ladder" of values can augment a conversation about personal drivers and what is important to the coachee.

Then ask the individuals to repeat the process, but this time choosing images that reflect the values of their work team, department, or organization. These values can be the explicit ones that their organization purports, or the unspoken ones that exist without clear reference. As a development professional, you may wish to enquire as to the evidence behind the placement of the hierarchy. Is the position to do with the feeling that an individual has, or based on concrete evidence and example?

Once this has been completed, have the individuals draw links between their values and their organization's values (as per Figure 11.8).

Then the session can move to an exploration of the differences, similarities, and discrepancies between the two value hierarchies. Facilitative coaching questions that may help are:

- What strikes you as important here?
- Where do the values overlap and how does this help you?
- Where is there disconnect and how is this problematic?

If a group all come from the same organization, the activity can be flipped. This is started by asking them to create a shared "values collage" relating to the organization by selecting and displaying an agreed handful number of images. Facilitate a conversation on how these values are manifested in reality (i.e. does the organisation "walk the talk"). Place the shared values collage at the center of the room, or large table. Repeat the exercise, but this time with individuals choosing a number of new images that reflect their own personal values. Place these individual collages around the edge of the room. Using sticky tack and string, have individuals map their values onto each others', and onto the group's shared values. Again, the possibilities of mixing graphical forms are endless.

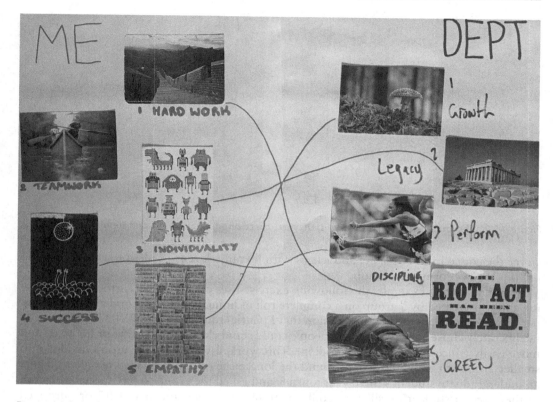

Figure 11.8 Linked personal values and organizational values

11.6 Collaborative Cartooning

On a day-to-day basis, a place when most people see drawings combined with text is in cartoon or comic strips. This mixture of forms is thus clear and accessible to people, and even a "bad" drawing can be supplemented with a speech or thought bubble ("oh no, I'm going to be late for my big meeting!!") or a caption. This dual-form lightens the pressure to draw well and frequently produces interesting results that are conduits to meaningful conversations. For example, in Figure 11.9, a group were asked to cartoon the notion of "Interdisciplinary Working" and chose to depict the good and bad collaborative practices they'd experienced as a central "angel and devil." They then annotated this image with speech bubbles and sticky notes as the conversation developed.

As always, the value in the exercise revolved around the normative support that participants offered each other ("oh, you've met a devil as well!") and the examples of best practice that arose while people were trying to find suitable metaphors for their lived experience.

Providing a longer, thinner roll of paper (a kids' "doodle roll") will encourage a group to think and draw in a number of real or (as per Figure 11.10) imagined frames or cartoon cells. This technique of comic strip drawing (like storyboarding) works well with storytelling approaches. We'd steer you towards the book *Understanding Comics* by Scott McCloud—not because of its facilitative techniques, but because it shows how nuanced and

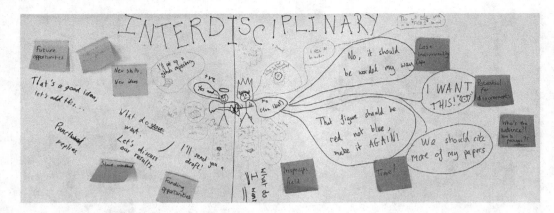

Figure 11.9 The duality of collaborative behavior, cartooned as an angel and devil

clever the comic form could be, and left us with literally dozens of ideas for how we could use this type of form in a session.

For a final comic example, the following exercise uses collaborative cartoon strip drawing and was created by a group on a complete roll of lining paper (used underneath wallpaper). It was created in the first live session that I (Curie) ran after the COVID lockdowns, so I deliberately chose an activity where people could stand close to each other or far apart and move easily (since everyone was standing). This worked well, with the group divided into smaller groups to walk and work around the long piece of paper. I asked people to depict an undergraduate student's three-year journey and asked the group to pay special attention to the places a student's resilience would be tested or where students "left" or "dropped away."

This process was interesting as though there was a left to right flow, people kept revisiting areas and moving back and forth (another mix and match of form and motion). For example, one of the group mentioned that she noticed a large drop when students moved into year two, and someone else noted that they thought attendance after the Christmas break was reduced. So, they would go back and discuss that. After thirty minutes, I asked them to review the whole cartoon (Figure 11.11) and then think about what "easy wins" (such as earlier pastoral support etc.) might be integrated into the curriculum.

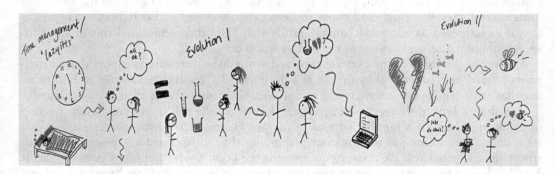

Figure 11.10 Extended and elongated comic strip form to capture a story

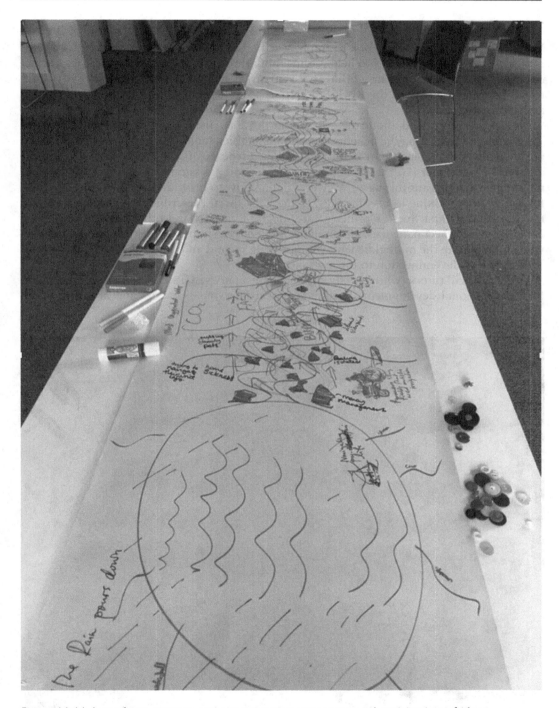

Figure 11.11 Long form cartoon strip encouraging movement and revisitation of ideas

11.7 Off to the Art Gallery!

We have worked hard in this book to emphasize that we are not all about creating "art" but rather use art-based processes to help groups think through key questions that arise during our professional development world. That said, art is made not just to "look pretty" but to tell us something about the world, to help us see differently. The final Mix and Match activity uses actual art.

I (Curie) am intrigued about the arts and health movement (you've probably guessed). This means interrogating the benefits arts and humanities subjects bring to the discourse on health. I am always delighted when I meet fellow advocates. I was invited by a director of a general practitioner (GP) training programme to lead a session at a local art gallery and museum—a truly beautiful space. We were trialing how to bring arts and health to the fore for the doctors training to become GPs. In the UK "social prescribing" is gaining momentum: this means first line (or primary care) doctors, nurses, and other care professionals being able to connect patients with non-clinical services to improve health in a more holistic way and integrate the mutual benefits of improving mental and physical health conditions. This then was the connection to the art gallery.

I met eight GP tutors (who directly support and supervise GPs in training) in the gallery for a professional development session. They were nervous—doctors and art don't often

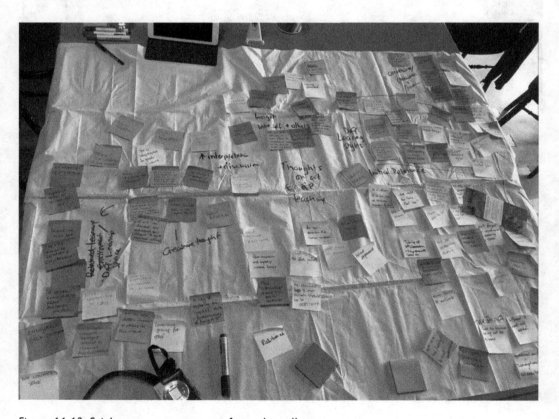

Figure 11.12 Sticky note concept map from the gallery

mix! I asked them to spend twenty minutes wandering around the museum looking at the paintings, photographs, masks, the décor of the space itself, sculptures, and exhibits of objects d'art collected from around the world. I asked them to find three pieces that "spoke" to them, connected or resonated with "where they were at" professionally. We then did a walk round, where each person took us to their three pieces. I had not factored in how much walking we would be doing as we went back and forth. They found it thought-provoking and we talked about how art in the museum (and then beyond the museum) might connect with the GP training scheme.

As they spoke, I wrote post-its. As a group we then gathered around the pile of post-its and, together, worked at theming them into a concept map onto a large paper tablecloth (Figure 11.12). My idea was to roll up the tablecloth but this did not work! The notes did not stick well enough, so I ended up having to photograph it in sections. That said, they said it was an enlightening experience for all concerned.

*

References

Buck, D and Ewbank, L (2020) What is social prescribing. *Kings Fund*, https://www.kingsfund.org.uk/insight-and-analysis/long-reads/social-prescribing

McCloud, S (2001) *Understanding Comics: The invisible art* (William Morrow Paperbacks)

Walsh, M (2017) *Centring: Why mindfulness is not enough* (Unicorn Slayer Press)

Chapter 12

Digital Possibilities

This book was conceived following an online meeting of a network of professionals, most of whom have never physically met each other. Barring one intensive writing bootcamp (while we sat in Curie's kitchen ostensibly co-writing, but actually fending off a lovable dog and a frankly savage cat), all subsequent conversation and creative collaboration occurred in the online space. The post-lockdowns work environment is hybrid, blended, or almost fully online, and while this arrangement confers certain conveniences to employees (less commuting) and certain professional advantages to projects and organizations (split-site collaboration across time zones), it doesn't necessarily help the socialized learning and "buzz" of a healthy workplace. Moreover, online working renders the life of a facilitator somewhat challenging, however good the collaborative technology being used actually is. Conversation is always more stilted, emotion runs lower, there's less room for kinaesthetic involvement, and we can never be totally sure that every group member is fully engaged and not multitasking or distracted. However, what we've noticed over the last couple of years is that a graphical approach can, and does, work in the virtual space—though perhaps in a slightly diluted form. In this Chapter we examine the possibilities of a digital approach—both on and offline. As independent facilitators we can't necessarily rely on any given technological tool or platform—and often the time we have with a group is limited, allowing no time to train people in complicated technology. As such we've tried to keep the examples and technology in this chapter as simple as possible. And in no way at all is this simplicity because at least one of us is something of a Luddite...

12.1 Lifting a Basic Webinar

Over the last few years, we've run and participated in a <u>lot</u> of webinars and online classes. From the earliest days of pandemic lockdown we realized that we needed to make these sessions as interactive as possible—otherwise why not just send the group a PDF of the content to be covered? In essence, a typical training room exercise in an online interactive webinar (using a platform like Zoom) might, in the early days, have been simply a breakout room discussion on a topic, perhaps with a nominated spokesperson to report back to the plenary room after a number of minutes. This is a perfectly acceptable exercise, though it can get formulaic very quickly. It's an educational space that can be immediately lifted by asking each breakout group to share a screen and each group to capture their discussion on one (e.g.) PowerPoint slide. This slide can then be shown to the main plenary room and provides a focal point for the group, both visually and intellectually. This "lift" of the exercise is partly due to the increased multisensory component (screen sharing, even if the participant

DOI: 10.4324/9781003410577-16

is "camera off") but also increases the accountability of the exercise—the sharing of the finished slide can't be busked. The group may have "had an interesting conversation" but the slide provides focus. However, do not be surprised if each breakout group produces a bullet-point list of their discussion points (which will certainly "look" similar to the other groups' and probably contain very similar words). A tiny tweak to this basic conversational exercise that makes a huge difference is to ask that each breakout group should "create an infographic" to capture their insights from conversation. This simple variation typically results in very different depictions—even if the raw intellectual ingredients on the slide are similar. This difference is illustrated in Figure 12.1, in which the left-hand screengrab shows a standard "list" (following no instruction other than "one slide") and the right-hand screengrab shows a Venn diagram (following a request for an infographic).

What's more, the infographic is potentially far more "unpackable" by facilitative questions. Using the example in Figure 12.1 (left), the intersections between the overlapping circles of the Venn diagram can be interrogated ("so what's the link between X and Y?") as can the solid circle in the middle ("so, what binds these elements then?"). While the "artistic" nature of the group's effort isn't particularly fancy, that doesn't matter. We've illustrated time and time again in this book that it's the process and the conversation that matters, not the finished product.

Occasionally a group will surprise you with their creativity or technical proficiency. Figure 12.2 shows an infographic fashioned in a Zoom breakout room—in just ten minutes—from a group who had never met each other before.

This effort provoked awed reactions among the groups from the three other breakout rooms, who'd simply created lists around the topic at hand. I'll be honest here—what was produced by this group was unusual. Technological restriction, social inhibition, time constraints, or a combination of these means that the *product* of this type of exercise is often underwhelming—even if the *process* and conversation is valuable. But for every time a group (especially in a virtual environment) doesn't rise to the challenge, it's worth persevering—simply for the times when what they produce is superb. Furthermore, if the facilitated exercise is part of a longer programme, a group that produces something memorable tends to set the tone and raises the standard for future group endeavors. Finally, if a group has a taste for infographics, and you decide you want to use them in a more involved and integrated way, it may be worth steering the group to a specialist infographics creator such as Piktochart (https://piktochart.com)—for their ongoing work after any facilitative time with you is finished.

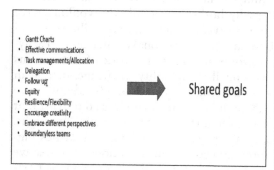
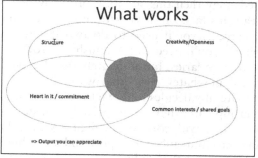

Figure 12.1 Comparison of two single-slide screengrabs from separate webinar breakout conversations

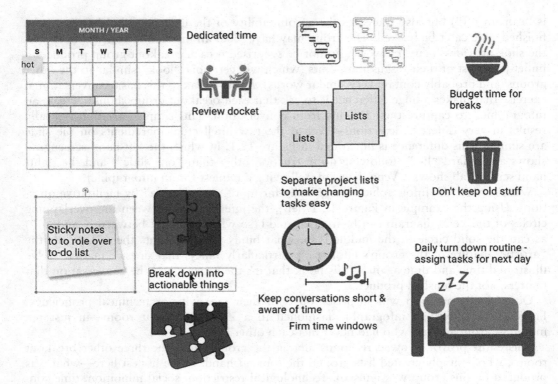

Figure 12.2 Infographic created by online workshop participants *in only ten minutes* to capture a breakout group conversation

12.2 Virtual Considerations

In spite of the hybrid nature of professional working, much of the facilitation work that we both do now happens back in a live environment. However, most of the training work (to which we bring a facilitative style) is online. Clients have realized that virtual courses attract more participants, get better conversion rates from sign-up to show-up, are quicker, and cost less than live workshops. If your training default is a directive chalk and talk pedagogy then this situation probably doesn't really bother you (and you wouldn't have read this far). But if your training style is more inclusive, interactive, and facilitative (and graphical) you'll need to do two things that for many professionals don't come easily. Firstly you'll need to relinquish control. Yes, a group needs a framework of instructions and boundaries, but ultimately they'll have untrammelled capability to engage, or not, in a task in whatever way they want. There's literally nothing you can do if a breakout group unilaterally decides to down tools. So, secondly, and linked to this, you'll need to trust that a group will behave appropriately and stay on task even if they are far from your oversight. Of course with some of the digital approaches, it may be (as with Graphical Text-posting) that group members can post and contribute anonymously. In this situation, of course we need to trust that individuals will behave appropriately, but as with all anonymous posting, there is always the chance that they will not and that their contribution or comment will stray into unprofessional or hateful territory. Some collaborative platforms screen for

profanities, which is a helpful aid, but—vitally—you need to have considered how you will handle things both professionally (challenge and report), and technologically (delete and block) if things go awry.

But what helps a facilitative trainer to work in an online way even before the introduction of a graphical component? To answer this question, we'll draw on the work of Katie Piatt (see Piatt 2022), an expert on Engaging and Playful digital teaching practice, and incorporate the following ingredients:

Influence—getting engagement requires a degree of influence and "modelling the way." If you want a group's energy and engagement, you need to lead by example.

Interactivity—a base-level of interactivity means things like using names, asking for "cameras on," using chat bar question-and-response approaches, polls, quizzes etc. (I steer new educators towards Aaron Johnson's (2020) *Online Teaching with Zoom* as a useful primer.)

Involvement—talking to dead air is hard, and the more you talk the less they respond, creating a vicious circle, so involve a group early, create a critical mass of involved participants, be curious, ask questions, and show them how you want them to behave.

Integration—regardless of whether you want them to engage in a graphical activity, it's essential that they are able to collaborate and work together. At the very least this means creating a "hive mind" list of ideas or suggestions in a chat bar. Essentially, are you creating value by using the group members as resources for each other?

Inclusivity—this means that groups should always be able to do what you want them to do technically. It also means that groups and individuals are involved in the decision-making processes about "how" you want to do things. This means being sensitive to needs of the individuals in the group, but it also means listening and being responsive and flexible in terms of the processes you wish to employ.

These ideas seem very sensible if you have a facilitative approach to your work, in which case they are fairly intuitive. But like many others, in the dark days of 2020 during the pandemic lockdowns, I realized that I needed to make tweaks and corrections to my approach and I started to read about distance education in the hope of gaining insight and answers as to how to get groups engaged through a screen. My tried-and-tested "live delivery" facilitation and training recipes (especially my whiteboard murals) had been stripped from me and, regardless of my ability to integrate, include, interact and influence, in all honesty I was panicking about how I was going to run my business. Luckily I came across a fairly old paper (Garrison, Anderson, and Archer 1999) about teaching criticality in an online environment, which helped my thinking enormously. While I have adapted their approach to suit facilitation, rather than teaching—and graphical work, rather than textual work—I owe a lot to their consideration (shown in adapted form in Figure 12.3) of three overlapping areas of consideration; namely Teaching Presence, Cognitive Presence, and Social Presence.

In short, to give an online graphical session any chance of working in the way you want it to, you need to create the "right environment" (via technological and social intentional design), nurture any participant-to-participant discourse (by modeling the type of behavior you want to see, and highlighting the value of peer support), and tailoring the activity and content so it has the best chance of working in a somewhat sterile, disconnected, and remote setting.

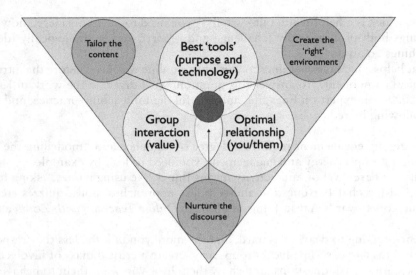

Figure 12.3 Considerations for online facilitation (after Garrison, Anderson, and Archer 2001)

12.3 Digital Issues

Basic graphical facilitation in an online space is possible, as we illustrated in Section 12.1, using nothing more complex than a hybrid meeting platform and a platform like Power-Point. Yes, Zoom and the like have whiteboard functionality—but we can't rely on people knowing how to use this function immediately. And remember that "graphical" can mean boxes, shapes, arrows, colors, and lines—not mastery of shade, line, form, and perspective. If in doubt I ask the groups and subgroups to choose the platform *that they want to use* to capture a discussion or process. Typically at least one of them will have a preferred tool—and this makes the process and short-circuits any discussion about who will screenshare and capture the conversation. So, to ensure any online graphical element has the best chance of working, it is worth considering the following questions:

1 Does the group they have the technical facility to do what you want them to do? Some-one joining using their cell phone won't have the same capabilities to engage graphi-cally as their colleague who has a widescreen monitor or a large touchscreen computer. Technological tools such as large display tablets and mousepens (see Figure 12.4 on next page) have the added advantage of providing instantly saveable, uploadable and interna-tionally sharable graphics, but similar results can be achieved in a low-tech way with a pen, paper, and phone camera.
2 Do they have technological permission to engage and contribute in the way that you need? (I.e. can they share *their* screen? Or can they annotate *your* screen?, etc.) This per-mission may be a simple change of the platform set-up menu at your end of the call, or it may need detailed instruction to help them to change their options.
3 Do they have "organizational permission" to do what you want to do? I frequently work with organizations (especially those in the educational fields) whose computer suites do not have webcams or speakers. There are, of course, sensible reasons for this techno-logical restriction, but it somewhat spoils a session plan if this detail only arises once

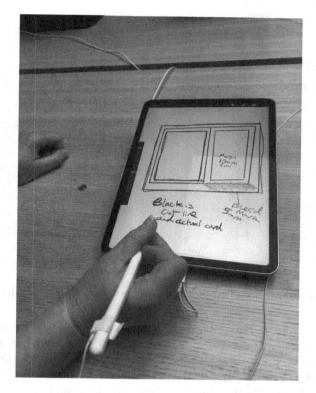

Figure 12.4 Instantly savable and internationally shareable graphics.

a session has started. With this scenario, delegates *can* share their screen, but tend *not* to—because there is no way for them to discuss and unpack what they create.

4 Do they have "intellectual permission" to annotate your screen? Don't be surprised if you are the first person in a teaching or training role who has invited a group to contribute in this way. Also, vitally, if they do annotate a screen or model that you put up—are you absolutely certain you know how to remove the annotations when you want to move the session on?

5 Do they have enough notice that such contributions are expected and required?

6 Do you have a "low tech" workaround if they are not able to contribute by screen sharing? (An example of a low-tech workaround would be the "umbrella reframing" exercise in Chapter 1.4).

12.4 Image Sharing and Digital Collaboration

Throughout this book, we've shown examples of how groups might come together and draw, map, or plot—and most of the time our examples have been drawn from a face to face environment. But of course, for the modern facilitator, using specifically designed software (such as Miro (https://miro.com) or Mural (https://www.mural.co)) allows not just virtual collaboration—as teams add to a shared document—but also unlimited space (a trait shared with other graphical packages and applications such as Concepts

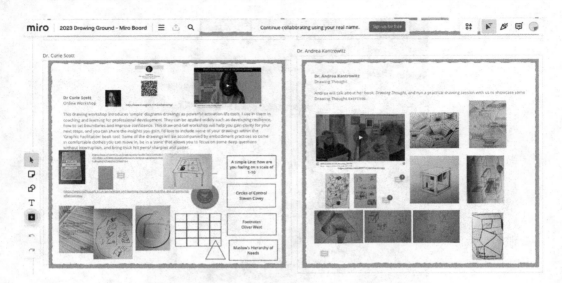

Figure 12.5 Sharing collaborative ideas in a graphical interface with a Miro board

(https://concepts.app/en/)). This unlimited space (i.e. no edge to the page) means that groups can, sometimes over several meetings, attach files and images to create a visual depiction or reference guide that can be returned to and used long into the future. What's more, using a shared design board (as in Figure 12.5) means that groups can create collages, annotate their ideas, and share links and films and other media in real time.

This technological functionality has clear advantages for collaborative teams, but in a teaching or training environment can also pay dividends. For example, Curie was once required to help in a teaching session with students from the hospitality sector. To illustrate the notion of how images and illustrations are vital to the industry, the cohort were asked to select images from their own collection of food and meals that they themselves had photographed with their smartphones. The group uploaded their images, direct from their phones, to a Padlet (https://padlet.com—an online platform for collection, curation, and displays of images), which was shared live with the group and beamed onto the large screen at the front of the room. Rather than a textbook example—or worse still, a purely theoretical one with no illustration—the group created their own discussion material. This material was interrogated with questions to do with memory, feeling, and situational perception of food and dining—all of which are vital elements in the hospitality industry. Essentially, while it lacks the kinaesthetic resonance of physical contact with paper, tape, and pen, collaging and creation of clusters, plots, and infographics is eminently achievable either in online space or in a live training room using technology to project shared creations.

This "PUCA" (*photograph, upload, curate, ask*) process can be used with groups who are perhaps less capable with collaborative or graphics software—since the individuals can draw or collage with physical material, then take a photo and upload it through a provided link. The shared end product (an illustration of which is shown in Figure 12.6) can then be discussed and enquired after. Essentially this means that any technique or tool outlined in the book so far can become digitally compatible—though the process takes a little time.

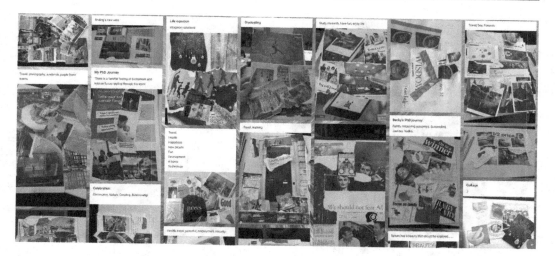

Figure 12.6 Screengrab of a graphical Padlet created and uploaded by a large cohort.

As with other examples used throughout this book, the conversation and articulation of themes in the images is the vital element here. In the case of Figure 12.5 this would mean asking the cohort as a whole to discuss the images (the "what?"), pull out themes (the "so what?") and transfer these realizations in actions and specific learning points (the "now what?").

12.5 Digital Play and Practice

While technological interfaces are pretty intuitive now, and many collaborative packages have ready-designed templates which make it easier for groups to work together, it is our experience that groups often struggle to use digital tools in the way that you may intend. If you plan to run an activity that requires groups to move beyond everyday software—or to use something completely new to them—it is vital to build in a short period of time to simply play and experiment with the apparatus before the actual "task" starts. As an example of the benefit of this agenda-free play, Curie was recently part of a Digital Drawing session led by Angela Brew of the Thinking Through Drawing (TTD) Group (https://www.thinkingthroughdrawing.org). The TTD group is an international collective of drawing practitioners and researchers, who meet to share ideas about how drawing can be used to facilitate and stimulate, amongst other elements, environmental connectivity, wellbeing and better mental health. The online workshop outlined here was to illustrate the value of digital drawing, and provides a perfect model of how to get groups to play and explore kit, be adventurous with it and support each other's learning—in this case with a collaborative graphics package called Miro (www.miro.com).

Firstly, the group were shown how to access the tool and a couple of rudimentary elements were demonstrated. Then the group were simply asked to play with the package and to create drawings on the shared board. No brief was given other than simply to "explore and experiment" for a period of time, "create drawings" and also to "talk about what you're doing." (It is worth emphasizing that this exploratory play does take time (perhaps a few minutes) but is a vital step in ensuring a group can derive the maximum benefit from whatever package you may be wanting them to use.)

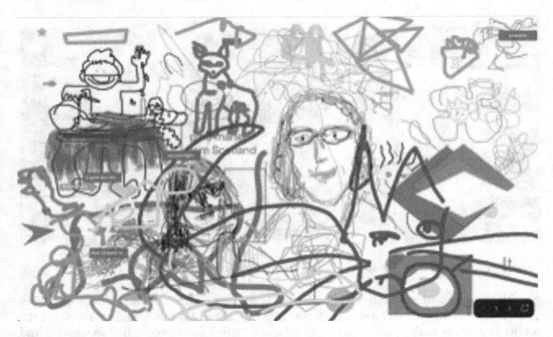

Figure 12.7 Results of technological "free play"—where a group both learns about a technological interface and teaches each other

From the screenshot in Figure 12.7, it is obvious that some of these drawings were higher quality than others and some people had a natural affinity for the platform (or had existing experience of it). However, what transpired was that the group started to have a conversation in real time about what each other were doing. Because in Miro, as with many other collaboration packages, the mark-maker's name appears next to their cursor, it allows identification and named enquiry about technique (i.e. "Sam, how are you doing *that*?"). The skill can then be demonstrated and practiced immediately. This peer-to-peer teaching allows the group to build a shared repository of knowledge and technique very quickly indeed. Moreover, this socialized education allows group members who are technically capable, but perhaps quieter, to speak up and find a leadership role that they may normally not have a chance to employ.

This "free play" technique can also reveal to a facilitator which group members are the champions and early adopters and what sort of group dynamics and strengths are at play. For instance: Who is naturally encouraging? Who takes risks? Who leads? Who builds on another's contribution (i.e. "I'll see your triangle and make it into a shark fin!")?

This warm-up activity, in and of itself, could act as a team development task if properly reviewed. For instance, a review that centers around the notion of "what have you learned about each other in the last ten minutes?" could be a powerful conduit to other deeper conversations.

12.6 Word Clouds—Text to Graphic Translations

In Chapter 11 (Mixing and Matching) we touched on the idea of mixing text and graphics. Using a digital approach here can make this blended approach very immediate and

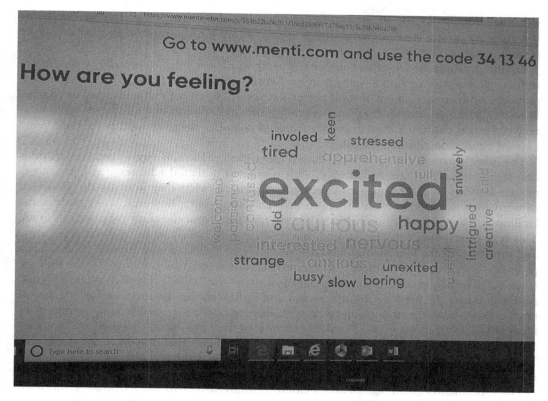

Figure 12.8 Word Cloud created around the declared "feeling" of a large group

accessible. Since text is easily recognizable and accessible to any group—even a large cohort who may not wish to, or be able to, fully engage—translating text to graphic is a quick way to "show" the reactions or feelings of a group. Many organizations use word clouds to present qualitative responses to feedback requests, but they can be a good conduit to help a group start to make a transition from a text mindset to a graphical mindset (from, if you will, "tell" to "show"). They can be created digitally in real time and (using a tool pairing such as Mentimeter (https://www.mentimeter.com) and the Menti (www.menti.com) app) create a visual representation where programme delegates or students can type in a number of responses and the frequency of these responses is reflected in the size of the words in the final word cloud plot (as illustrated in Figure 12.8). This translation from pure text to a graphical image is, in its own right, a helpful accelerant for further graphical activities later in a programme. Such a plot can be created in a live room or in an online setting—providing people know in advance that they will need to run two pieces of software at once.

The word cloud in Figure 12.8 was created a few minutes into working with a new group of trainee lecturers. They had, at that point, undertaken a group activity and were asked to say honestly how they were feeling in five discrete words. Using the Menti cloud led to a teaching point about how students' feelings change within the lesson setting and being reflexive and responsive to the atmosphere in a teaching room. In this case, the package was set to allow the graphic to update continually and allow people to repeat a word they could already see. It could, however, have been set to fully reveal only after everyone had

inputted. What is important, from a facilitative point of view, is that a time limit is set for the input stage—to avoid a group sitting around waiting for contributions that are never going to come.

Enabling people to see others' immediate responses is helpful, especially if people are feeling uncertain or tentative—which in our world can occur at the start of a longer programme, or around assignment time, or at a team development event in times of change. However, you may decide that only revealing the final cloud once all entries have been received might capture a more complete range of cognitive diversity—i.e. people not being swayed by the contributions of others.

The other great advantage of word clouds (regardless of the app used to generate them) is that they generally remain anonymous. This is of great potential advantage as it engenders greater honesty in the room—with people contributing what they actually think instead of what they think others want them to say. This anonymity, however, poses risks to the facilitator. The most obvious risk is an inane response from the class prisoner or clown. This type of response can't be ignored, but it's (hopefully) likely to be an isolated response and thus tiny on the word cloud, and can probably be deflected with humor. (Menti has a profanity filter that can be employed to remove certain words and responses before they are revealed.) The bigger risk, however, is that of surprise—i.e. when a revealed collective group response shows the need for an unexpected and radical change in direction for a session. I once asked a departmental group to suggest, using a collective word cloud, directions for ideas for their future projects. The department lead had, in advance, assured me that they "all wanted to move in direction X." The word cloud revealed otherwise. Dramatically. This was a brilliant facilitative reveal—though the boss was somewhat annoyed—but it did require a completely improvised pivot for the rest of the away day.

The other major advantage of word cloud translations is that the technique lends itself to being carried out in complete reflective silence as people think carefully about their choice of words. Silence is a powerful coaching tool (see Turner 2021), however it is not often utilized in facilitation. However, when combined with powerful questions (see Wood Brooks and John (2018) and Guccione and Hutchinson (2021)), it can yield very powerful results indeed. In fact, it is sometimes worth giving people extended notice (i.e. prior to a break) that you are going to request words (or any input) from them to encourage quiet thinking, and to cater to people with a preference for introversion. As a facilitator, regardless of whether you are using a digital interface or paper and pens, think carefully about how much time a group is silent for; a deliberate, intentional, reflective silence—not a passive aggressive resentful one. It's certainly something that as consultants we both have to deliberately remember to include in our work—not least because as external agents we feel somewhat fraudulent if a group is not in an activated energetic state and "on task" at all times.

12.7 The Graphical Possibilities of AI

Throughout this book you'll notice that we're erred on the "low-tech" side of things, using traditional pens, paper, and physical stationery. Mainly this is through a deliberate desire to share ideas that "work" and that are well tried and tested. However, by both intentional curiosity and professional necessity, what we're now starting to explore is the creative and combinational possibilities of technology and, specifically, Artificial Intelligence (AI) to supplement and augment a group facilitation process.

AI software (and by the time you read this there'll be more of these and better than those we've seen so far—like Dall-e, see https://openai.com/research/dall-e) can create combinational images very quickly indeed using specific, natural language instruction to create appropriately tailored graphics. This means that groups can create images perfectly tailored to their own lived experience. These images could form the basis of a discussion and can be shown individually or made into a group collage to help explore issues and topics (as set out in Chapter 11).

For instance, you could ask participants to use a mix of nouns and adjectives to describe their organization or culture, and then run these words through an AI image generator to create a depiction that can be easily uploaded to a virtual whiteboard or Padlet, or screen-shared and then discussed. For example, as a focusing exercise you might individually ask a group of participants to:

1 Identify their organization as a type of machine (e.g. a car, washing machine, or submarine) ("What type of machine would this company be?")

<div align="center">and</div>

2 Classify the *function* of the organization (e.g. retail, education, research etc.) ("So, what's this machine for?," which in and of itself is a wonderfully rich facilitative gambit...)

<div align="center">and</div>

3 Describe its *metaphorical appearance* (e.g. shiny but corroded in the hidden parts) ("And how would you describe the look of it?")

<div align="center">and</div>

4 List some elements that describe what it's like to work there (e.g. pressurized, supportive, fun etc.)

Combining these descriptors into a composite using AI results in an immediate image that can be used as part of a session. For example:

- participants could view each other's pictures and guess at the words their colleague chose to represent their team or organization
- participants could create two images with words describing firstly "how things are" and secondly "how I'd like them to be"
- images could be combined into a collage or used in individual reflections or paired discussions

Removing a limitation, or the participant perception of a limitation, of "the need to be able to draw" allows for very elaborate graphical metaphors to be created instantaneously. With a little thought, you'll quickly realize that the combinational possibilities here are enormous. For instance:

- What if the management hierarchy was depicted as being from a particular time period in history?
- What if the vision of the company was shown in an impressionistic, cubist, surrealist, or classical style?

- What if a team could be shown as different types of zoo animals depending on character trait?
- What if the culture of the organization could be shown instantly as colors or shapes to kick-start a conversation?
- What if a change process could quickly be captured as a cartoon strip? Each participant could create an image to depict a phase of the change in the way that it related to them ("the dysfunctional hot mess"; "the unrealistic new vision"; "the reluctant staff dinosaurs"; "the green shoots of progress"; "the new dystopia" etc.). These images could create a cartoon strip or a screenshared narrative to facilitate reflection on lessons learned or otherwise.

As with all the other tools and techniques herein, the value is not in the image creation per se, but in the conversations and realizations that a graphical process propagates. As a facilitator of a graphical process, the open-ended questions and discission prompts to aid the group are where you personally add value. For example, with the AI image generation example above, a facilitator might need to ask questions such as:

- What was behind your choice of descriptive words?
- Has the generator captured your "mind's-eye" impression of things accurately or would you want to make alterations?
- What thoughts and impressions does this image lead to?
- What do we collectively notice here?

And, as always, the focus for a facilitator is probably likely to be that of helping an organization (or individual) to progress. As such, questions such as:

- Where would you envision the organization moving towards?
- What sort of images would constitute a utopian view of what you want to achieve?
- What elements need to be present in the future and which need to be removed, modified, adapted, or changed?

This is an area terrifyingly rich in possibility for the facilitator, and we look forward to exploring it more as it develops as an intuitive and more widely used tool.

*

References

Garrison, D, Anderson, T, and Archer, W (original 1999) Critical inquiry in a text-based environment: computer conferencing in higher education. *The Internet and Higher Education*, 2(2–3), 87–105

Guccione, K and Hutchinson, S (2021) *Coaching and Mentoring for Academic Development* (Emerald Publishing)

Johnson, A (2020) *Online Teaching with Zoom: A guide for teaching and learning with videoconference platforms* (Excellent Online Teaching Series)

Piatt, K (2022) Engaging digital teaching practice. In Nolan, S and Hutchinson, S (Eds.), *Leading Innovation and Creativity in University Teaching: Implementing change at the programme level* (Routledge)

Turner, AF (2021). Silence in coaching. In Passmore, J (Ed.), *The Coaches' Handbook: The complete practitioner guide for professional coaches* (Routledge/Taylor & Francis Group), 132–140

Wood Brooks, A and John, L (2018) The surprising power of questions. *Harvard Business Review*, 96(3), 60–67.

Part IV

"Drawing" It all Together

Writing a book, especially a book that centers on professional practice, is a curious experience. On one hand it's a chance to showcase our professional abilities to an audience, but at all times, as with facilitation, the book has to be centered on the reader and engage them with questions, ideas, pragmatism, and tactics. In this we hope that we've been successful.

However, the practice of writing about one's "profession" (with all the connotations of that word from "expert" to "paid") means that you invariably start to ask questions of yourself and interrogate your own capabilities. "Do I do my job as well as I'm pretending in this writing?" you start to ask—and as such you start to really focus on your craft with renewed interest and curiosity. What's more, you start to experiment just a bit more than usual. You push at boundaries with groups. You take more risks. You ask them to suspend any cynicism as you wave paints and crayons and postcards in their face. You ask more of their creativity and artistic talents. You try things out simply because you're asking your readers to change their behaviors and practices, and so then you should be able to do the same.

And interesting things happen.

So, in this final, short, section of the book we'll draw all the strands of the book together and pose a final set of questions and challenges to the reader. We'll then speculate about what the future might hold for a graphical approach to facilitation. Our hope is that you'll find new and interesting territory in the way that we have.

DOI: 10.4324/9781003410577-17

Chapter 13

Reframe Your Thinking and Picture the Future

The late humorist Miles Kington once stated that "Knowledge is knowing that a tomato is a fruit; wisdom is not putting it in a fruit salad." I've been thinking about these words throughout the writing process and as I read back through the previous twelve chapters.

In this book, we've shared our own approaches to the challenge of facilitating groups in a creative and meaningful way that stimulates conversation, realization and action. There's a lot of knowledge on display and lots of models, tricks, and approaches to the art and craft of facilitation. We've examined the basic purpose of the facilitator, and set out a reminder or primer of the role itself. We've illustrated how dots and lines and sticky notes can help groups to examine complexity. We've shown how shapes and models can aid groups in setting direction and making decisions. We've sketched out how media can be employed to assist in realising and articulating visions. We've indicated how different movements, technologies, and creative approaches can shift groups towards compelling actions. But will all of this knowledge make you, the reader, a wiser practitioner or will you be asking groups to put tomatoes in their fruit salad? In short, it seems prudent to address the question of: How might we move beyond the knowledge elements of graphic facilitation skills to the wisdom of a really good facilitator? And what's more: How might this skill, knowledge, and wisdom be employed in professional world that has shifted seismically in recent times?

13.1 The Five Perspectives of Facilitation

So here, in this final chapter, we present no more tools. There are, however, some lessons, questions, and five overarching perspectives. We'd suggest that you see them as ways that you might revisit the tools and techniques outlined throughout the book. These perspectives are:

- Purpose—are you clear on the purpose of your interventions?
- Engagement—are the rules of engagement explicit?
- Role—are you clear on what your role is and is not?
- Group—are you paying attention to subtext, relationships, and emotions?
- Self—are you reflective, reflexive, and aware of your personal effect on things?

DOI: 10.4324/9781003410577-18

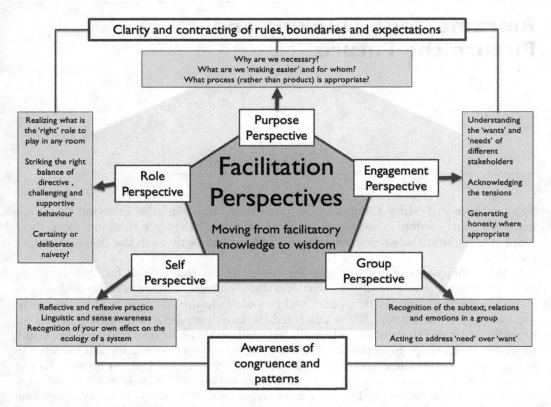

Figure 13.1 The Five Perspectives of Facilitation

These perspectives and the relationships between them are shown diagrammatically in Figure 13.1 and we'll explore them and the connections between them each in turn.

- **Purpose Perspective**—*are you clear on the reason for your interventions?*

If facilitation is, by definition, "making things easier" then facilitators need to be absolutely precise in our understanding of "why" we are necessary. What specifically is getting in the way of a group finding things easy in the first place? It's not a particularly pleasant thing to realize, but quite a lot of the time a facilitator's job could be done by creating "time" for a group, protecting them from distraction and letting them sort it out themselves. Frequently, what we really are is an "accelerator"—which in and of itself is a useful function, but perhaps less mythical than some professionals would have you believe. Also, it's worth enquiring as to "how" are we making things easier, and "what" *specifically* are our efforts working towards? Failure to address these big questions properly means that any tool or intervention that we choose has perhaps only little better than random chance in terms of effectiveness. Things might work or they might not.

Moreover, and this question is very real and very important, at what point does the graphical "product" become to you more important than the process of creating it? For example, once when working with a group I drew a considerable and impressive (and,

damn it, beautiful) model onto a whiteboard with a very large and very neat freehand circle at the center. The model had built nicely throughout the session and I was feeling very pleased when a course delegate suddenly had a "eureka!" moment, jumped up and drew a large and messy arrow right across the middle of the model—joining two things that we previously hadn't realized were connected. The group were excited and energized, and the session was a triumph. A part of me was delighted that the group had experienced an epiphany that was transformational and fuelled action. But a significant part of me was annoyed that they'd spoiled "my" model. I did a lot of hard thinking about purpose on the drive home that day.

- **Engagement perspective**—*are the "rules" clear and explicit?*

Earlier in the book we touched on the notion of using graphics to "get at the honesty" in groups. Honesty is, it's fair to say, a "good" thing. However, there have been many, many occasions in my career where I have steered groups away from absolute brutal truth, because the ramifications of full disclosure would be utterly catastrophic to a project or working endeavor. And, even if we have a facilitative duty to help groups to confront truth, do we have the contracted time in which to do it? If you work with a group day in, day out then you may have time to create an omelette from the eggs broken by truth-telling. If you're with a group for three hours, all you'll leave them with is an eggy mess. Essentially, just because you can do something doesn't mean that you should. Establishing these parameters is the essence of engagement awareness.

Engagement perspective is concerned with the, often complex, balance of relationships that a facilitator may have with the client and the group that they actually work with "live." This is not about the role(s) that we play in the room (that comes later), but it is about expectations, boundaries, rules, and contracting. As anyone who has ever had a job and a life knows, what is good for an employer and organization is not always what is good for employees. Better organizations try to align these agendas as much as possible. Organizations with high employee churn tend not to. In the same way, what is good for the contracting organization is not always good for a team or the individuals therein.

So, are you as a facilitator (especially a freelancer) clear on the rules of engagement? Are you clear what the client wants—and have you considered what you will do if there is a conflict of interests between the organization and the individuals? Fundamentally, whose agendas are you serving? Any experienced professional facilitator will tell you that the situation and challenge that a client describes prior to the engagement and then what actually manifests in a real room when all the team are present are sometimes miles apart.

It's not a simple conversation, but it is an essential one, to broach the question of how fixed is the client with regard to the outputs and outcomes that they want you to move a group towards. If the group wants (or more vitally, needs) to turn left at the traffic lights, is that a legitimate option for you? Of course, any professional wants to do the "right" thing, but whose version of "right" are you working to? The individual, the group, or the paymaster?

Once you've reconciled this possible tension, you need to consider whether or not you have a deep enough toolkit to handle the flexible nature of your engagement. Like the tools in a cantilever toolbox—those at the top are familiar and comfortable and will be your go-to options, those deep in the darkest recesses of the box are the ones that you'll probably use *least well* but only retrieve in an emergency—*when it's most vital that you get things*

right and do no harm. So, again, tool knowledge is one thing, tool mastery and sufficient practice and comfort with your emergency options is something very different.

- **Role perspective**—*are you clear on what your role really is?*

The role that one plays in a training room or facilitation space is linked to, but not the same as, purpose. Ultimately clarity of purpose should define our actions, but there are many ways to reach any given destination and thus many roles that can be played. Contracting with the client or sponsor will help provide some clarity, but can also restrict the professional flexibility that you may need to do "best" by the group.

So, will your playfulness be appropriate? Will your style suit the group? Where will you strike the balance between professional confidence ("I know what I'm doing?") and deliberate ignorance ("I'm an outsider, show me how you do things?"). And as we've already mentioned, if your lens for engagement is the picture you create, there can easily come a point where a session becomes more about you than the group. Avoid this at all costs.

So, where will you need to provide a hierarchy and framework? Where will you simply instruct the group as to what you want them to do? Where will you provide structure and objectives? Where will you be the one to confront the elephant in the room? Where, ultimately, is it the right time to take charge of the group and hold the responsibility? And what will you do if they don't comply?

Where will you co-design and co-create a session or intervention that is meaningful to the group? Is it appropriate to negotiate the processes and outcomes with the group? Is your opinion more or less valid than any other in the room?

Where will you simply be a resource for the group to draw upon? Where will you set the stage and the environment, but ensure that the group take full ownership of their direction and process? And if this is the style you decide to employ, how will you justify (to the client, and also to your inner self who has a touch of imposter syndrome) the fee that you are charging or the salary that you earn?

There is, of course, considerable professional overlap between the notions of Purpose, Engagement, and Role, which lays in the area of ensuring clarity and contracting rules, boundaries, and expectations—both with the client or sponsor and with the actual group.

- **Group Perspective**—*are you paying attention to subtext, relationships, and emotions?*

Are you really paying attention to the group or are you focusing on the process of facilitation, or worse, the product of any graphically facilitative exercise you deploy? Throughout this book we've tried to emphasize the needs of the process over a snazzy product, but a wise and experienced practitioner should be able to keep one eye on the dynamics in the group itself and not just on the process that is developing.

For instance, where are the alliances in the group? Who is providing influence and leadership (regardless of status)? Where are the cliques? The oppositions? Who is providing perspective? Who generates the ideas and who provides the structure? Where are the unspoken "micro conflicts" (the silent eyebrow raise at a pivotal moment that no one sees apart from you)? What is the emotional state of the room? What are people feeling but not saying? Are you noticing patterns of behavior, and if you are—are you judicious in what you will do with this information?

We find it is often the case that noticing behavioral patterns and being "group aware" is potentially a hugely useful service that a facilitator can offer—but, critically, such

conversations can distract from the pre-ordained process and outcomes of an away-day or similar. So do we speak up, or let things go by "unnoticed?" Of course, we could speak up—but *should* we? Herein is a tomato/fruit salad decision. And if you've invested time and effort, and potentially resources, in a graphical plan for an event, the temptation to let things slide in the interest of "finishing the picture" is exacerbated considerably.

Linked to this, do you have a requisite empathy with what you are asking the group to do or with how they may be feeling in any given moment? In the opening section of the book we explored overcoming resistance to graphical tasks, which is connected to empathy and recognition of the vibe in a room. But it extends beyond this; too little empathy and a session won't take off, too much and you won't be able to take the group to places of discomfort and challenge.

Of course, unless an issue is explicitly raised, much of the time facilitators need to rely on their "reading" of the cues, subtext, and often what is *not* being said. And we really don't know for certain what any given signal means. As such you need to be conscious and aware of patterns of action and behavior and looking out for congruence in these—and then gently enquiring as to the accuracy of your interpretations.

- **"Self" Perspective**—*are you reflective, reflexive, and aware of being aware?*

Most of the content and topic matter of this book is visual in nature or relates to things that people see. As such, when we work in a graphical medium much of the language that we use starts to become visual; we have "vision," we "frame" a discussion, we "picture" the future, we request "clarity." Without getting bogged down in the disputed theories of learning styles models, it's easy to "see" that our work can start to favor a certain type of representational system—the visual. In doing so, we ignore or marginalize people who might engage with content in a more auditory way ("does that sound right to you?" or "what might that tell us?") or in a more kinaesthetic sense ("are you getting for this or do we need to be more concrete in our examples?"). A skilled facilitator, teacher, or communicator will recognize that their language has drifted away from a balanced representation system—or may even be consciously "matching" the language of the group (see Knight 2009) and reframing examples to fit linguistically. They are not simply aware of the delicate balance of task, process, and people, but aware of their own effects of this complicated ecology. This self-awareness can take many forms and there are overlaps and similarities between being switched onto, and reading, the needs of the group (the relationships, emotions, and unspoken sentiments) and understanding and managing your own needs and drives. This combination of self and social awareness is essentially the prime component of Emotional Intelligence (EQ) (See Goleman 1996 as a primer), and while EQ is an important component of a good facilitator, all the IQ or EQ in the world counts for little if you don't reflectively or reflexively act. And awareness, and the desire to act, also count for little if you don't have the requisite variety of tools to do so.

13.2 Changed World, Changed Approaches?

The world of work has changed dramatically since 2020. The change in working practices forced by the COVID pandemic and socially distanced workings irreversibly altered the way that many professionals viewed their work and operated. Yes, things may seem to have reverted to some sort of "normality," but the change in practices is obvious if one simply

walks around an office or university campus, or takes a commuter train, on a Monday or a Friday. Teams are simply not as socially connected as they once were. Hybrid working and online conference calls have resulted in meetings that are more task-focused and perhaps less creative than they might be. We certainly spend less time finding out about our colleagues.

At the same time, perhaps linked causally or perhaps coincidentally—or more likely a bit of both—we've seen a rise in reported anxiety and mental health concerns. In answer to these changes, organizations, in our experience, are making efforts to improve workplace culture and to be, and be seen to be, more inclusive and responsive—yet often this is hampered by the aforementioned rise in remote working practices; it's hard to have an inclusive culture if people aren't there. At the same time, perhaps accelerated by pandemic-related conversations about workplace inclusivity and culture, organizations are now starting to be more aware of and prepared for the needs of neurodiverse employees. And since facilitators are often called upon to help organizations "think differently" about their strategies as well as build better and more inclusive cultures, it would seem appropriate that facilitators should also look at their own practices and enquire as to whether the methods that they employ are suited. To this end, one of my favourite encounters over the last year was with a workshop participant who told me that that mine was the first session they'd ever been to where they felt able to contribute fully with confidence. We'd done nothing complex— just some simple mapping of future possibilities—but they had been able to draw, rather than write, which—as they quietly told me during lunch—for someone with dyslexia was somewhat empowering. This caused me to reflect very hard indeed on just how inclusive my professional practice both had been and currently was.

During the dark days of the Cold War, strategic thinkers coined the label of a VUCA landscape; one that is simultaneously volatile, uncertain, complex, and ambiguous. Post-lockdown working practices, political uncertainty at a national and global scale, economic insecurity, changing technologies, and Artificial Intelligence, as well as a workforce and student body that are also changing and demanding that organizations support them properly, means that we are once again in a VUCA environment. So what does this mean for coaches, trainers, facilitators, and development professionals?

In a complex and uncertain landscape, leaders and professionals need to think carefully and strategically—and also with agility, for in times of complexity and ambiguity there lie opportunities. They also need to learn fast and fail fast so they can unpack lessons quickly (David Wilkinson's 2006 work, *The Ambiguity Advantage*, makes particularly insightful points on this topic). Organizations and teams need to enquire as to their existing practices and challenges and replace the ones that are no longer relevant. Things need to evolve at a rapid rate to keep up with their volatile environment. New ways of working require new ways of thinking. Things need to be made easier. And this means that at some level there is a real need for the sort of service that quality facilitators, coaches, and trainers can provide.

13.3 Lessons Learned Along the Way

Of course, none of this is to say that a graphical facilitation approach is a panacea that will change the world, but it is something that we know generates involvement, participation, and taps into insight from people who are genuinely able to "picture things differently." And moreover, it helps people to share their insights and learning with each other in a

meaningful way. So as this book draws to a close, in the spirit of sharing insights and learning, we present the lessons that we, as an author team, have learned along the way.

Lesson One—Process is Always more Important than the Product

To paraphrase my (Steve's) mildly disrespectful teenage children, we've been "banging on" about this lesson since the start of the book—and so we hope you've absorbed it. Challenging a group to produce something graphical and creative will always produce interesting conversations and creative interpretations that facilitate new insights. The process is always, if not richer than the conventional orthodoxy, then at least different to it. And different is good. However, it must be said that we've learned we're always still secretly pleased when a group produces something fantastic—irrespective of the process involved in creating it. Regardless of the value added, this group-drawn infographic *wasn't* a bullet-point list—and everyone's day was richer as a result.

Lesson Two—Help Groups to Unpack Genuine Meaning from any Task

Building from the first lesson, since we started writing the book we've learned that it's imperative that we enquire after, challenge the meaning of, and listen to the stories about the graphics that our groups produce. Of course, we did this prior to the writing process,

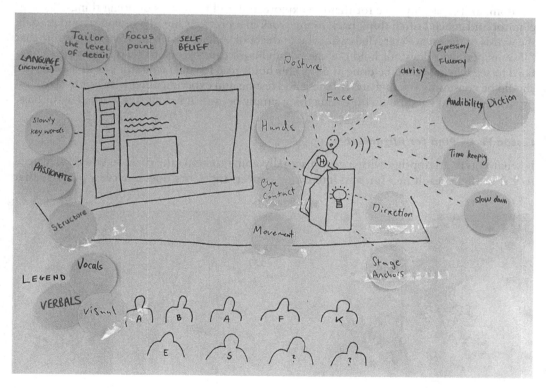

Figure 13.2 This group-drawn infographic could have been a bullet point list.

but we've learned afresh over the last year or so just how important this interrogation and translation is.

Lesson Three—Ensure that Groups Derive Value from Each Other

This is also not a new lesson to us, but it *seems* new since much of the practice that informs the writing has been done post-lockdowns, as people step back blinking into a live work environment. Regardless of whether you are facilitating a workshop, a meeting, or an away day, are your group members really gaining value from each other? If they're not learning from, supporting, challenging, listening to, and building on the contributions of each other, it's hard to know why anyone is in the room. The session could've been an email. Fortunately, drawing pictures with groups makes this easy. Professional environments have changed, but one thing never will—people's innate desire to connect, tell stories, and share their pictures and worlds.

Lesson Four—Have You Provided enough Freedom in enough Framework?

Bouncing ideas between the two of us has again and again highlighted the complementary differences in the way we approach our work. One of us loves frameworks and structure; the other space and creativity. Which is not to say we can't do both. But the lesson is to ensure that a learning group is provided with enough structure and material, but also enough space, freedom, and especially time for them to explore and find new ways of doing things. As a facilitator and coach I often think back to my work in a previous life as a biologist, and reading the words of the great Peter Medawar, who in the book *Advice to a Young Scientist*, wrote that "If an experiment does not hold out the possibility of causing one to revise one's views, it is hard to see why it should be done at all." This holds true for the facilitator's craft as well. We should be constantly refining and listening and testing and experimenting with our tools to improve them—and we shouldn't use something simply because it has always worked in the past.

Lesson Five—Plan for Alignment

Is what you're attempting with a group actually going to help take them to where they need to go? It might result in a fun and interesting conversation, but does it serve a purpose that

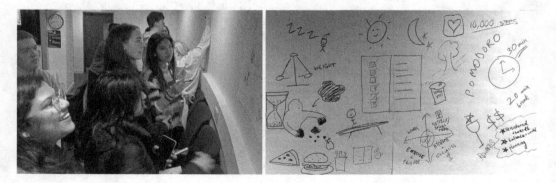

Figure 13.3 A group deriving value from both the process and the final graphical product

meets the individuals' or group's need as well as the larger organization? This writing process has made both of us think about planning for purposeful alignment.

Lesson Six—Use What You've Got

No whiteboard? No problem—use individual sheets of A4 paper and stick them together. No fancy artistic materials? No worries—graphical facilitation can happen by sticking four labeled sheets of paper in the corners of a room and asking people to distribute themselves throughout the model you've created. Our sixth lesson is to use what we have. This is partly about being prepared but also about using the things that our delegates have with them. After all, every single person that you work with has a powerful technological image capture and manipulation device in their pocket.

Lesson Seven—Be Ready, because Graphical Goes Deep

In writing this book—and it may be linked to the times in which we are working, or it may be because we've dug deeper with things and consciously tried to push further than before—but we've had richer and more raw conversations with groups than ever before. We've seen lots of smiles. Getting folk drawing can lift even a serious topic. But there have certainly been tears shed in groups—which, if handled appropriately, means that something has been raised that had previously been suppressed and this is almost certainly of long-term benefit to the group or individual. So are you prepared to engage with groups at a deeper level than a usual bullet point list, or a normal breakout room conversation, might provoke? Of course everyone is professionally doing their best and, to quote Plutarch, "fighting a hard battle," but that does not mean we shouldn't challenge and help the groups to confront the difficult deep conversations, as well as support them.

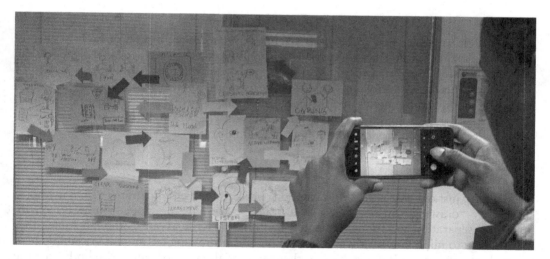

Figure 13.4 Use what you have, and let them use what they have!

Lesson Eight—Get a Community of Practice

Perhaps the best thing about the whole process of writing this book is that it's given both of us a ready-made community of practice. Meetings earmarked for progress reporting and document sharing have been cast aside after one of us has shared what we've been doing and the other has become very excited. For instance, last week's editorial meeting was usurped completely with this exchange:

> "I got them to make masks!"
> "You made masks!! Wow. Oooh—you could draw two-sided masks and get folk to talk about what they reveal and what they hide…!"
> "Oh yes!! And then…" etc. (for some considerable time).

Lesson eight is to reach out to people and find your community of people who are prepared to experiment and try things out. Meet up, share ideas, build, and extend each other's ideas. In our experience, really talented professionals are always happy to share and play. Nurture them when you find them and support each other.

Lesson Nine—Be Brave and Resolved

Henri Matisse once said that "Creativity takes courage." Over the last few months we've realized that a graphical approach requires bravery. We've both had setbacks and knocks when we've tried new ideas out. Not everything has worked in the way we initially thought. Both of us have had conversations with contracting employers who have raised one eyebrow and expressed tacit (and in one case explicit) doubt as to whether what we propose to do will work with their group. We hope we've illustrated in this book that a graphical approach can be serious as well as playful, but the moment you mention the words "draw," "paint," "build," or "sculpt" there will be, somewhere, some resistance. Be brave and commit to your course. And, if in doubt, remember that it's about the process…

Lesson Ten—Remember to Keep Being Playful

We've both learned this year to be more inventive in our design, but we've both frequently had to stop and check that whatever we help groups to do, say, or create, it is always in the cause of "making something easier." However, perhaps the biggest lesson for us is that it's important to find the joy in what you do. Working in a graphical way with groups is challenging at times, and frequently requires large amounts of mental effort from a facilitator—but it is never dull. So, go and be playful and inventive. Because if you are creative, the groups with whom you work will follow your example.

*

And, finally, just one last note. We started this book as we both integrated visual methods, specifically "drawing," in our facilitation practice. We have developed our ways of doing things separately and thought it might be "fun" to write about it (though some other words come to mind now). However, to be honest our drawing techniques are simply how we facilitate sessions. We don't think of them as special, jazzy, or clever. We both keep the

purpose of things clearly in mind and we both have the luxury of being able to use whatever techniques we want to run a session. So, we use visual methods because, bluntly, they work! Discussing, planning, organizing, and writing this book as a collaboration has stimulated our excitement at facilitating well. There are many, many graphic facilitation techniques that each of us use that the other had never envisaged. So, we both now have an even bigger repertoire of exciting things to try out. We hope that, having dipped into this book, you too can see lots of ways to apply some of these ideas.

Go and be playful and make it easier for your groups to discover and decide and realize and articulate and plan and envision a better, brighter place.

CS and SH (March 2024)

*

References

Goleman, D (1996 New Edition) *Emotional Intelligence: Why it can matter more than IQ* (Bloomsbury Publishing)

Knight, S (2009, 3rd Ed) *NLP at Work: The essence of excellence* (Nicholas Brealey Publishing)

Medawar, PB (1979). *Advice to a Young Scientist* (Harper & Row)

Wilkinson, D (2006) *The Ambiguity Advantage: What great leaders are great at* (Springer)

Index

Note: Page numbers in *italics* refer to figures. Numbers in **bold** refer to tables.

2 × 2 matrices 77–78, **116**, 147–148
5Ps 129
5S Pillars System 108, **115**
7S model 86, **115**

affinity charts **115**
Agerbeck, Brandy 3
agility 17
Analytical Hierarchy Processing 69
arrows 2, 25, 26, 37, 70, 77, 81, 87, 106, 110, 119, 127, 167, *168*, 184, 197
art gallery 178–179
articulation 4–5
Artificial Intelligence (AI) 190–192, 200
Artist Book 156–157, *156*
arts and health movement 178
assemblage 156; *see also* collages
Authority/Freedom Leadership style model 77
Ayoa 33

Baastrup, Loa 3
Balanced Scorecard **115**
bar charts **115**
beach drawings 49
Beach School 152–153, *153*
Beck, Harry 91
Berinato, Scott 117
Bird, Jenny 3
Block, Peter 103, 112
board games 90
bone folders 158
"Boston Square" 77
Brew, Angela 187
bricolage 156; *see also* collages
Bubble Charts **115**
building blocks 163–164
Buzan, Tony 3, 64

cartoons and cartooning 27, 175–176, *176*, 177
Cause and Effect Analysis **115**

change leadership 60
circles: circle as clock face 122, 124, *124*; compass and direction finding 122, 126–128; holistic comparisons 122, 128–129; targeting--proximity to core 122, 123, *123*; unification and equality 122, 125–126; Venn diagrams 122, 181
Civic Engagement model 103, 112
clarifying 17, 18, 75, **116**, 137
clay 154, 162–163, *162*
clustering **115**
clusters 64–65, *68*; beyond basic 67–69; and sticky notes 66; strategic 69–70
co-creation 4; *see also* collaborations
Cognitive Therapy 5
Collaborate 109
collaborations 40–41, *41*; in cartoons 175–176, *176*; virtual 185–186
collages 110, 131–135, 155; digital 132, 134; displaying 134, *134*; examples, *43*, *131*, *132*, *133*, *134*; for exploring concepts 132; reflections on 133–134; three-dimensional 132, 154–157, *154*, *155*, *156*; values 174, *175*
comfort zone 9, 42, 45
community map 69
community of practice 137, 204
concept maps 64, 94–95, *95*
concept software 33
Concepts 185
confidentiality 44
conflict confrontation and resolution 20
connections: lines illustrating 64–65; and sticky notes 66, 67; *see also* clusters
Conversation Mapping 20
conversations 5–6, *6*, *8*; action plan 67
conversion 4–5
Cost v Value 77
Crawford, Sarah 3
creativity 32, 118–120, 204

critical stories 83, *84*
culture change 135
curiosity and enquiry 17
customer delight vs implementation cost **116**
Cynefin **115**

Data, Information, Knowledge, Wisdom
 (DIKW) model 73
de Bono, Edward 126
decision filters 75
Decision Trees **115**
Deming cycle **115**
design boards, shared 186
diagnosing and solving 18–19
dialogue 6; *see also* conversation
Digital Drawing 187
digital photography 85
dominoes exercise 88–89, *89*
doodling 143
Doomsday Clock 124
Doughnut Economics 122
drawing 204–205; beach drawings 49; blind
 138–139, *139*; with the body (embodiment)
 152; collaborative 187–188; digital 187;
 digital play and practice 187–188; expressive
 lines 60, *61*, 62–63, *62*; freeform (for
 writers) 137–138; line as visual documentary
 63–64, *63*; lines and marks (simple) 53;
 lines as illustrator of change 58–60, *59*; lines
 illustrating connections and clusters 64–65;
 metaphorical lines 56–58, *56*; mindful
 141–144, *144*; mixing with shapes and
 directions 167, *168*; observational 138–139;
 picturing the ideal 136, *136*; pre-session 48;
 as thinking aid 60, *61*, 62; warm-ups 45–46,
 45; and the written word 168–169, *169*, *170*

Edwards, Betty 138
Effort v Impact 77
Eisenhower Box 77
embodied facilitation 152
emojis 109, 122
Emotional Intelligence (EQ) 199
empowerment 3
encoding 109–110
engagement 44–47, *46*
ethnography 64
exercises: online *19*; "Redesign the Umbrella"
 18, *19*
Experiential Learning 39

facilitation: art of 13; changing approaches
 199–200; deriving value 202, *202*; elements
 of 16–20; embodied 152; framework
 vs. freedom 202; graphical approach to
 14–16; hierarchical approach to 14; lessons
learned 200–204; online 182–183, *184*;
 personal style 16; planning for alignment
 202; process vs. product 201; purpose of
 13–14; unpacking meaning 201–202; using
 technology 20–21; using what you've got 203
facilitation perspectives 195–199, *196*;
 engagement 195, *196*, 197–198; group 195,
 196, 198–199; purpose 195, 196–197, *196*;
 role 195, *196*, 198; self 195, *196*, 199
feasibility frame 69
feedback 39, 49, 53, 91, 96, 126, 160, 189
Fishbone cause/effect diagrams 108, **115**
Five Team Dysfunctions 73
flexibility 32, 38–42, 45
flipchart paper 29, 126
flipcharts 77, 111, 128, 174
Flow Channel 108, 113
flowcharts **116**, 118
focusing 16
Forcefield Analysis 81, 108, **115**, 119, *120*
"Form, Storm, Norm, Perform" 108
Four Player Model 108
frameworks 112–114, *113*, **115–117**, 117–118,
 173, 198, 202
free play 187–188
freeform graphics 130–131; collaging (2D)
 131–135, *131*, *132*, *133*, *134*; creating vision
 135–137, *135*; observational drawings 138–
 139; visualizing "flow" 137–138, *137*
freewriting 130
From / To charts **116**

Gantt charts 54, **117**
Gap Analysis **116**
Generative Drawing 24
glue stick 30, 132
Google Jamboard 33
Gornall, Sarah 3
graphical sessions: at the end (cleaning up)
 48–49; getting people to draw 44–46; going
 deep 203; online and hybrid 180; preparing
 space for 42–44, *42*, *43*; during the session
 46–48
Grief/Change Curve 108, 111
ground-rules 44
group interaction 47
growth mindset 45

Habitat Framework **115**
handouts 48
happy chart 54
Hawking, Stephen 131
Hebb, Donald 64
hemispheric specialization theory 96
Hepburn, Emma 85
heptagons 86, 87

Heron, John 20
Hersey Blanchard model 77
hexagons 86, 87–90, *88*, *89*
histograms **115**
honesty 126, 148, 190, 197
horizon scanning 99

icons 109
idea cube 67
idea desert 75
idea generation 68–69
image capture 6–8, *7*
image creation 2–3, *2*
image sharing 32, 185–187, *185–187*
images: AI-generated 192; annotated 172–174,
 172, *173*; examples *36*, *37*; from
 smartphones 32, 186; stockpiling 131, *131*
inclusivity 136, 183, 200
infographics 181, *182*, *201*
interlocking circles model 103
Ishikawa, Kaoru 108, **115**
Ishikawa Diagram 108, **115**

kami 158
Kano model **116**
kinaesthetic engagement 4
Kington, Miles 195
Knowledge Spiral 6
Korzybski, Alfred 91
Kubler-Ross, Elisabeth 108, 111

Leadership circles 108
leadership vision 135
learning: associative 64; experiential 35, 39;
 specific vs. open-ended 35–36
learning capture 3
LEGO® bricks 44, 101, 154, 163–164, *164*,
 170–171, *171*
Lewin, Kurt 81, **115**
Likert scales 53
listening, active 17

Madden, Matt 83
magazines 132
mandalas **116**, 122
Mappa Mundi 126
maps and mapping: cartographic conversations
 91, *92*, *93*, 105–107, *105*; concept maps 64,
 94–95, *95*; facilitative questions 95, 98, 101,
 102, 104–105, 106; graphical geography *93*;
 mapmaking 1; mapping a journey 97–99,
 98, 119, *125*, 137–138, *137*, 176; mapping
 discussions and group interactions 104–107,
 105; mapping relationships 102–104, *103*;
 mapping the future 99; mapping values 174;
 maps to navigate complexity 94–96, *95*;

organizational roadmaps 100–102, *100*,
 101; stakeholder mapping 102–103, *103*;
 Talker and Drawer 96; three-dimensional
 155; understanding structure 96–97, *97*;
 whiteboard 93, *93*
market growth v market share 77
masks 160–161, *161*, 204
Maslow's Psychological Hierarchy of Need 73
Matisse, Henri 204
matrix models 77–78
McCloud, Scott 175
McCurdy, Katie 54, 56
McGilchrist, Ian 96
McKinsey 7S model 86, **115**
Medawar, Peter 202
Menti app 189, 190
Mentimeter 34, 189
metaphors 4–5, 47–48, 56–58, 109, 119, 172
Minard, Charles 58, *59*
mindful cards 172
MindMap Mastery 64
MindMaps® 33, 64–65, 94
Miro 33, 185, 187–188
models **115–117**, *117–118*
montage 156; *see also* collages
MoSCoW Analysis **116**
MS Teams 34
Mural 185

Napoleon Bonaparte 58
neural networks 64
neurodiversity 33
notetaking 17

online sessions 180–181; anonymous posting
 182–183; digital issues 184–185; digital
 play and practice 187–188, *188*; graphical
 possibilities of AI 190–192; image sharing
 and digital collaboration 185–187, *185–187*;
 and participant engagement/involvement 183;
 virtual considerations 182–183, *184*; word
 clouds 188–190, *189*
Opportunity Scoring **116**
ordering ideas and information 148, *149*,
 150–151, *150*, *151*; dialogue *151*; diamond
 nine 148, 150–151, *150*
organizational hierarchy 100–102
organizational map 69
origami 157–160, *157*, *158*, *159*
Osterwalder, Alexander 3

pace, energy, and impact 15
Padlet 134, *187*
paper: flipchart paper 29, 126; printer paper 29
paraphernalia 15
participation 15; active 3–4, *4*

patterns 54
PCDA (Plan-Do-Check-Act) Circle **115**
peer support 183
pens: marker pens 29, 85; whiteboard pens 30, 169
pentagonal scaffold *86*
pentagons 86
permission giving 44
personal style 16
PESTLE analysis 129
physical movement 147–148
Piatt, Katie 183
Pictal Health *56*
pie charts **115**
Pigneur, Yves 3
play 204–205; free 187–188
Polar Charts 128
possibilities 9, 13, 15, 39–40, 118; digital 180–192
postcards 30, 172
post-it notes *see* sticky notes
PowerPoint 25, 34, 77, 180, 184
practicalities 15
pre-thinking 48
Probability vs. Impact Matrix **116**
problems of resistance 16
process 9, 15, 201
process flow chart *118*
PUCA (photograph, upload, curate, ask) process 186
purpose 9, 13–14, 15
pyramidal hierarchies 73, *74*

Quality Improvement **115**
qualitative data 95, **115**, 129
quantitative data **115**, 129
Qvist-Sorensen, Ole 3

Radar Charts 128, *128*
radar plots 86, **117**
Raworth, Kate 122
realization *5*, 38, 60, 62, 83, 104, 106, 109, 110, 113, 163, 166, 187, 192, 195
Reflective Professional Practitioners 39
reflexive practice 41–42
reframing 17–18
Resilience Road 56–57, *57*
resistance 14, 16, 199, 204
review *38*; after-event reflection 39; "What?" "So What?" and "Now What?" 38, *38*, 187
Roam, Dan 3
Rohde, Mike 3

scissors 30, 132
screensharing 184, *185*

sculptural materials 154, 170, *171*; clay 154, 162–163, *162*; "found" 162–163, *162*, 171
sculpture, annotated 170–171, *171*
semantics 91
Serious Play® 163
Seven Habits of Highly Effective People 86
shapes 142; circles 122–129; hexagons and more 86–90; squares and rectangles 77–85; triangles 72–77
Shaw, Graham 3
Sibbet, David 3, 122
silence 169, *170*, 190
social prescribing 178
spider diagrams 64, 94
squares and rectangles 77–85; boxed comparisons 79–83, *81*; matrix models 77–78, *79*; square as frame (storyboarding) 83–85
stakeholder analysis 103–104
Stakeholder Engagement 108
stick figures 27, 109
sticky notes 30, 66, *66*, 67, 92, 109, 111–112, *111*, *118*, 127, *127*, 171, *178*, 179; creating clusters with 66; creative use of 67–69; placement on target *123*
sticky tack 30, 132, 174
Stormboard 33
storyboarding 83–85, *84*, *153*
string 30, 65, 107, 122, 152, *167*, 168–169, 171, 174
Sustar, Helena 67
SWOT grid (Strengths, Weaknesses, Opportunities, Threats) 77, 109, **116**
Syed, Matthew 136
symbols 109–110, 142; arrows 2, 25, 26, 37, 70, 77, 81, 87, 106, 110, 119, 127, *167*, *168*, 184, 197; mathematical 110; yin-yang 122

Tannenbaum Schmidt Model 77
tape (invisible or masking) 29
targets **116**
Teams 109
technology 20–21; collaborative 180; for the tool kit 33–35
templates 140–141, *141*; face or body 144–146, *145*, *146*; hand as template 140–142, *142*
tessellation 87–90, *88*
Thinking Hats 126
Thinking through Drawing (TTD) 187
time: depicting 124; as filter 75, *75*; intervals 133; mapping 91; respect for 44, 45, 48; unstructured 68
time-keeping 16

timelines 53, 54, *55*, 56, 69, **117**, 124,
 152
tool kit 29–31, *31*; models and frameworks
 108–109; online and hybrid 33–35; using
 what you've got 203
TOWS grid **116**
triangles 72–77; funnels and filters
 74–75, *75*; inverted pyramids 73, *74*;
 pyramidal hierarchies 73, *74*; wedges
 76–77, *76*

Urgency, Legitimacy, and Power 103
Urgency v Importance 77
user experience 54

Value/Effort grid **116**
Vaughan, Kathleen 156
Venn diagrams 122, 181
virtual groups 20, 21, 58
visual index 64, *65*
visual position 147–148
visual voting 147
visualization 4, 5
voting 169
VUCA (volatile, uncertain, complex,
 ambiguous) landscape 200

Walsh, Mark 152
warm-ups 45, 188
watching and noticing 16–17
webinars 180–182
Weighted Elements 20
WhatsApp 34
what/so what/now what? **38**, 38, 187
whiteboards 25, 26, 43, 111–112, 169, 174;
 in collaborative software 81; multiple 33;
 software 66; virtual 33, 35, 66; in Zoom
 81, 184
Wicked Problems 108
Wilkinson, David 200
Word Clouds **115**, 188–190, *189*
workplace wellbeing 141–142
written words 168–169, *169*, *170*
WWWWH (what, when, who, why, and how)
 140

X=Y line framework 113–114

yin-yang symbol 122

Zoom meetings 33, 34, 180; breakout groups
 180–181, *181*; chat bar 109; whiteboard
 function 81, 184

Printed in the United States
by Baker & Taylor Publisher Services